T0372267

ART OF THE LIPS

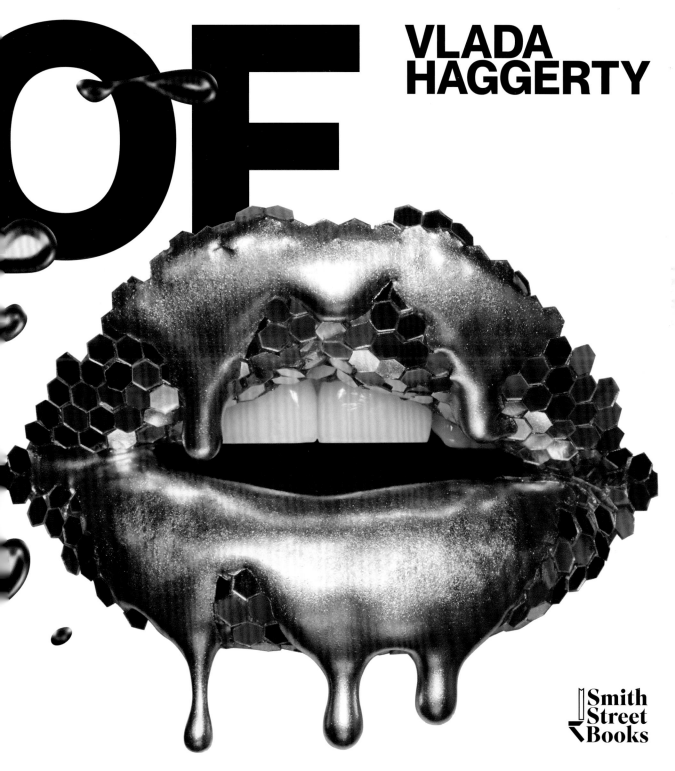

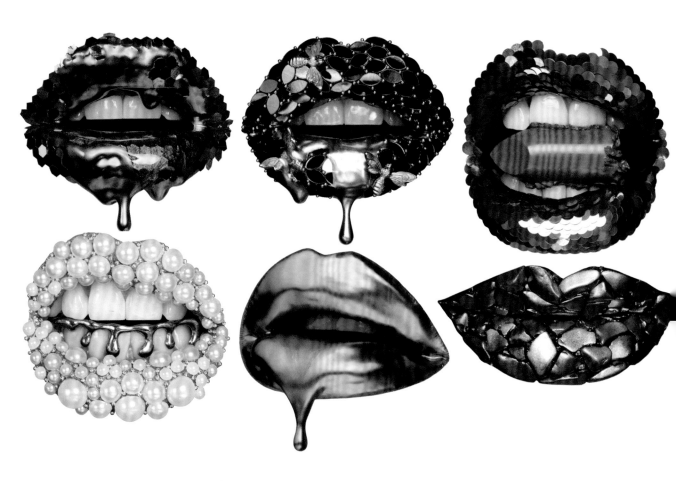

ADORNED 9
LIQUIFIED 83

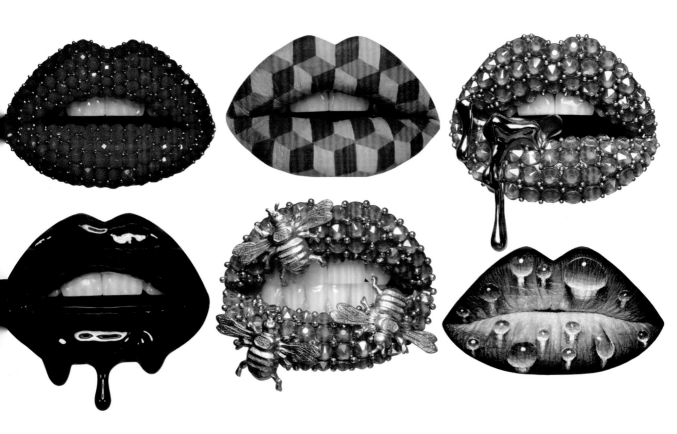

INTRODUCTION

Art of the Lips has been my dream for over five years. It features my favorite and most intricate works from 2015 to 2022.

My life completely changed when I discovered the wonderful world of lip art. In December 2014, when my husband and I moved to Los Angeles, I had no friends or work leads. My husband traveled a lot for work, and I spent a lot of time at home by myself. One day I thought to myself: "Why do I need to wait for other photographers to work with? I can do this myself!" So, I did. I picked up my husband's camera and started experimenting with different makeup looks.

Lip art was such an explosion of creativity for me. It was fresh and unusual and quickly became my favorite creative outlet. And it wasn't just a creative outlet for me, it became my own kind of meditation. It has done wonders for my mental health. Tedious applications, colorful paints and intricate designs put my busy mind to work and allowed my racing thoughts to stop for a while. This work requires such concentration that my thoughts stop completely, and my thinking brain can get some rest. The fulfillment I feel when completing a lip art creation is like nothing anything I'd experienced before. Even though this medium is very unusual, to me lip art is a true art form and I'm so happy to share it with the world through this book.

I am very grateful to my followers on Instagram for showing such interest in my work. It always inspires me to keep creating. If it wasn't for all the wonderful people leaving kind comments, sending me sweet emails and direct messages, I would have not gone as far as I did in this field. Thank you.

I'm also very grateful to my husband, Aaron, who inspired me to pursue my dream of becoming a makeup artist. I wouldn't be where I am today without his love and support.

Finally, I want to thank my mother, Natalia, who helped me become the artist I am today. Thank you for always having my back and believing in me even when I wanted to give up.

Vlada Haggerty

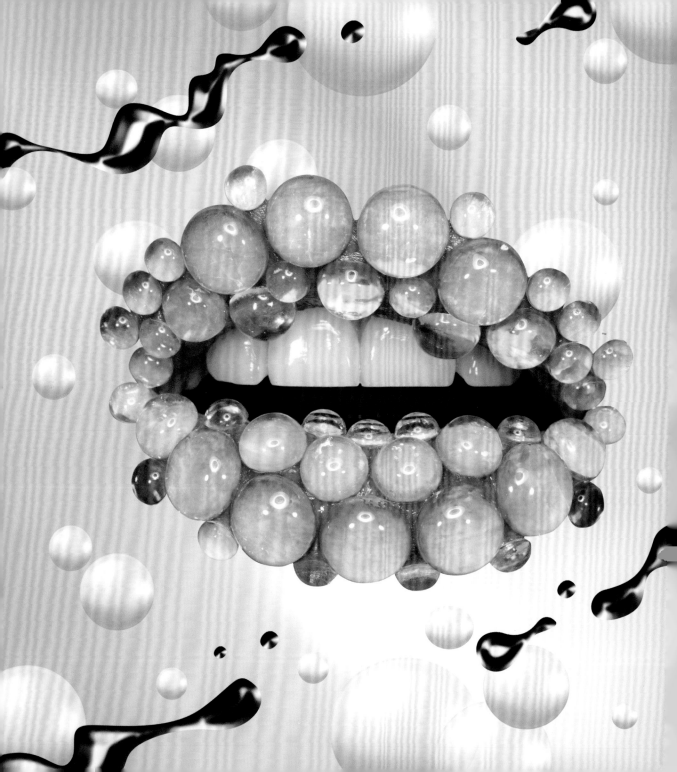

ADORNED

This decorative style was one of the first lip art techniques I tried. I use stickers, sprinkles, large glitter sequins, turquoise, beads, gold leaf and other craft-store finds. Often the adornment provides the inspiration for the art.

I use liquid to matte lipsticks as a base and Pros-Aide (a medical-grade adhesive) to create my designs. These looks are usually created on the fly. I don't sketch them out first as I do with my painted lip art. It's always an improvisation and I love this part of the process.

I created my most intricate adorned lip art in 2018. I called it "USB" (page 46). It consisted of three layers of large glitter (large, medium and small) to create a honeycomb pattern. It took me over three hours to finish and I wanted to give up half-way through! Creating the lip art, shooting and retouching took approximately five hours in total. People ask me how I have the patience for this. To me, this is not work – it's a form of meditation. When I create lip art, my thoughts stop, and I can pause everything and just be in the moment. It's truly a wonderful feeling.

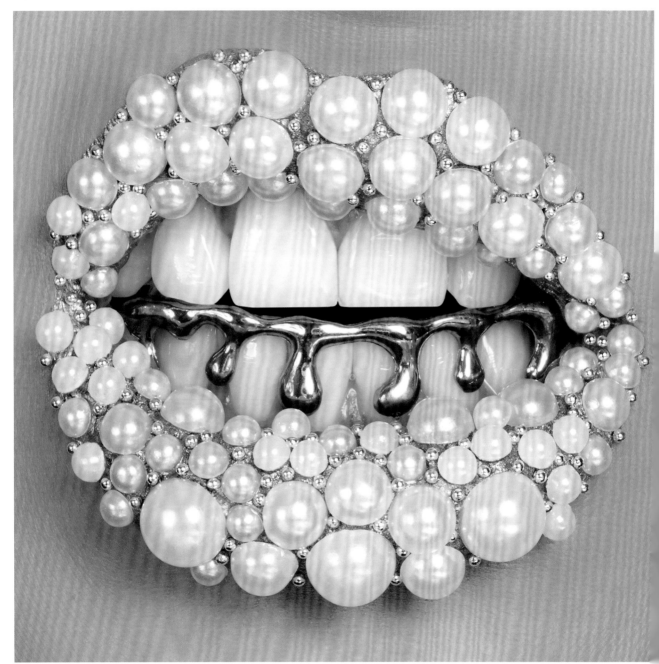

2017 PEARLS
Liquid lipstick · gold leaf · half pearls ·
caviar beads · grillz

10

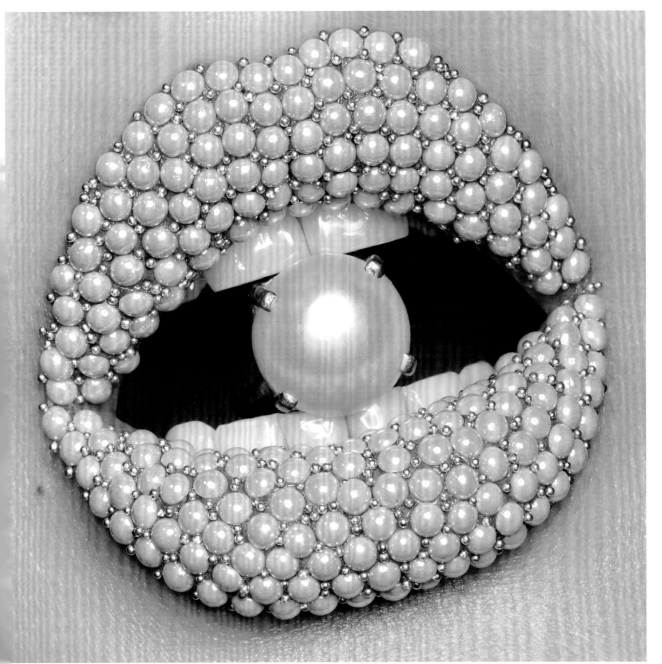

2018 VENUS
Liquid lipstick · half pearls ·
caviar beads · pearl ring

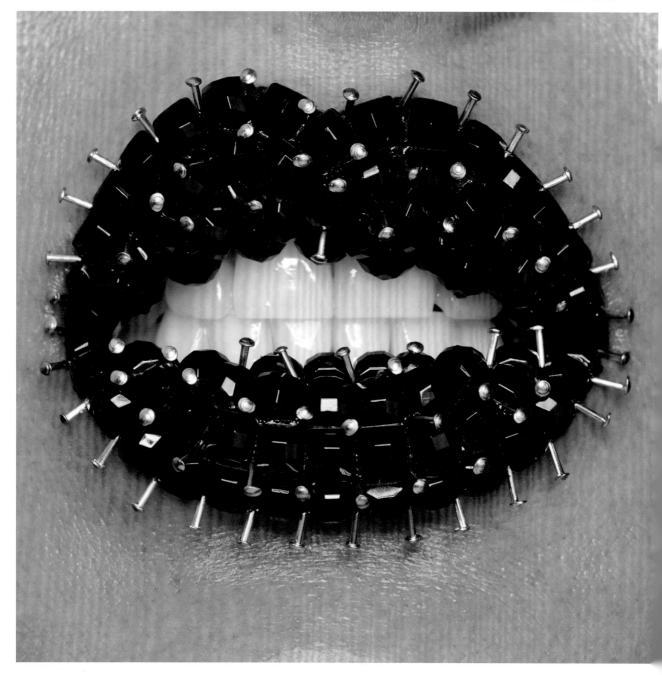

2020 PIN LIP
Liquid lipstick · resin gems ·
doll house nails

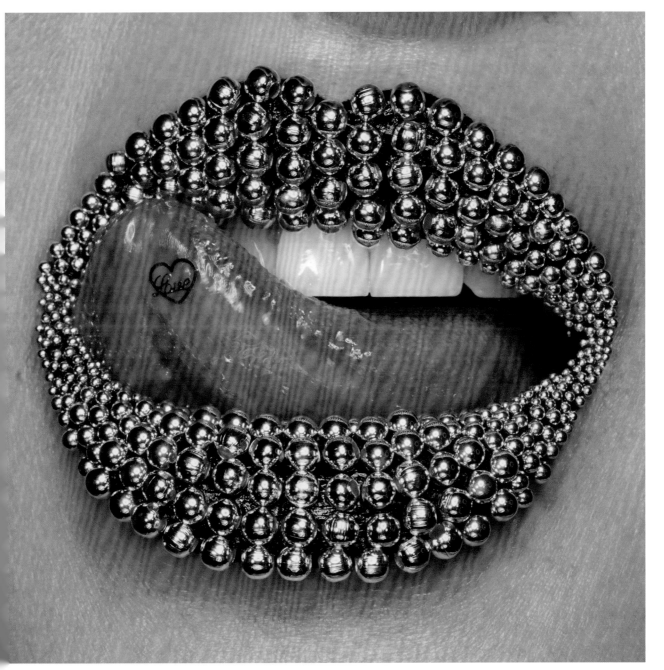

2020 LOVE
Liquid lipstick · plastic beads

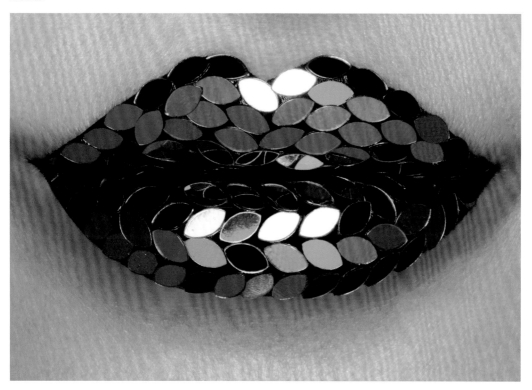

TIP Try using Pros-Aide instead of lash glue for a more secure and long-lasting application. Pros-Aide is a professional-grade medical adhesive used in special effects makeup to apply prosthetics, facial hair, etc. It is safe and non-toxic, and is specifically formulated for sensitive skin.

2020 MOTHER EARTH ↑
 Liquid lipstick · large glitter

2021 SWEET LIES →
 Liquid lipstick · imitation
 gold nuggets · pendant

14

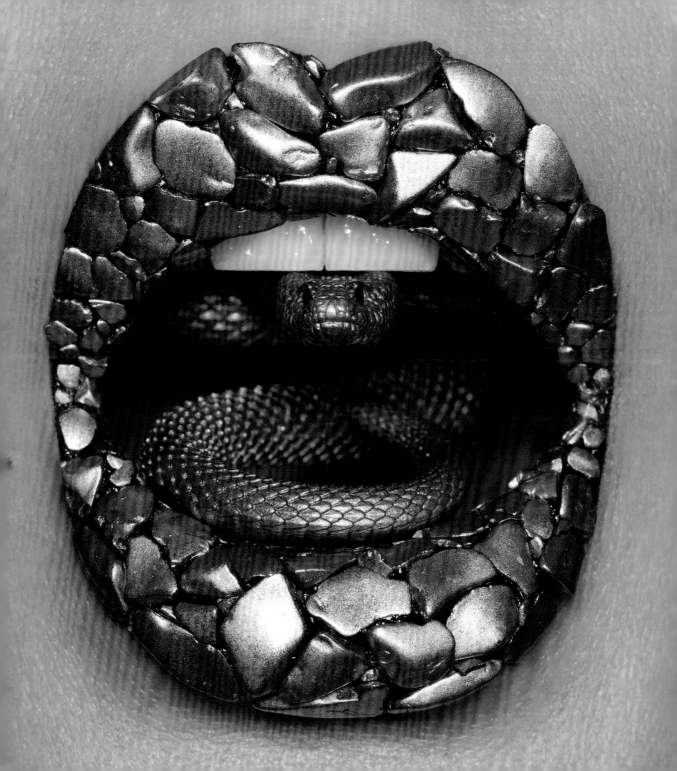

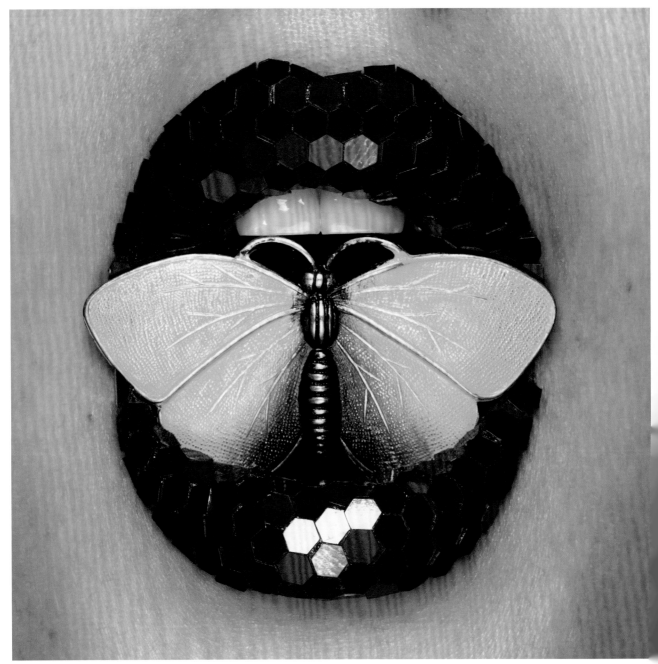

2020 POLLINATE
Liquid lipstick · large glitter ·
pendant

16

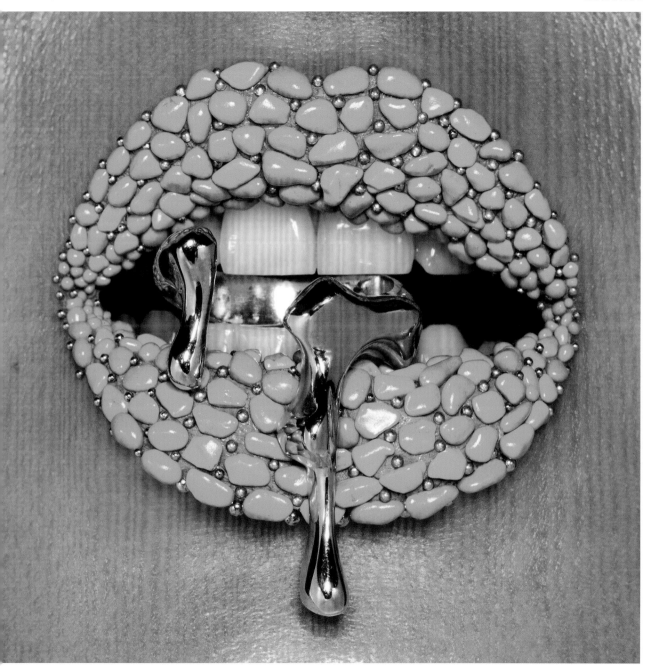

2021 TURQUOISE
Liquid lipstick · turquoise ·
caviar beads · ring

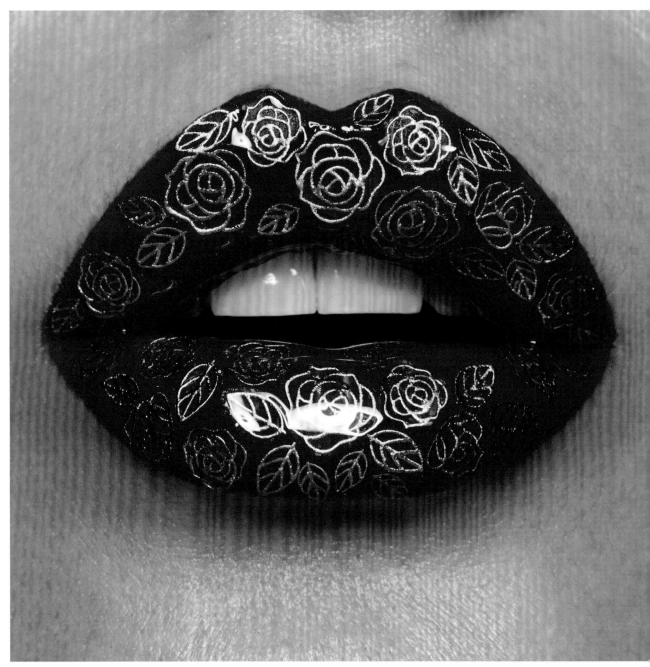

2020 GILDED ROSES
Liquid lipstick · nail art stickers ·
clear lip gloss

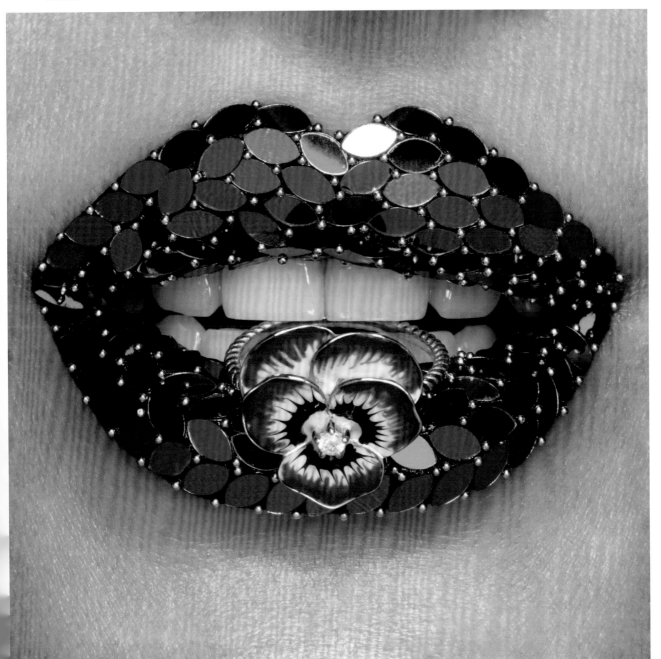

2020 SPRING
Liquid lipstick · large glitter ·
caviar beads · ring

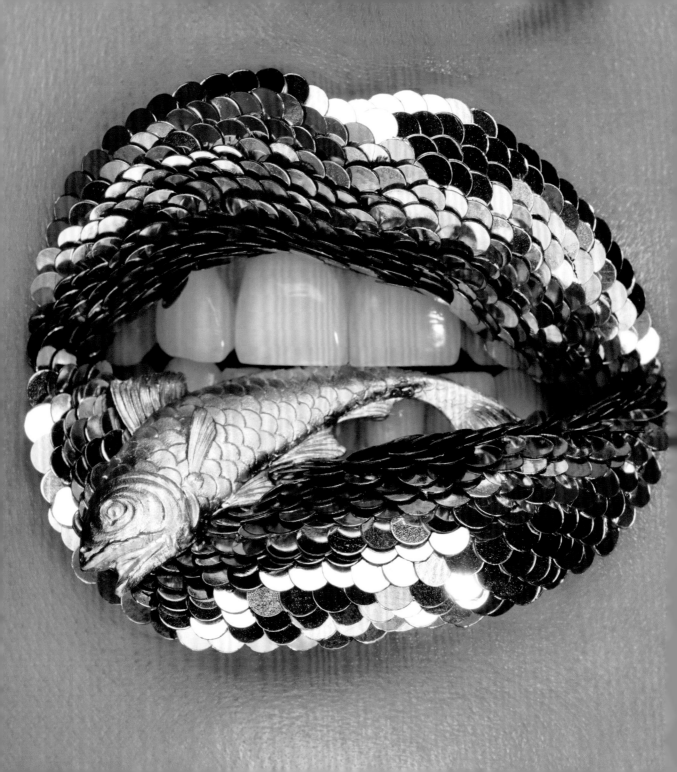

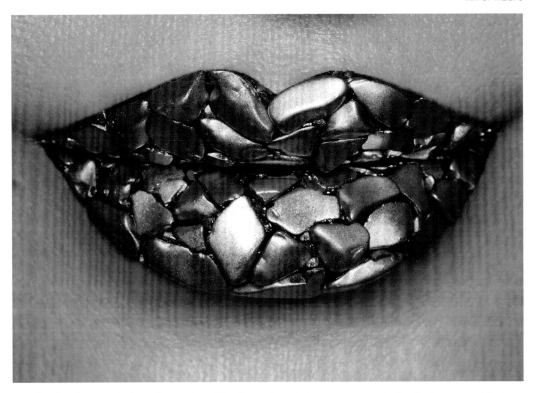

TIP Apply adornments from the center of the lips outwards to ensure your design looks symmetrical. The corners of the lips are more forgiving if you make a mistake.

2019 CATCH OF THE DAY ←
Liquid lipstick · large glitter ·
pendant

2021 GOLDEN SMILE ↑
Liquid lipstick · imitation
gold nuggets

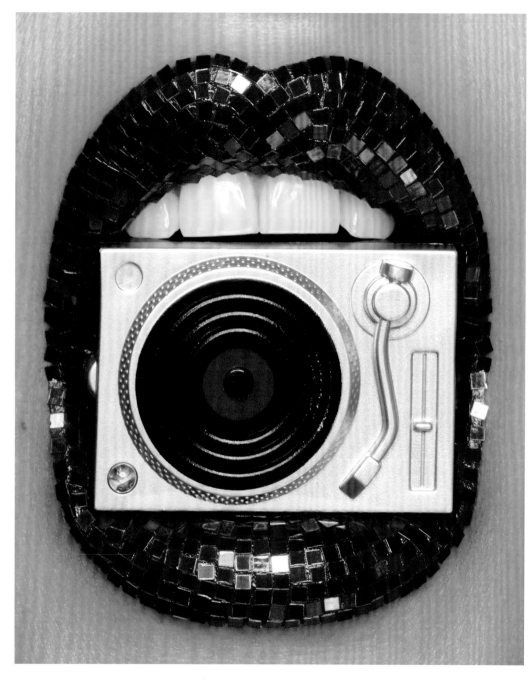

2018 TECHNO
Liquid lipstick · large glitter ·
miniature turntable

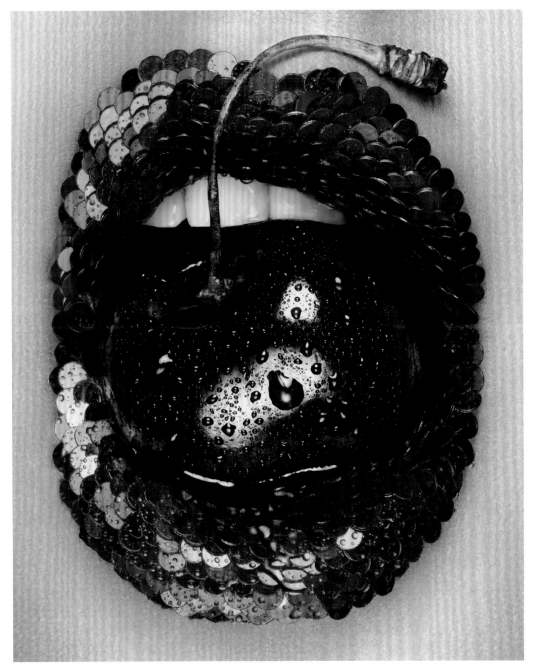

2017 SWEET CHERRY
Liquid lipstick · large glitter ·
cherry · water

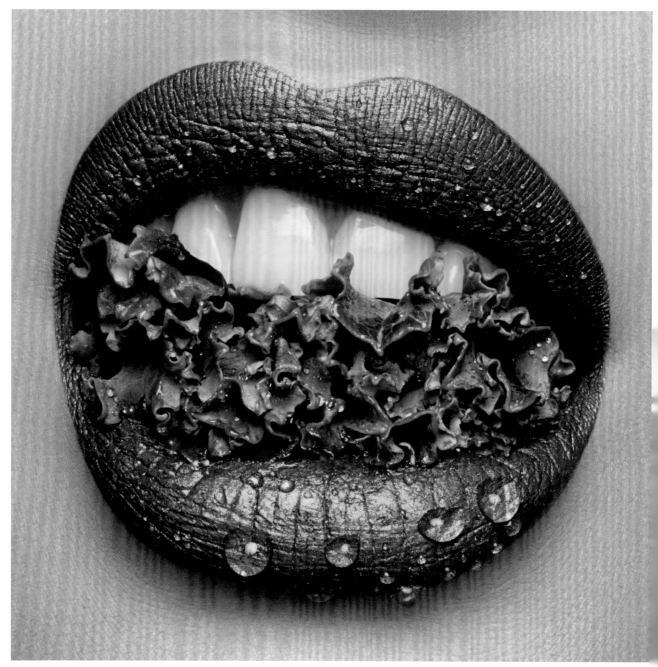

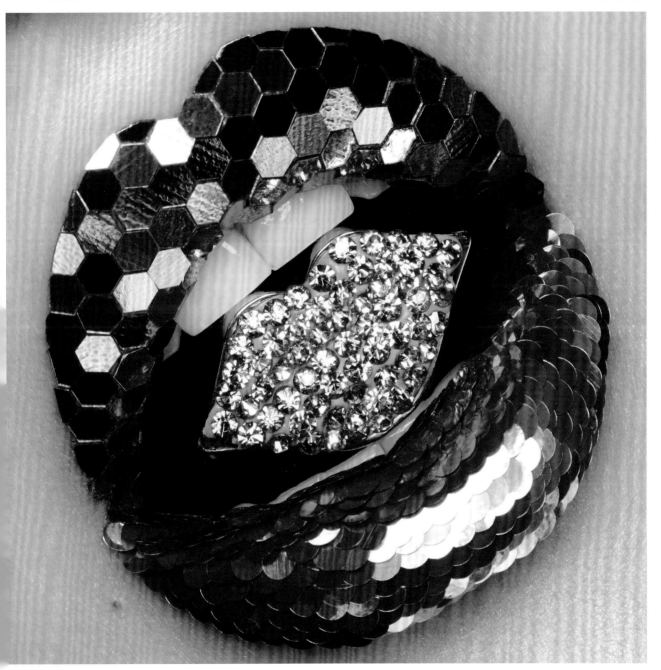

2018 PINK GOLD
Liquid lipstick · large glitter ·
lapel pin

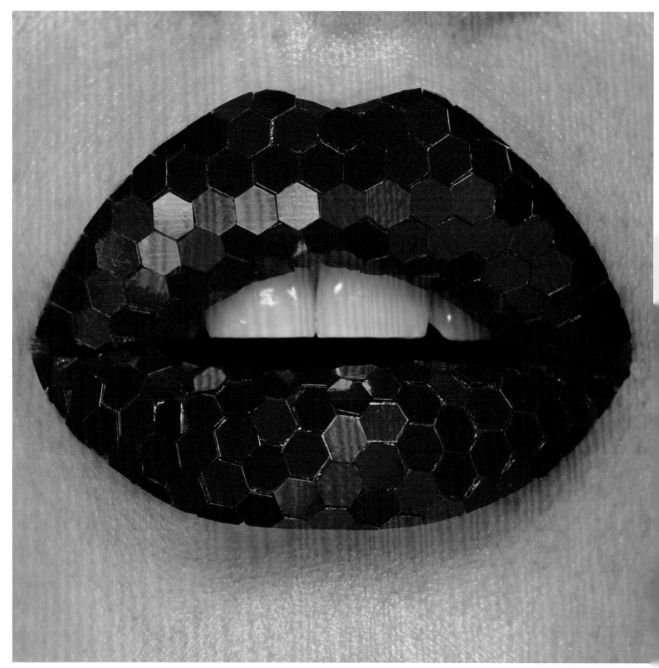

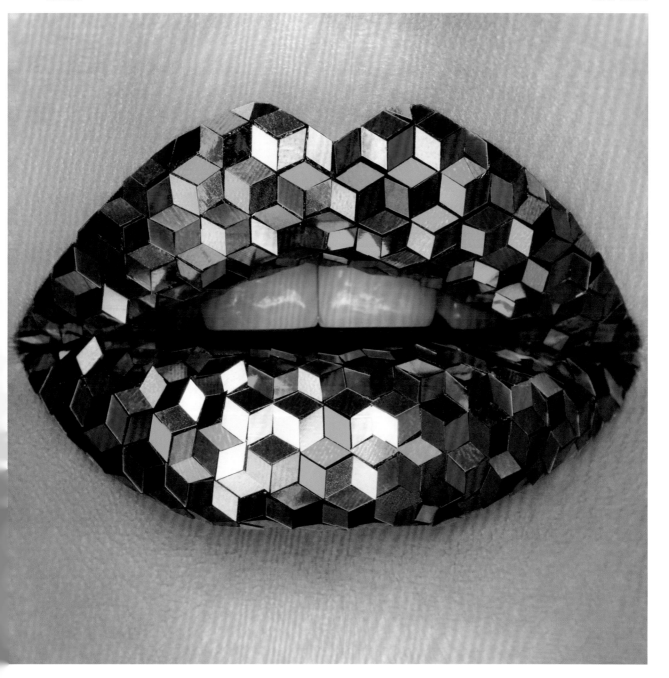

27

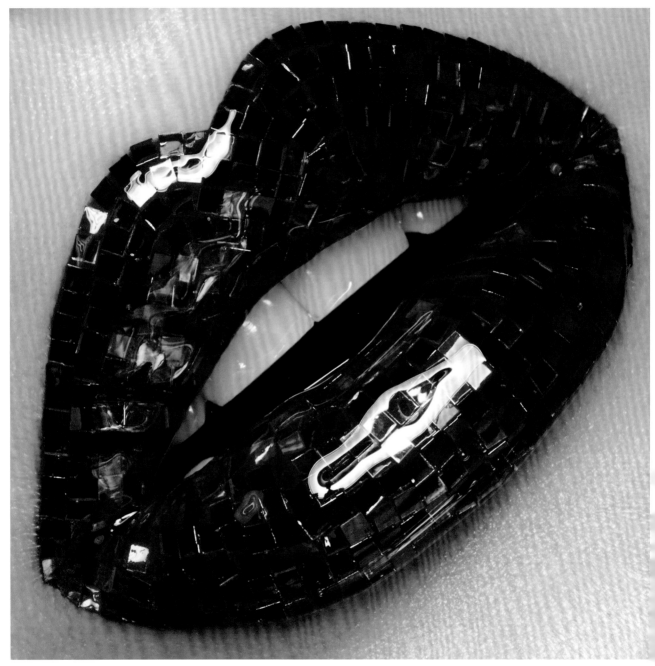

2018 PATENT DISCO
Liquid lipstick · large glitter ·
clear lip gloss

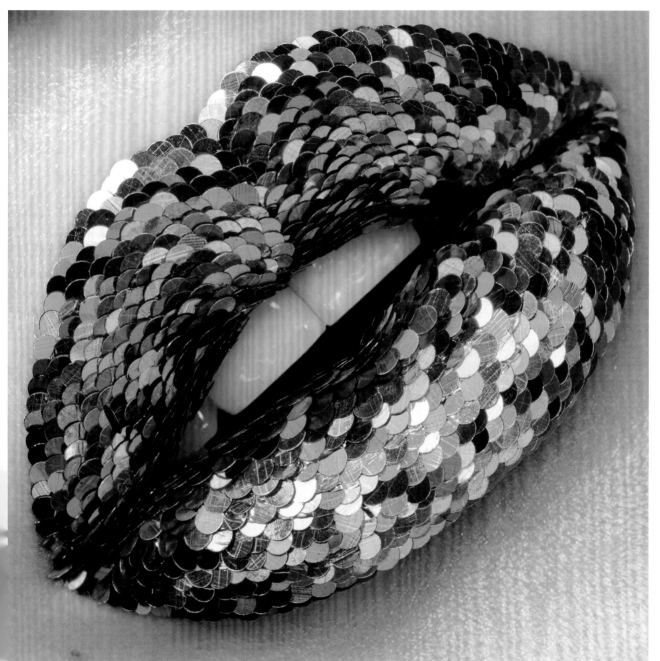

2018 ARIEL'S LIPS
Liquid lipstick · large glitter

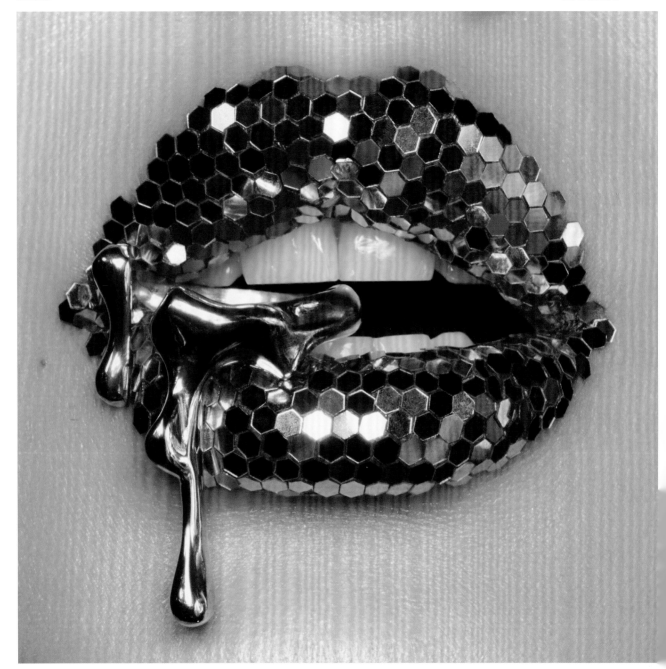

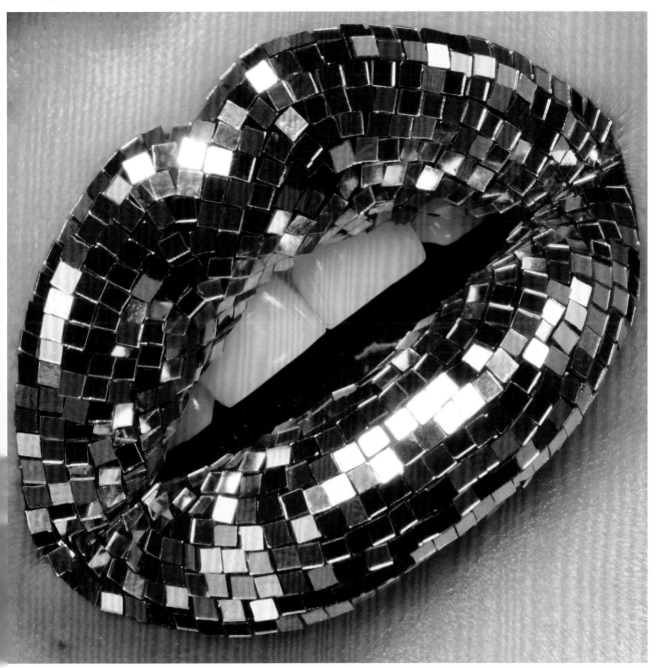

2018 GOLDEN DISCO
Liquid lipstick · large glitter

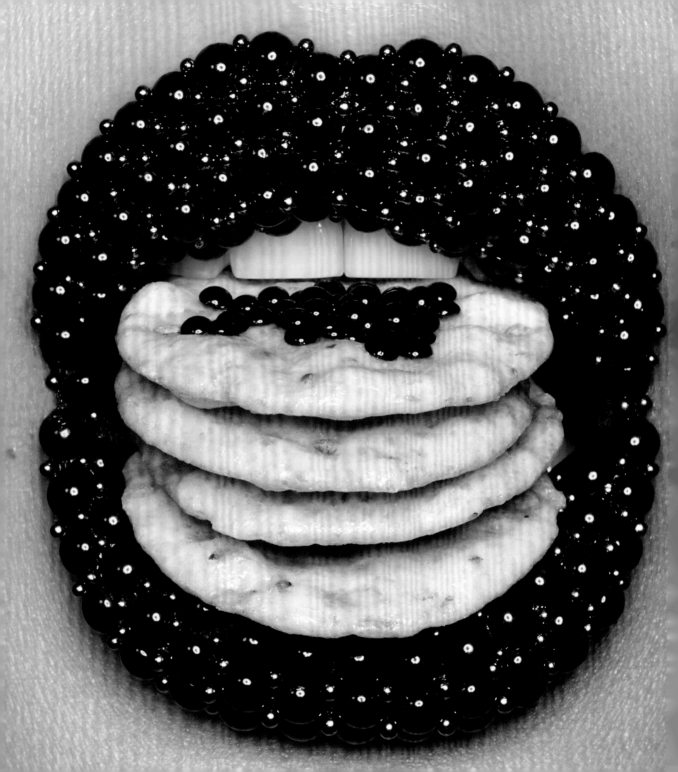

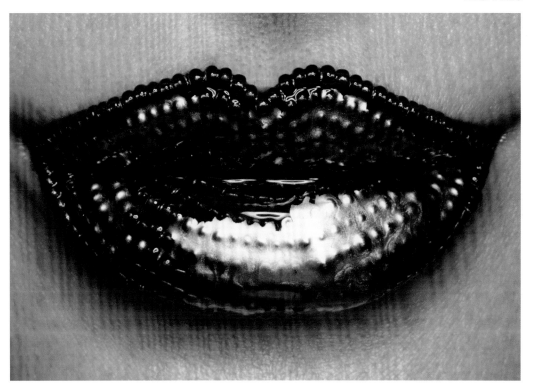

2018 HORS D'OEUVRE ←
Liquid lipstick · glass half beads ·
caviar beads · rice crackers

2018 GILDED POMEGRANATE ↑
Liquid lipstick · glass seed beads ·
gold pigment · clear lip gloss

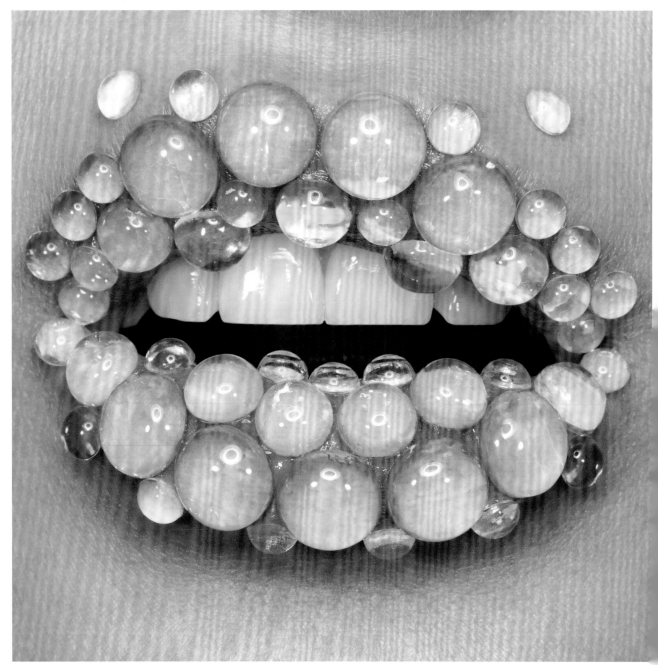

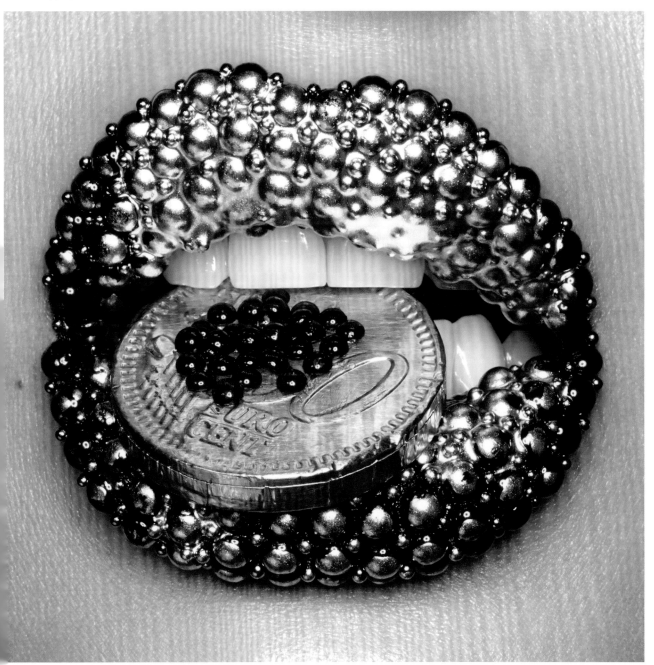

35

2018 MATERIALISM
Liquid lipstick · glass half beads · caviar beads
· gold pigment · clear lip gloss · chocolate coin

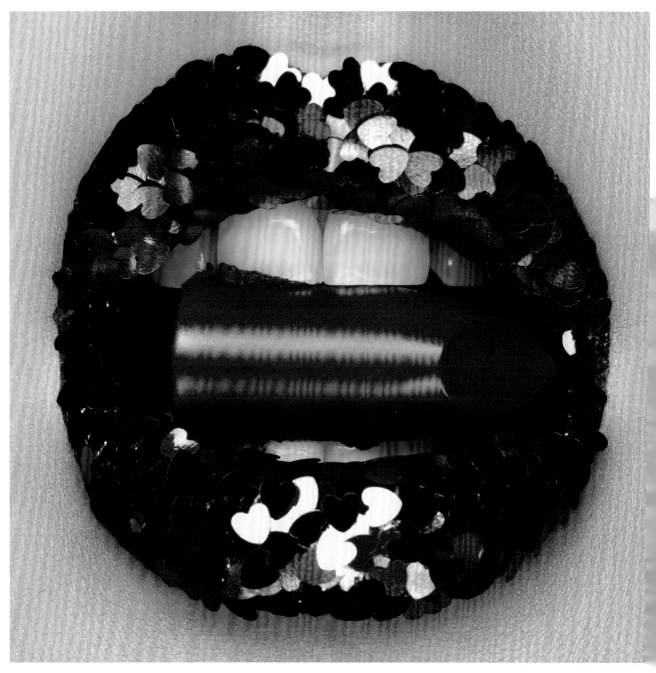

2017 FETCH
Liquid lipstick · large glitter ·
lipstick bullet

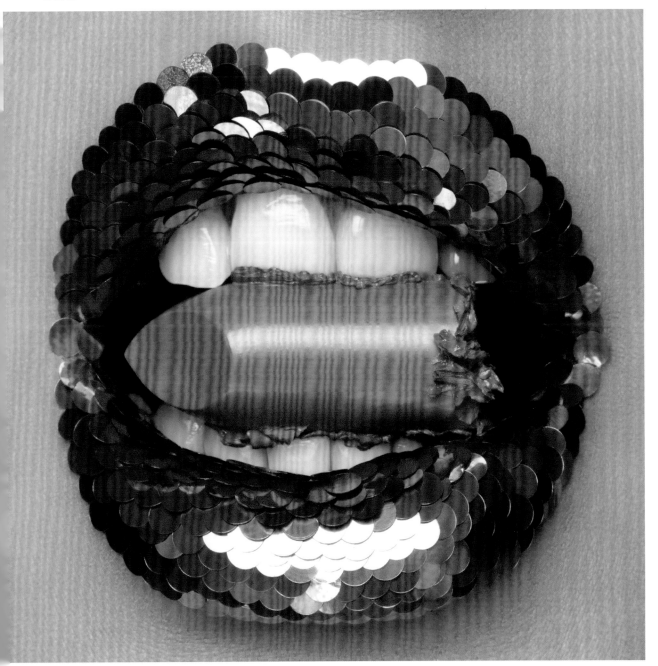

37

2017 PASTEL FETCH
Liquid lipstick · large glitter ·
lipstick bullet

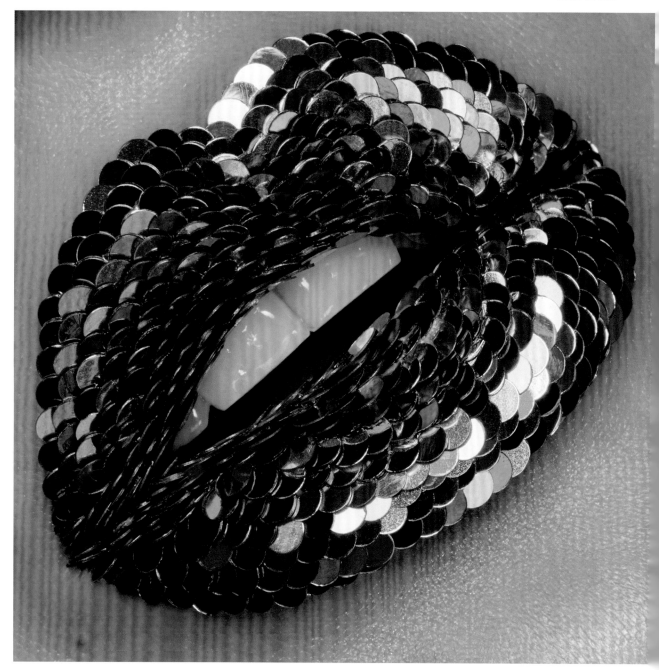

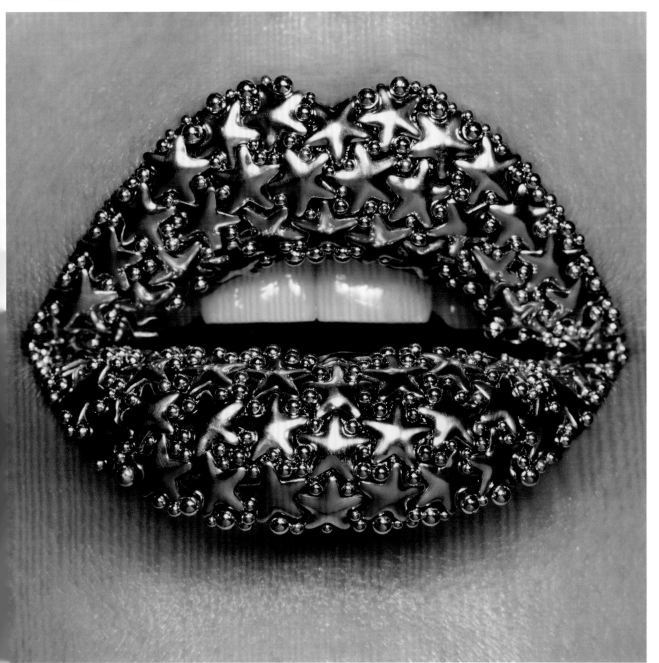

2020 STARS
Liquid lipstick · metal stars ·
caviar beads

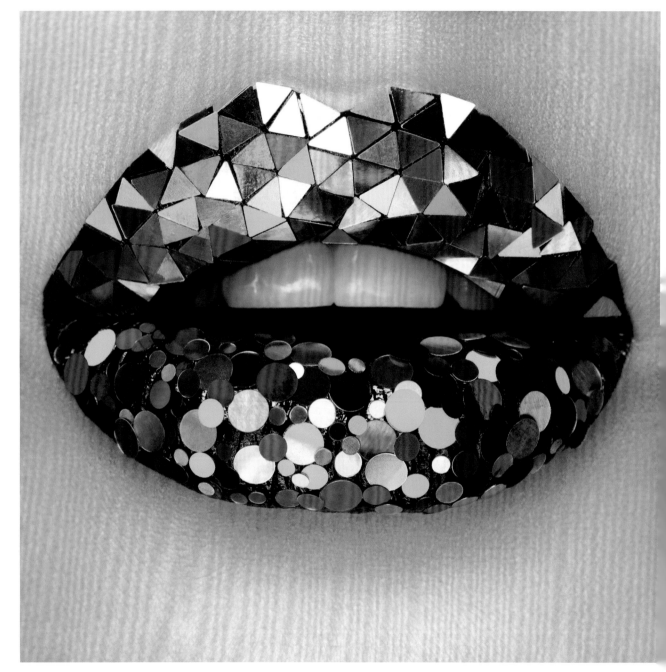

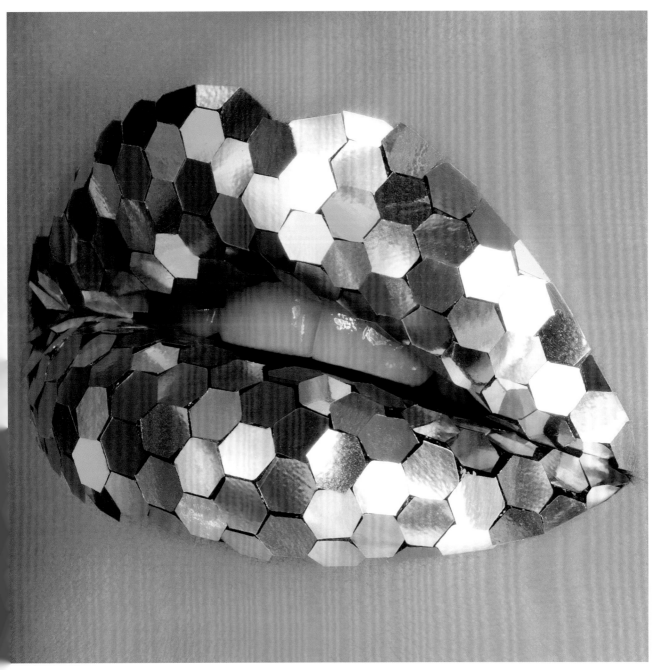

41

2017 HOLO
Liquid lipstick · large glitter

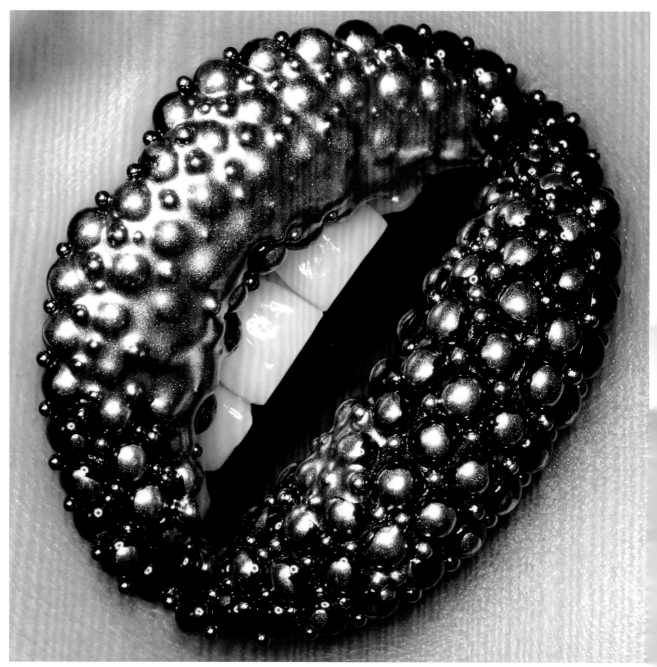

2018 TEXTURES
Liquid lipstick · glass half beads · caviar beads ·
gold pigment · clear lip gloss

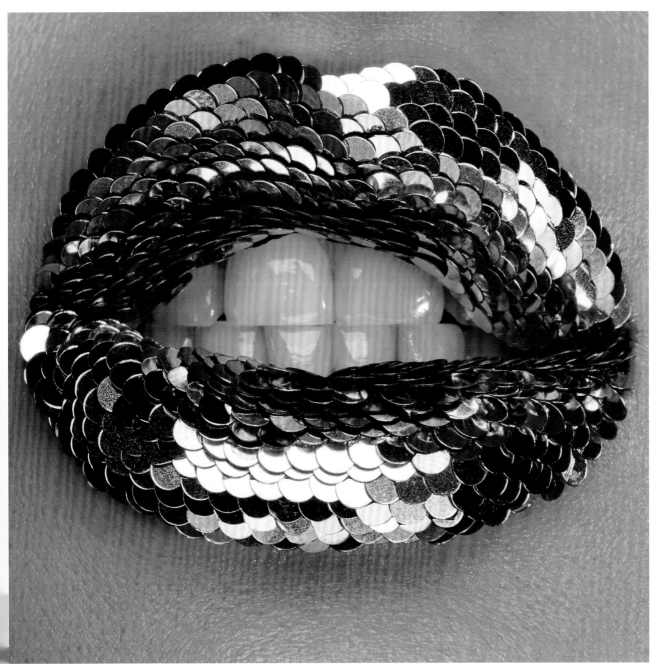

43

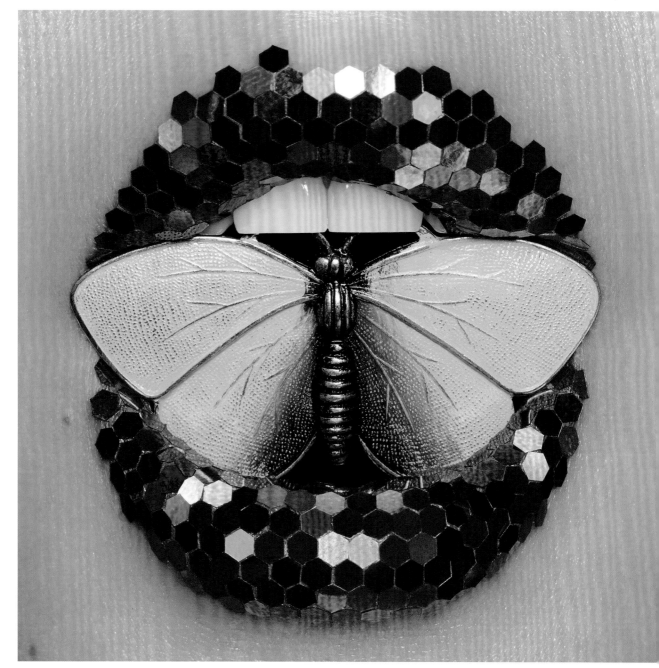

2018 I CAN FLY
Lliquid lipstick · large glitter · pendant

44

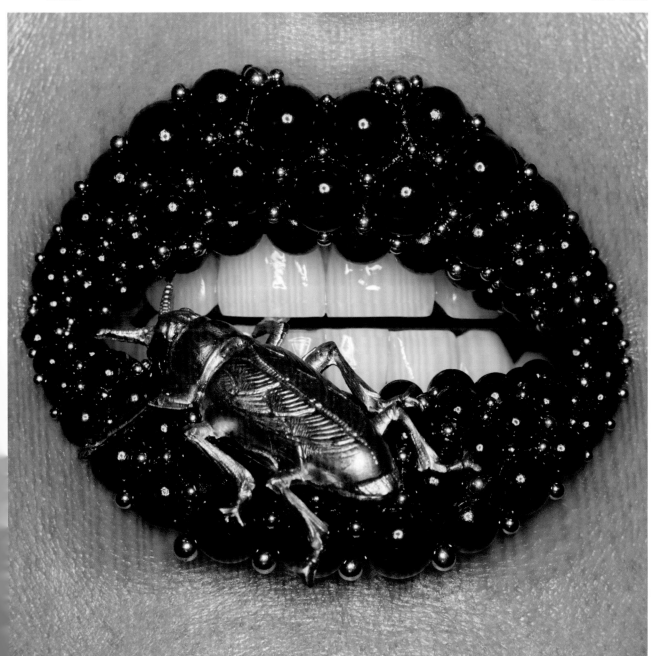

45

2020 VISITOR
Liquid lipstick · glass half beads ·
caviar beads · metal bug

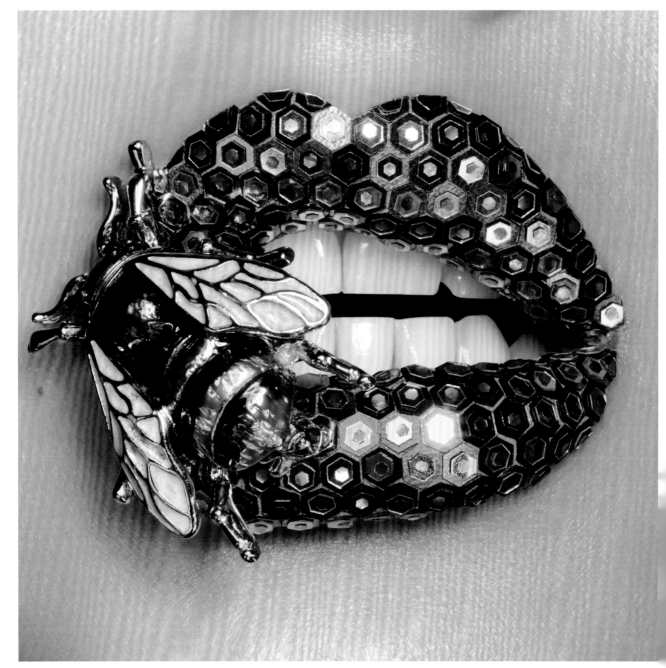

2018 USB
Liquid lipstick · large glitter · brooch

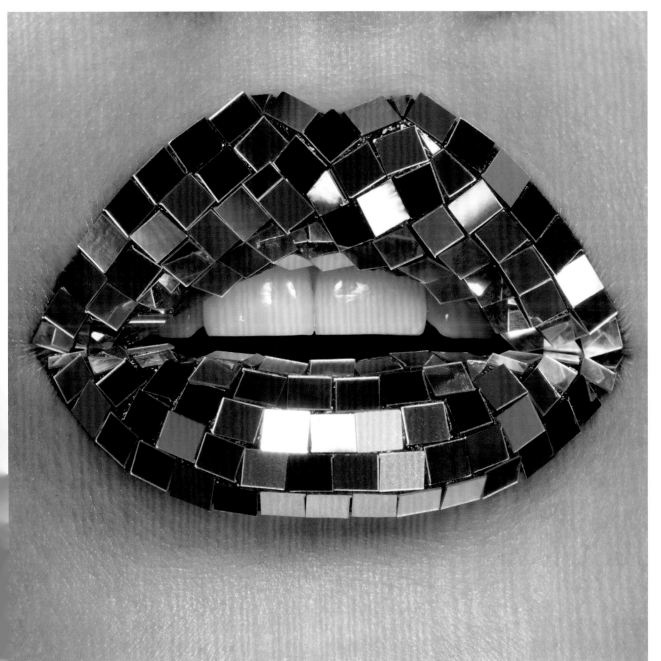

47

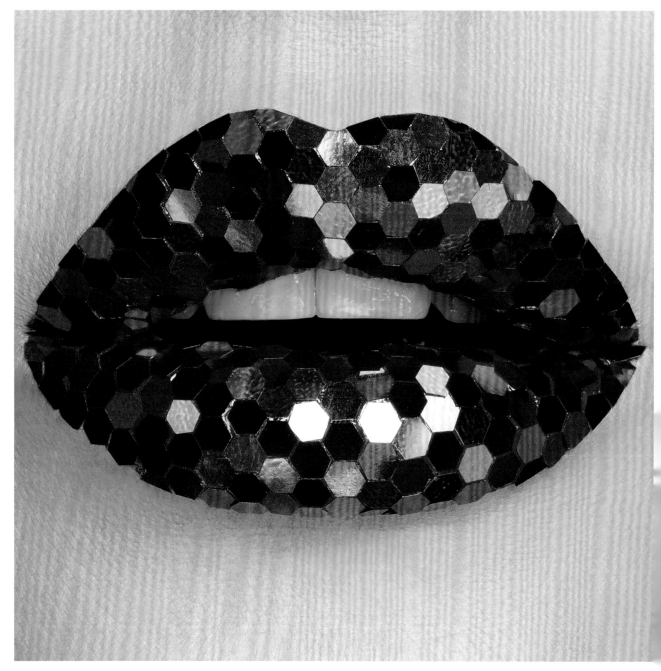

2017 RUBY HONEYCOMB
Liquid lipstick · large glitter

48

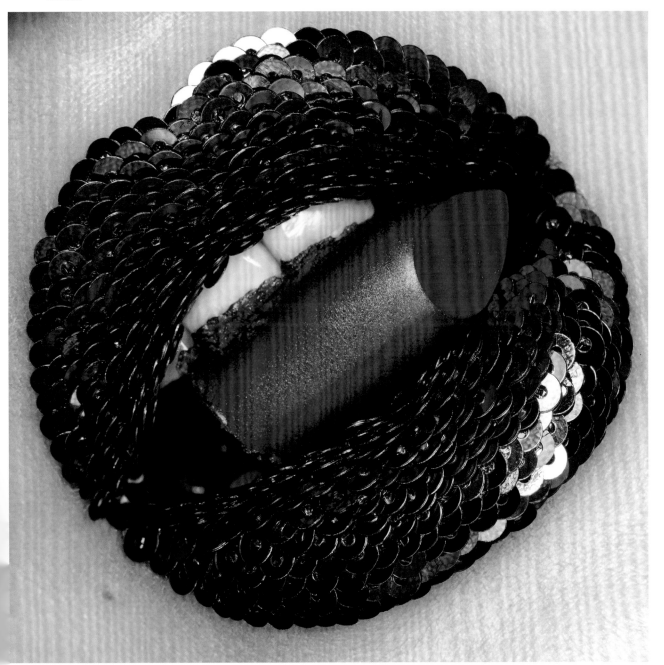

2018 ULTRA VIOLET
Liquid lipstick · sequins ·
lipstick bullet

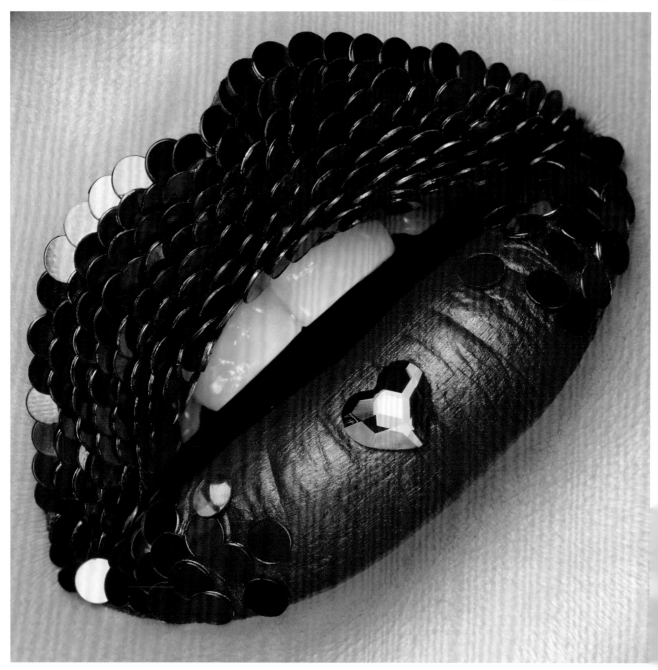

2017 MAN EATER
Liquid lipstick · large glitter ·
glass crystal

50

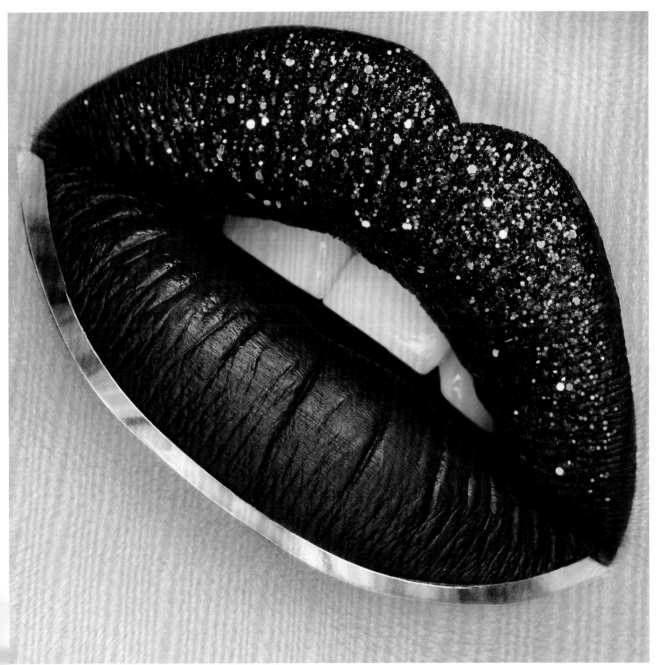

2017 TAR PIT
Liquid lipstick · glitter ·
holographic craft paper

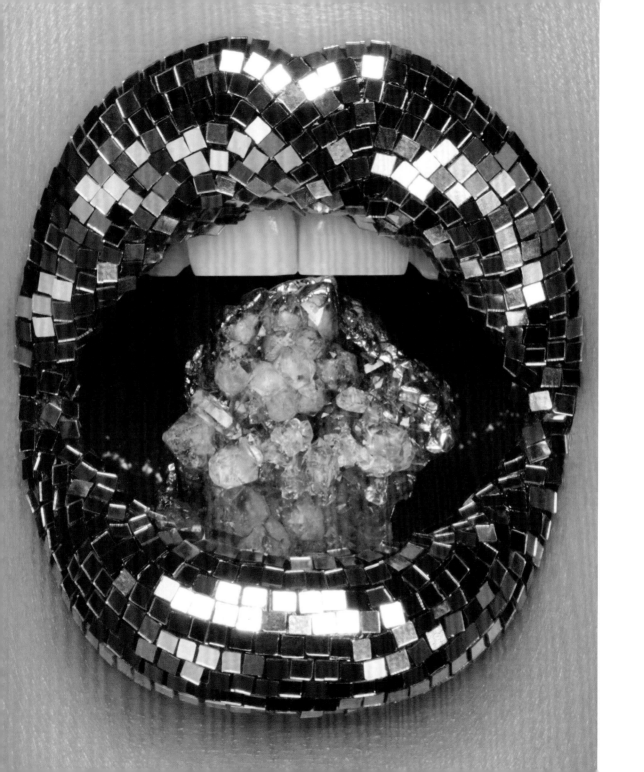

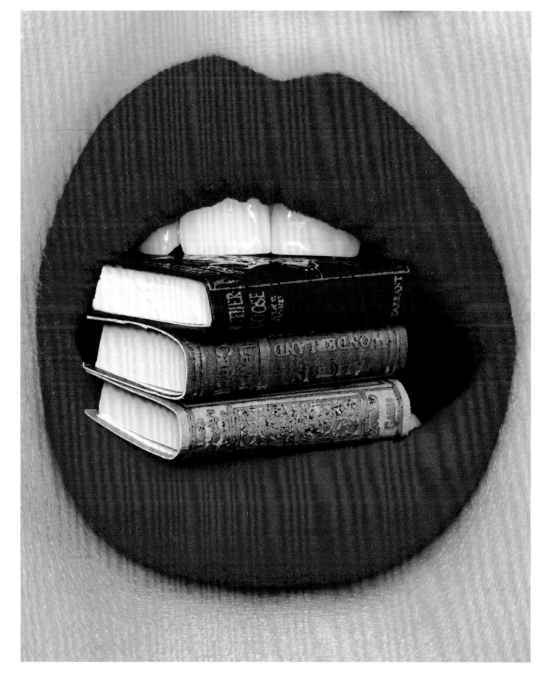

2018 AMETHYST ←
Liquid lipstick · large glitter · ring

2018 COZY BLANKET ↑
Liquid lipstick · flocking powder ·
doll house books

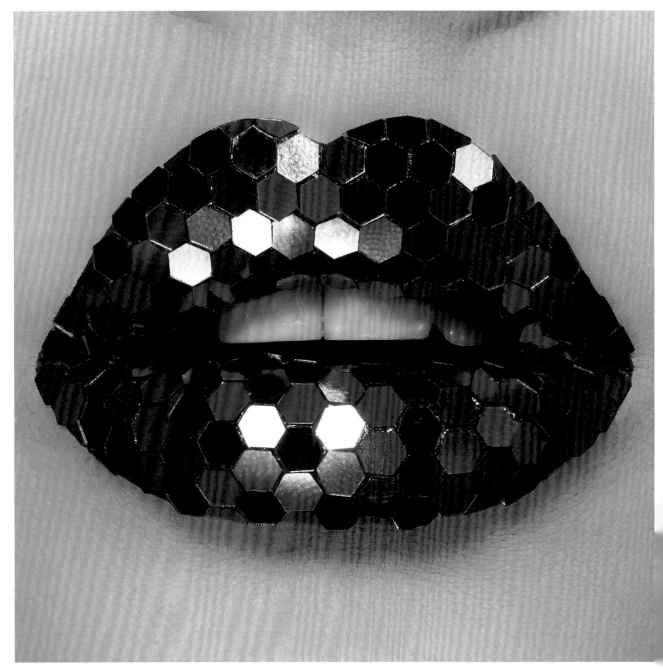

2017 COSMIC
Liquid lipstick · large glitter

54

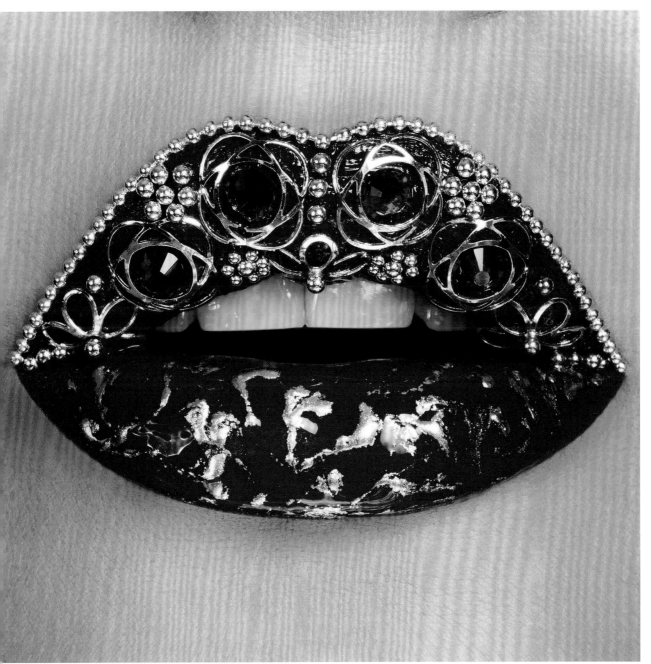

2017 ROYAL EGG
Liquid lipstick · caviar beads · crystals · nail
art elements · gold pigment · clear lip gloss

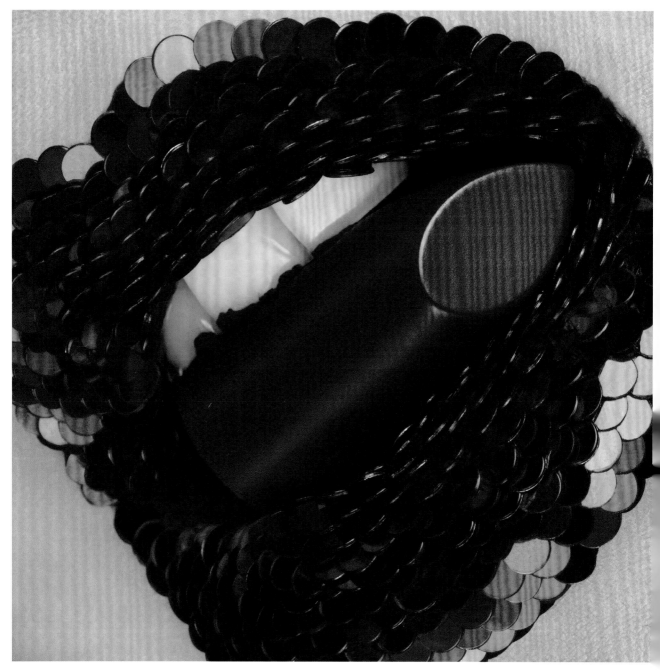

2017 INFRARED
Liquid lipstick · large glitter ·
lipstick bullet

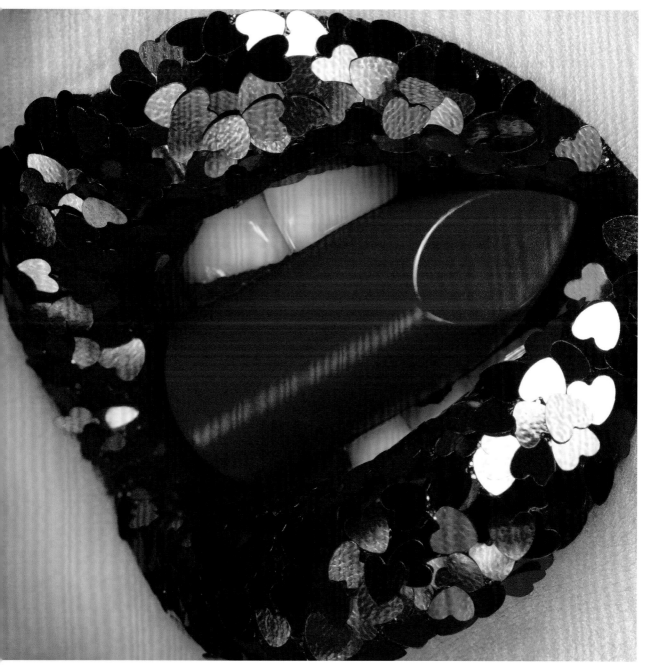

2017 PUNCH DRUNK
Lliquid lipstick · large glitter ·
lipstick bullet

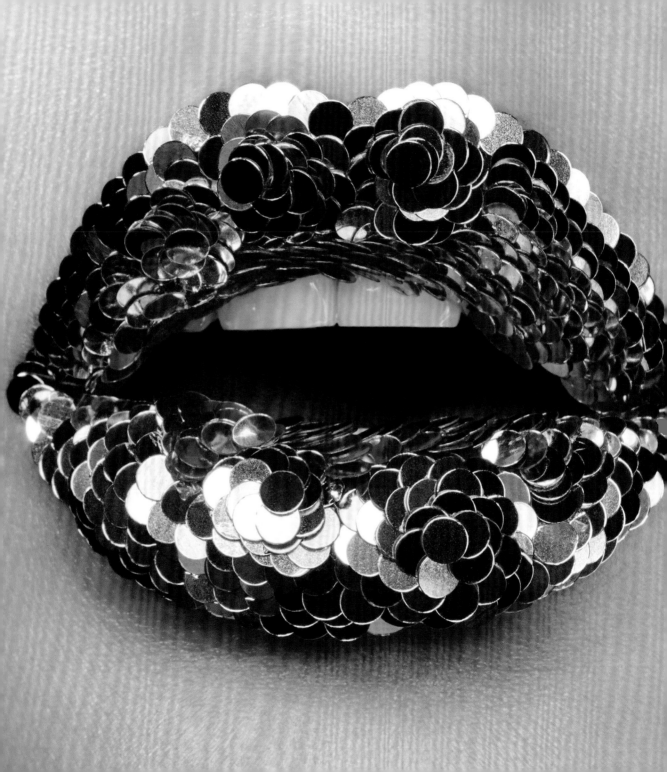

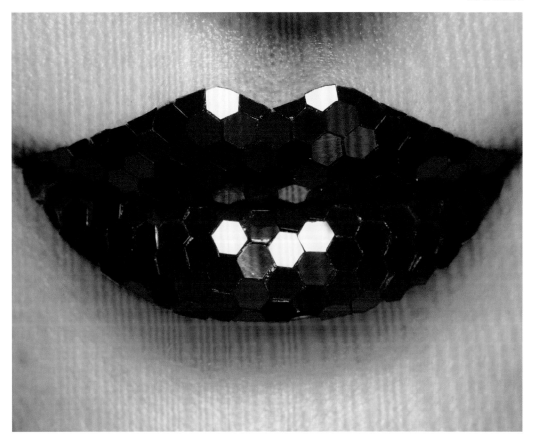

2018 VORTEX ←
Liquid lipstick · large glitter

2020 PINK SMILE ↑
Liquid lipstick · large glitter

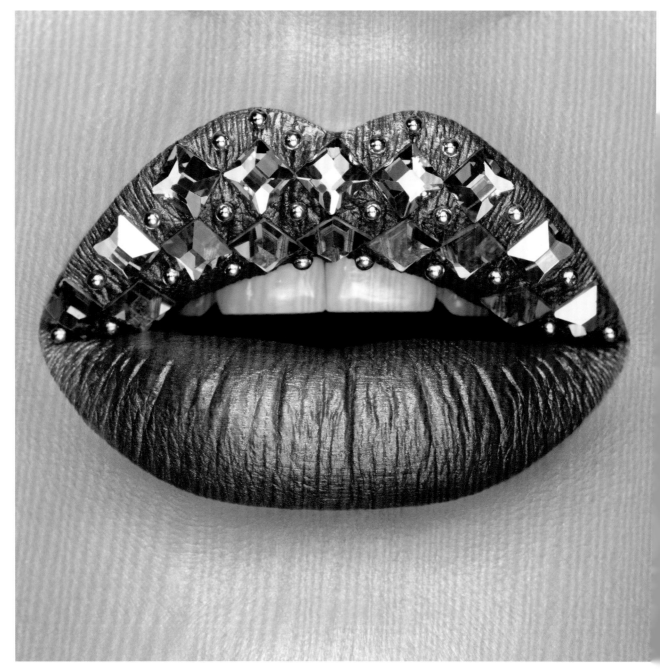

2017 RUST FUND
Liquid lipstick · square glass gems ·
caviar beads

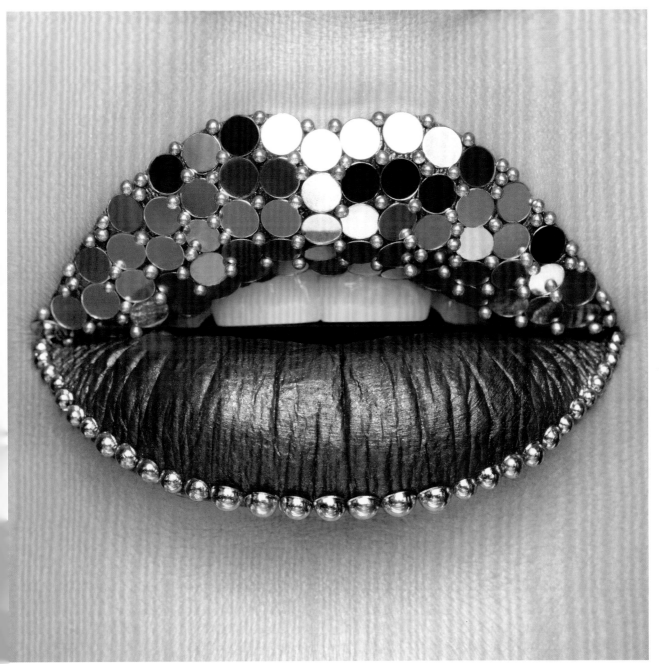

2017 BOLD DIGGER
Liquid lipstick · large glitter ·
caviar beads · half beads

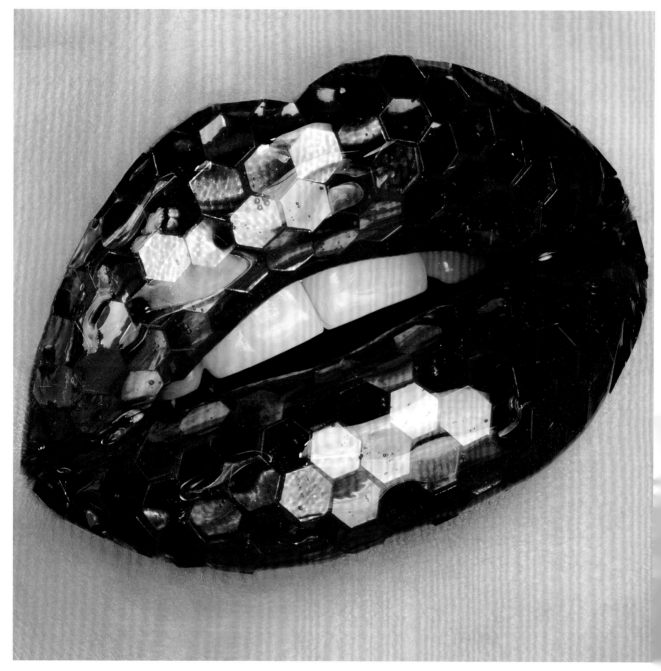

2017 GLAZED
Liquid lipstick · large glitter ·
clear lip gloss

62

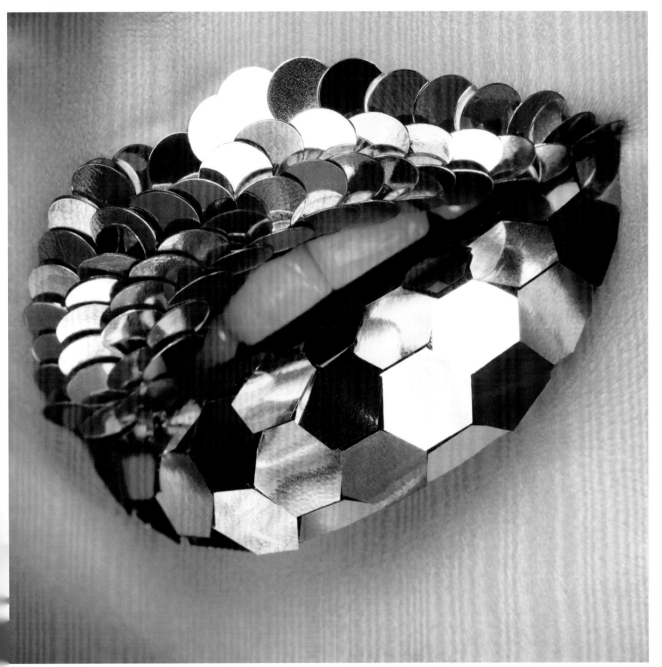

63

2017 GILDED
Liquid lipstick ·
various large glitter

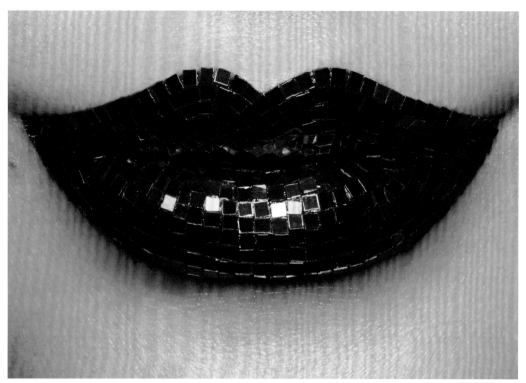

TIP If you're using liquid lipstick as a base, wait until it is completely dry to the touch before applying any adornments.

2018 DISCO RED ↑
Liquid lipstick · large glitter

2018 HONEY →
Lliquid lipstick · large glitter · grillz

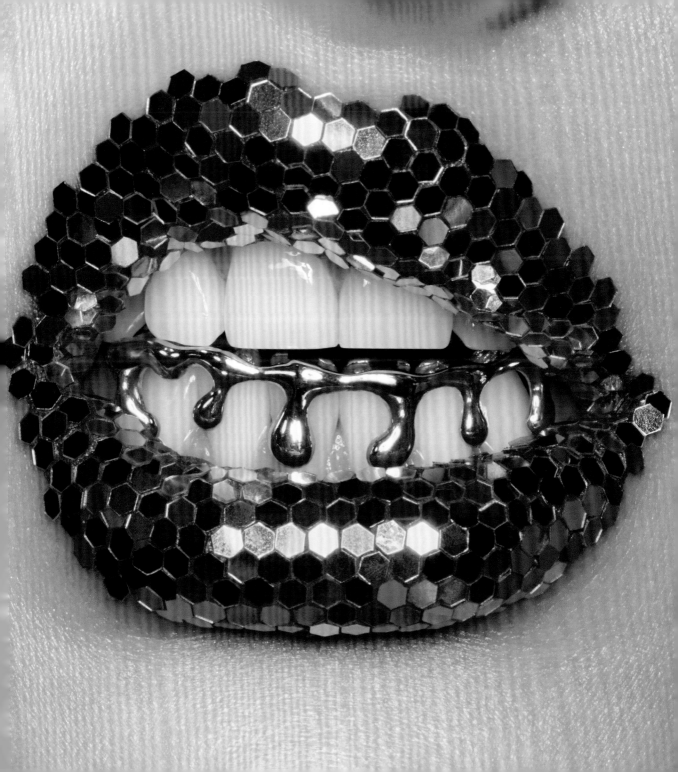

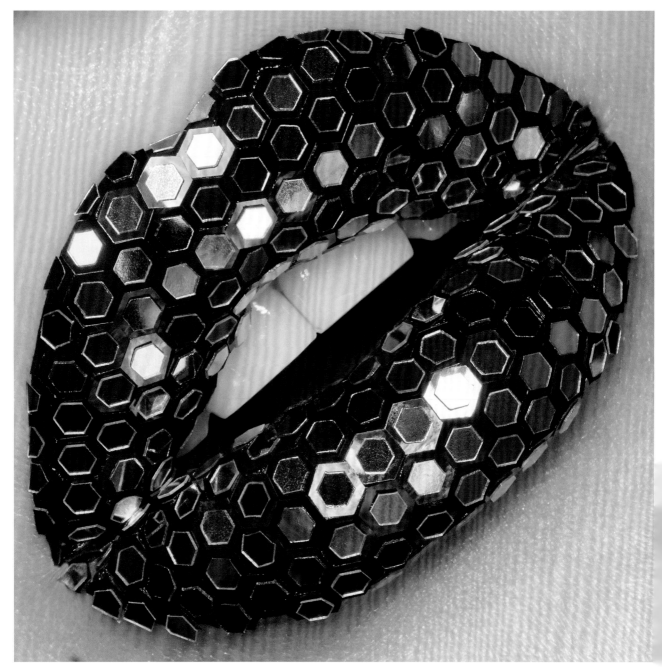

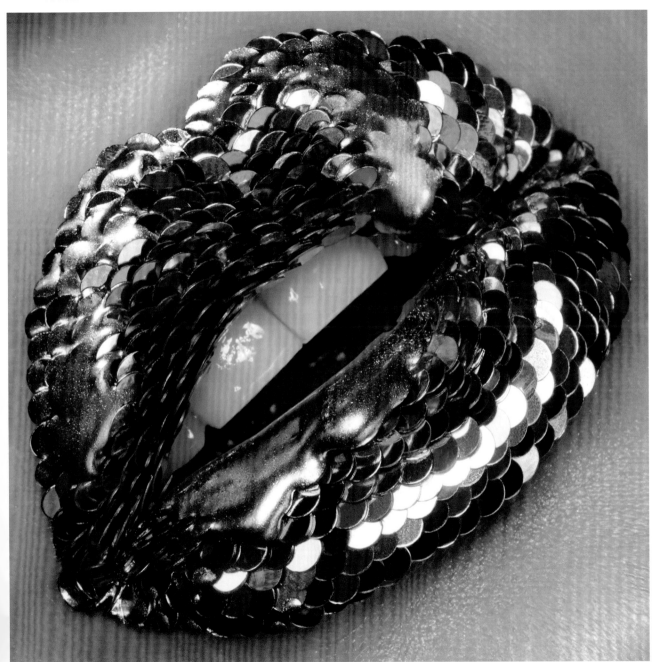

2018 GILDED GILLS
Liquid lipstick · large glitter ·
gold pigment · clear lip gloss

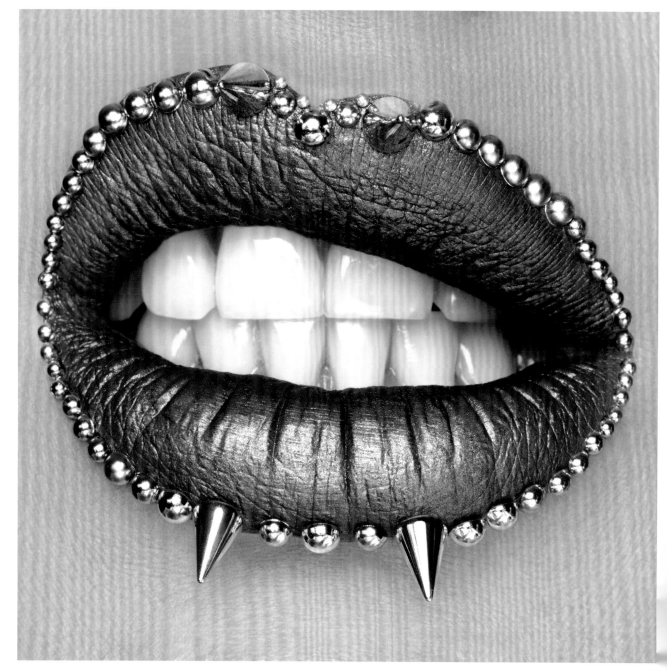

2017 PUNKED ROCK
Liquid lipstick · metal half beads · spikes

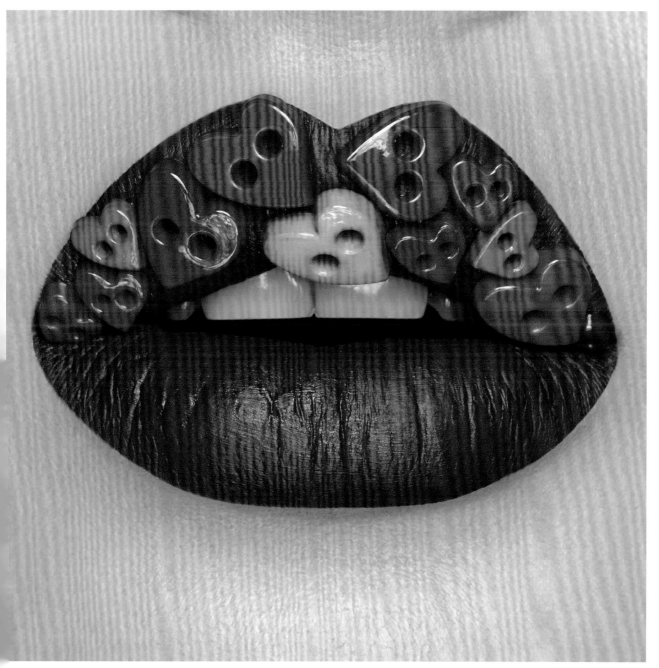

2017 THROWBACK JAM
Liquid lipstick · buttons

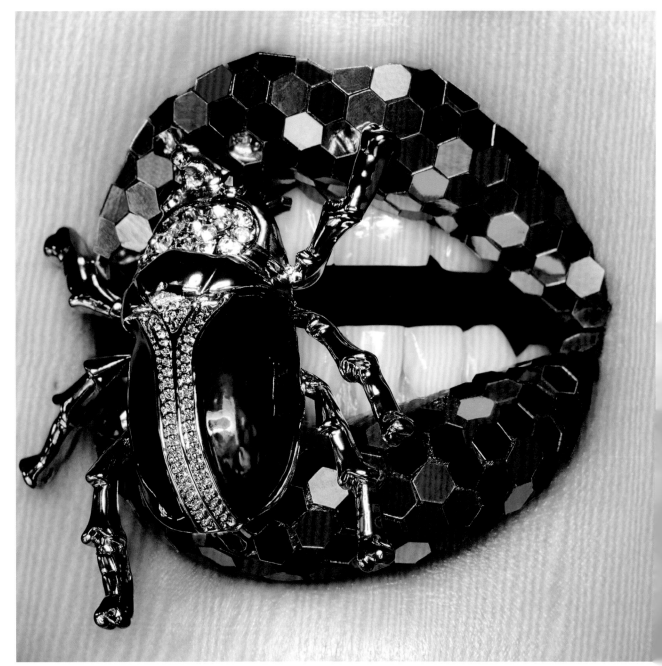

2018 COBALT
Liquid lipstick · large glitter · brooch

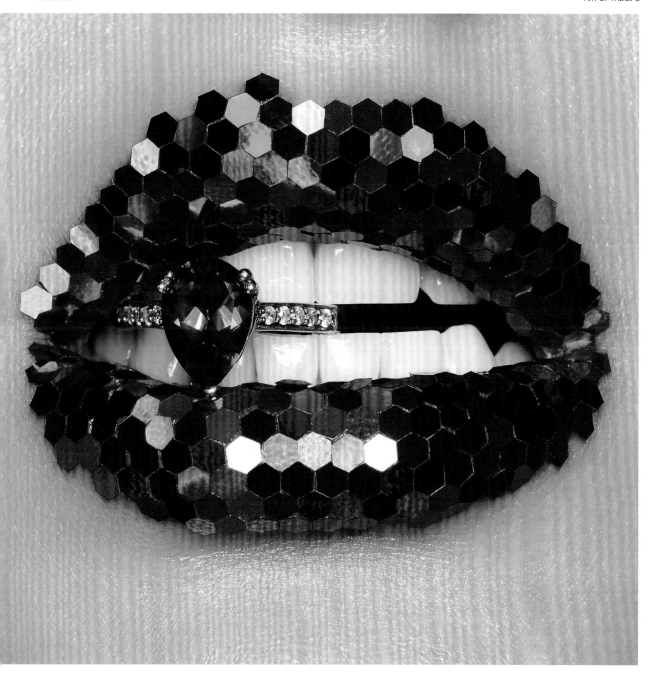

2018 PINK RING
Liquid lipstick · large glitter · ring

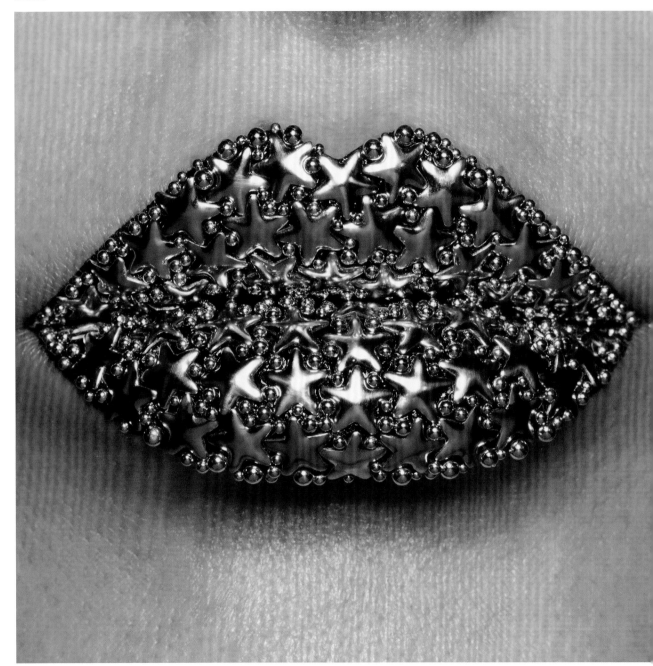

2020 GALAXY
Liquid lipstick · metal stars · caviar beads

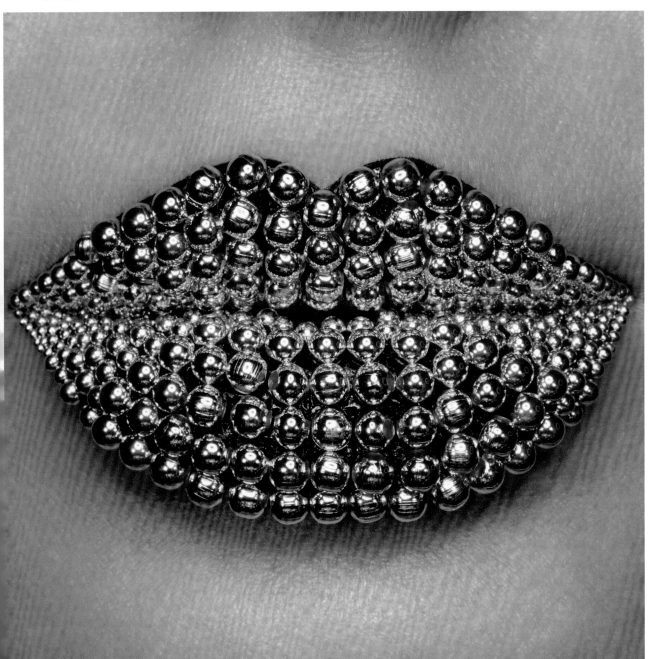

73

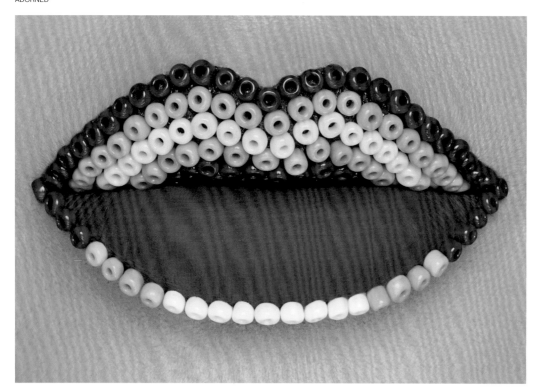

2017 ULTRAVIOLET ↑
 Liquid lipstick · seed beads

2018 FUSCHIA →
 Lliquid lipstick · large glitter · ring

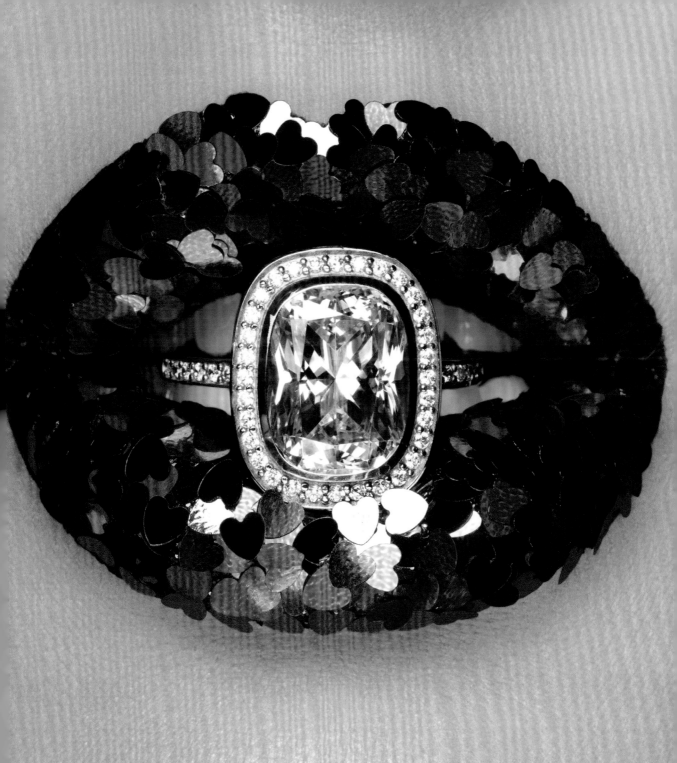

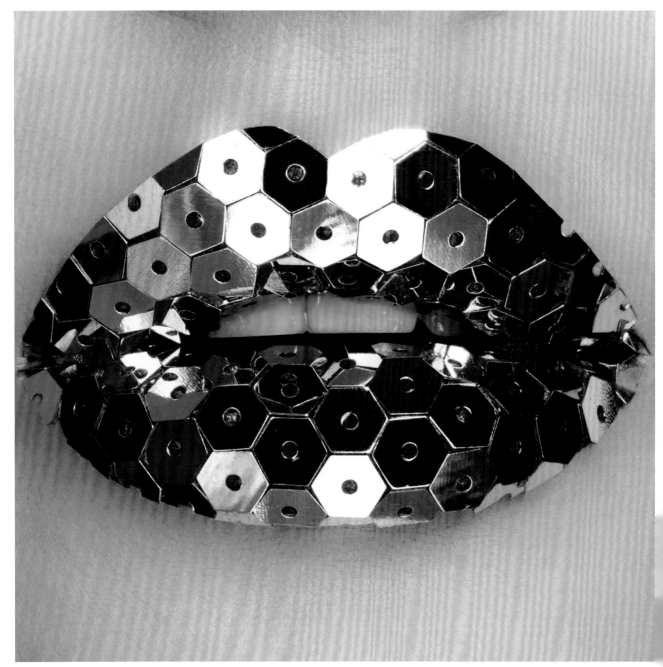

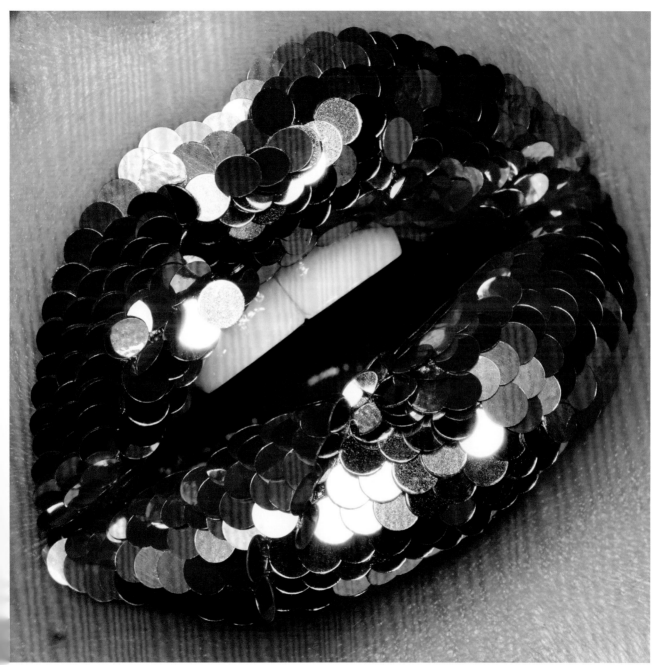

2018 SEQUINS
Liquid lipstick · large glitter

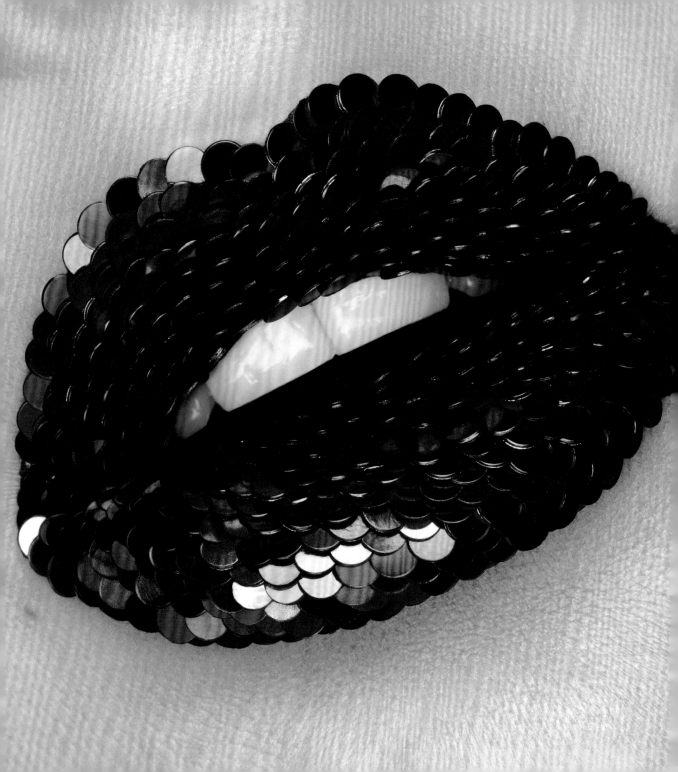

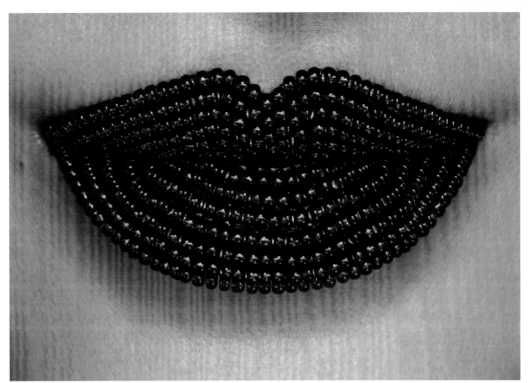

TIP I painstakingly applied these beads one by one. Afterwards, my friend Will Malherbe (who is also a makeup artist) told me this trick for a faster application: string the beads onto a thread, apply them to your lips in rows, then remove the thread. Brilliant!

2017 RED MERMAID ←
Liquid lipstick · large glitter

2020 POMEGRANATE ↑
Liquid lipstick ·
glass seed beads

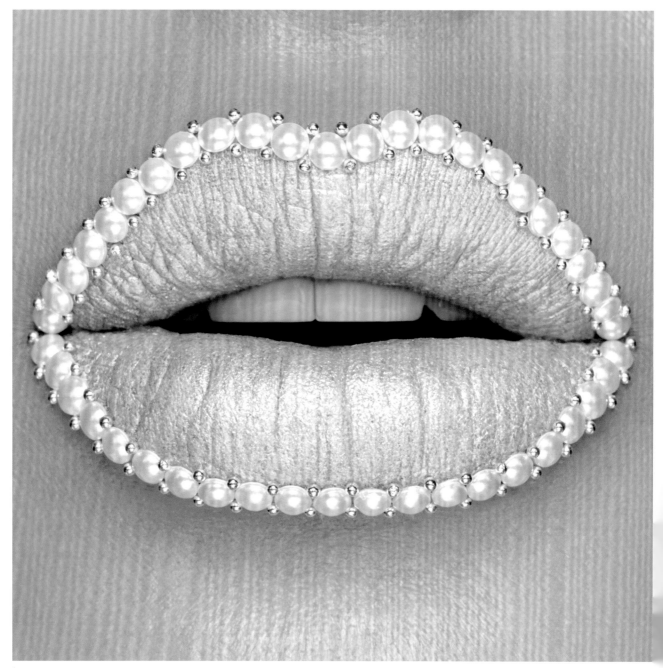

2017 PEARL PLEASE
Lliquid lipstick · half pearls ·
caviar beads

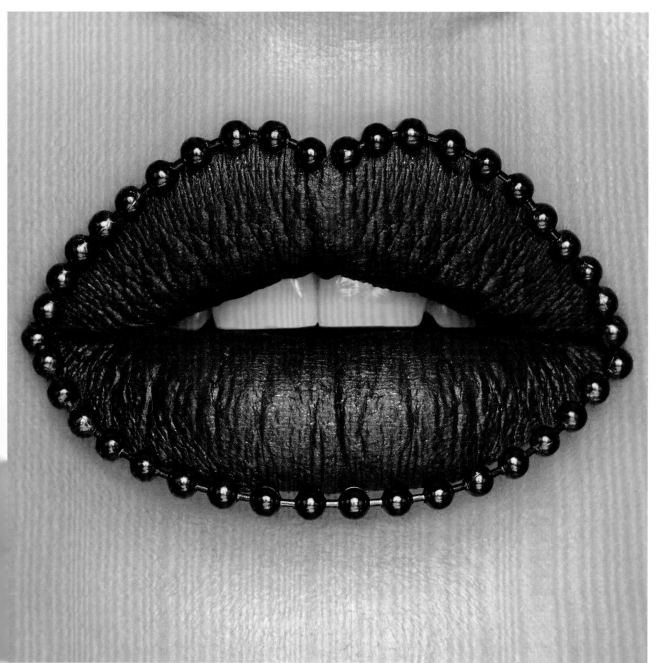

2017 MAKE IT REIGN
Liquid lipstick · bead chain

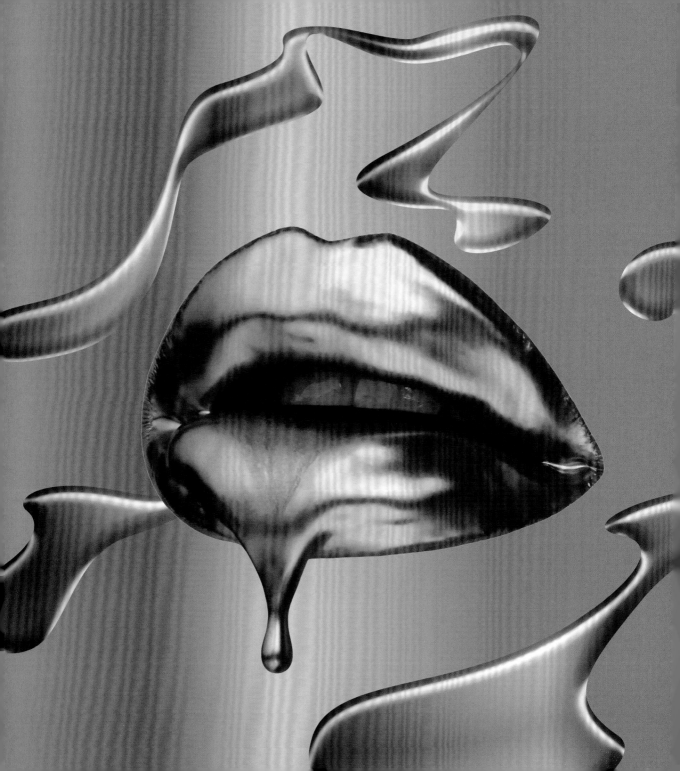

LIQUIFIED

This is probably my most well-known technique. Something that began as a happy accident and completely changed my whole life.

It was a hot day in Los Angeles. I was sharing a studio space (a spare bedroom) with my husband. He had his music studio on one side, and I had my little makeup and photo station set up on the other side. I was trying to capture a photo of extremely glossy metallic lips. I was alone and at the time I didn't have a screen to watch what I was doing while I was taking the photos. I was just pressing the shutter button on my camera and hoping for the best. I took a few photos and felt a strange pulling sensation on my bottom lip. When I looked down, I saw that the metallic mixture I'd created had dripped onto my white shirt. "Not again!" – I thought. I had ruined so many clothes already with makeup, and this was a metallic pigment that would be impossible to get out. I got a little frustrated but then I looked at the monitor and I felt butterflies in my stomach. I had captured four images of the progression of the rose gold drip. I knew I'd never seen anything like it before. I was elated! This is how one of my most famous photographs, "Rose Gold" (page 101), was created.

That one photograph turned my world upside down in the most wonderful way. So many opportunities came out of that one image. Some of them I had to fight for. Some of them were offered to me. Rose Gold is truly my lucky penny!

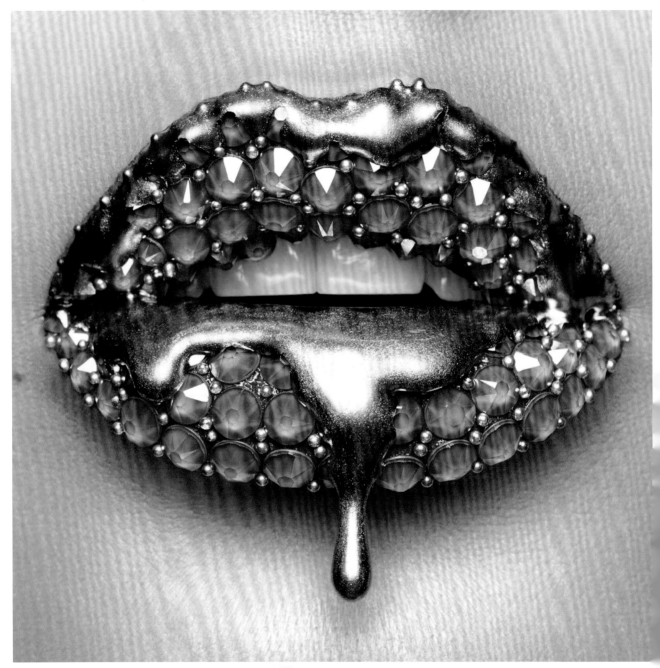

2017 MELTING CARAT
Liquid lipstick · glass crystals · caviar beads ·
gold pigment · clear lip gloss

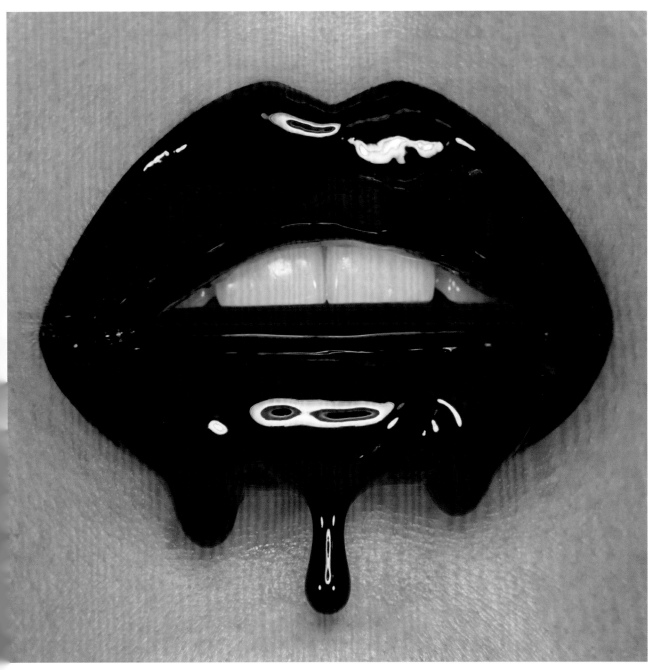

2020 TAR
Lliquid lipstick · clear lip gloss

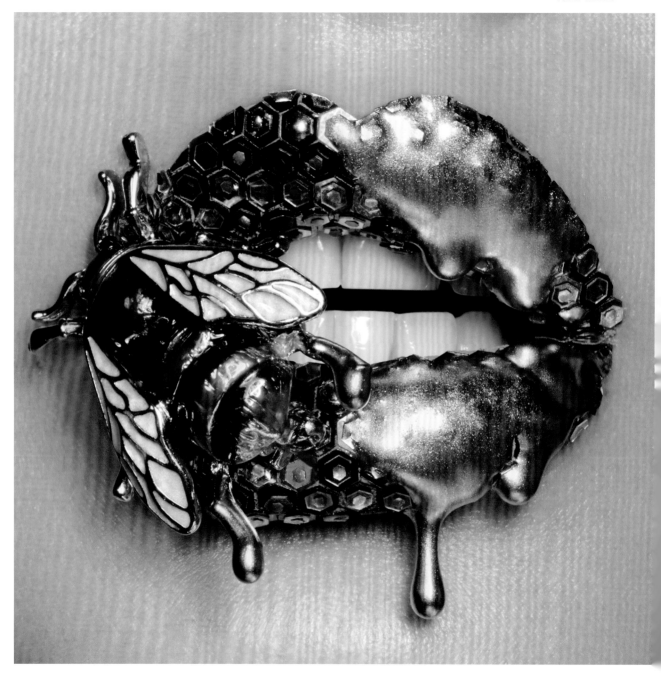

2018 BEE ON A LEAF
Lliquid lipstick · large glitter · gold pigment ·
clear lip gloss · brooch

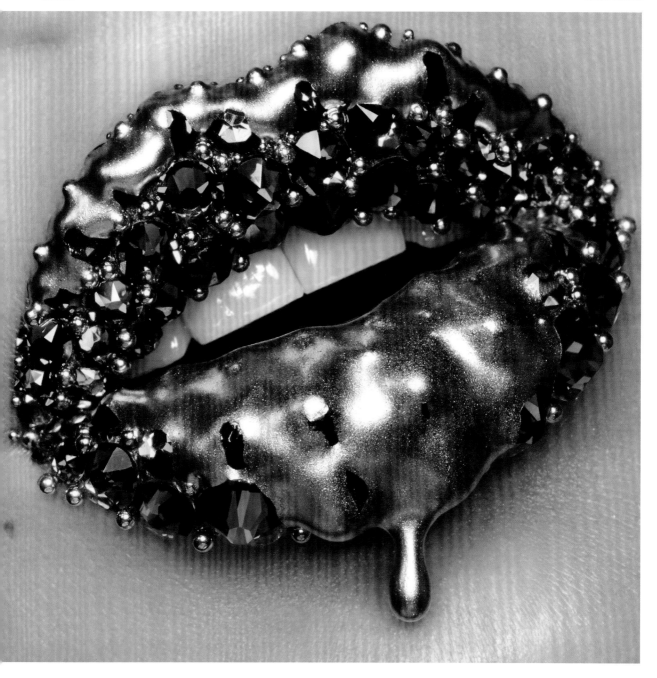

2018 MELTING CARAT GREEN
Liquid lipstick · glass crystals · caviar beads ·
gold pigment · clear lip gloss

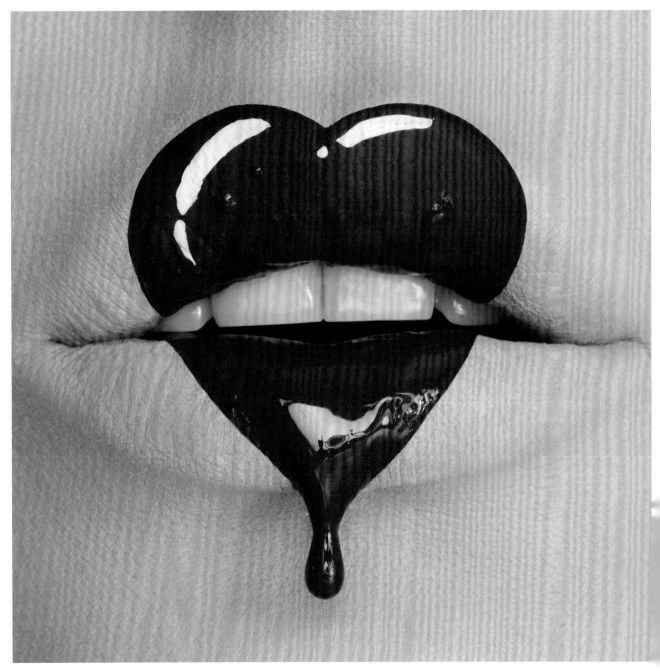

2016 BLEEDING HEART
Concealer · liquid lipstick ·
body paint · clear lip gloss

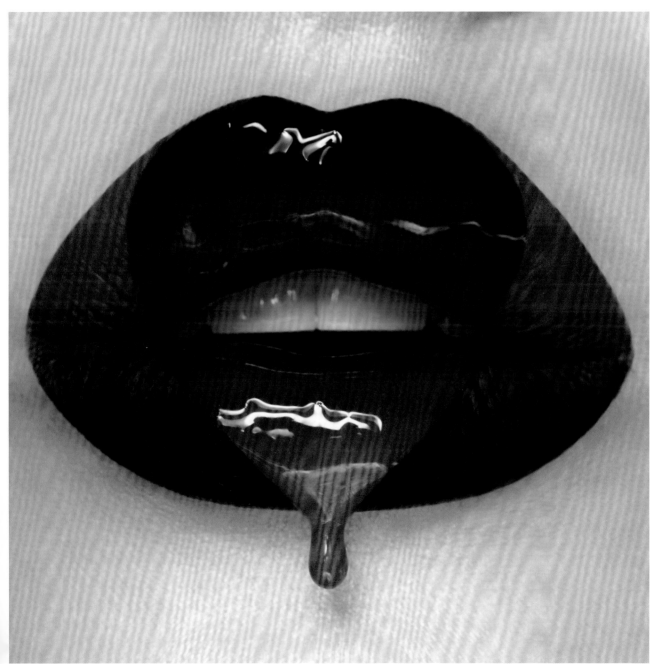

2016 HEART
Liquid lipsticks · clear lip gloss

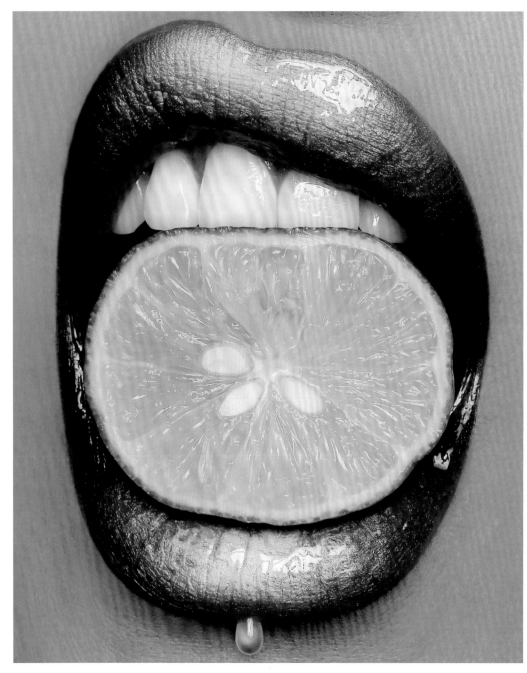

2016 LIME ↑
Liquid lipstick · metallic eyeshadow ·
clear lip gloss · key lime

2017 WINTER BERRY →
Liquid lipstick · clear lip gloss ·
water · raspberry

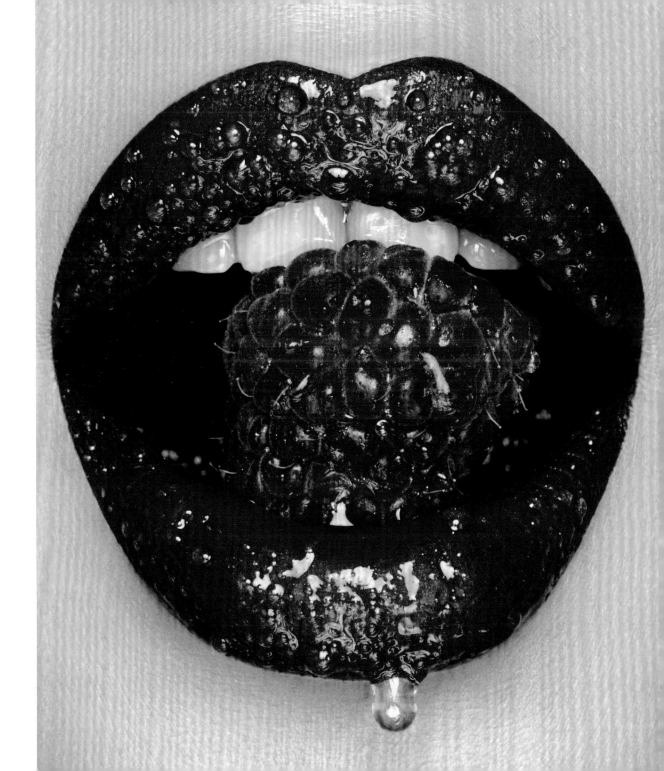

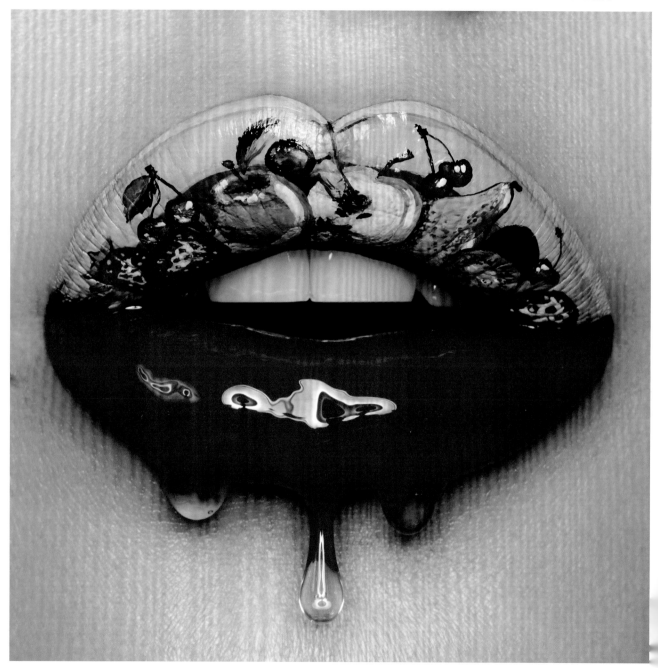

2018 JUICY FRUIT
Liquid lipstick · body paint ·
clear lip gloss

92

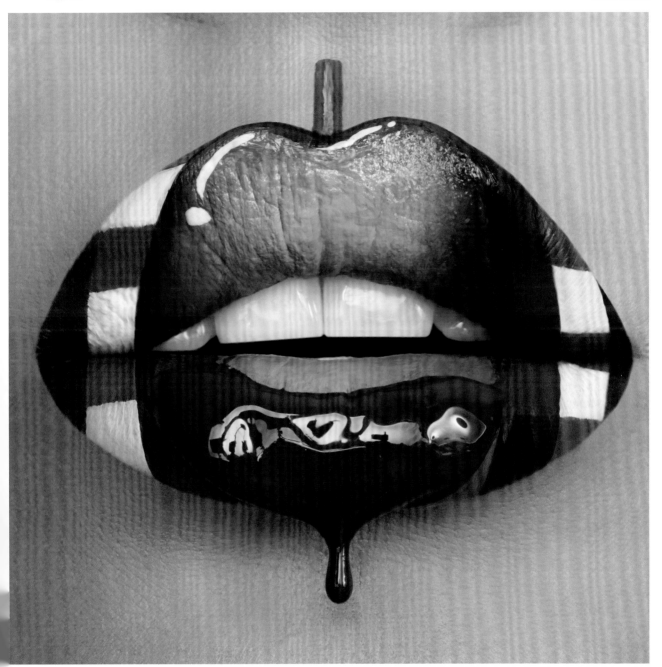

2016 CARAMEL APPLE
Liquid lipstick · body paint ·
clear lip gloss

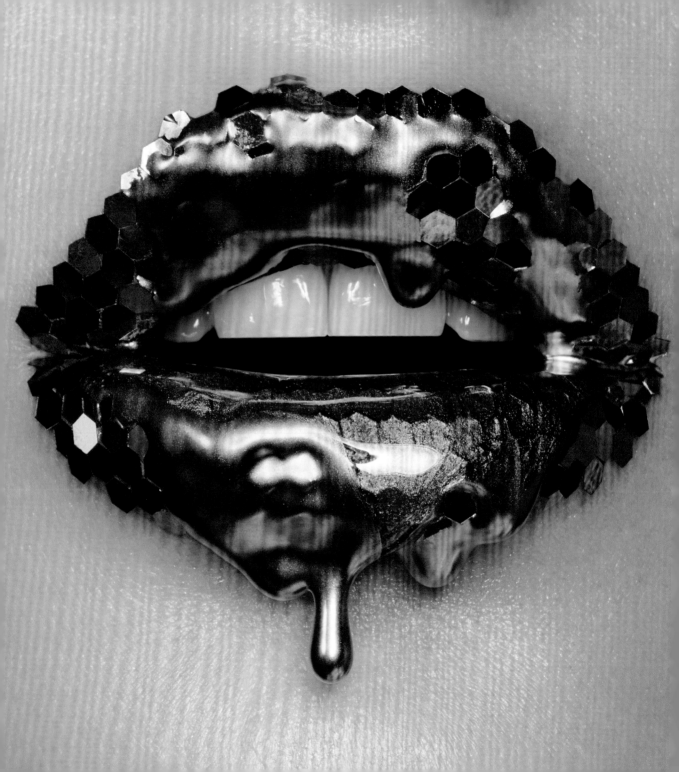

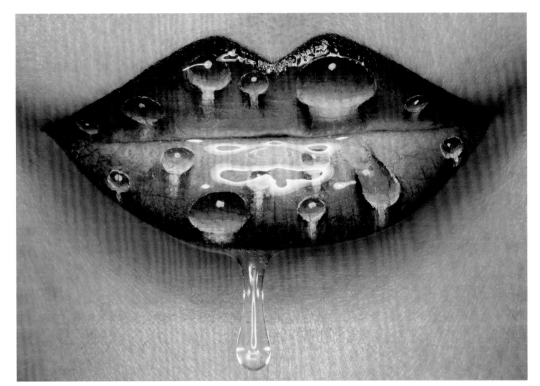

2018 DRIPS ←
Liquid lipstick · large glitter ·
rose gold pigment · clear lip gloss

2020 RAIN ↑
Liquid lipsticks · body paint ·
clear lip gloss

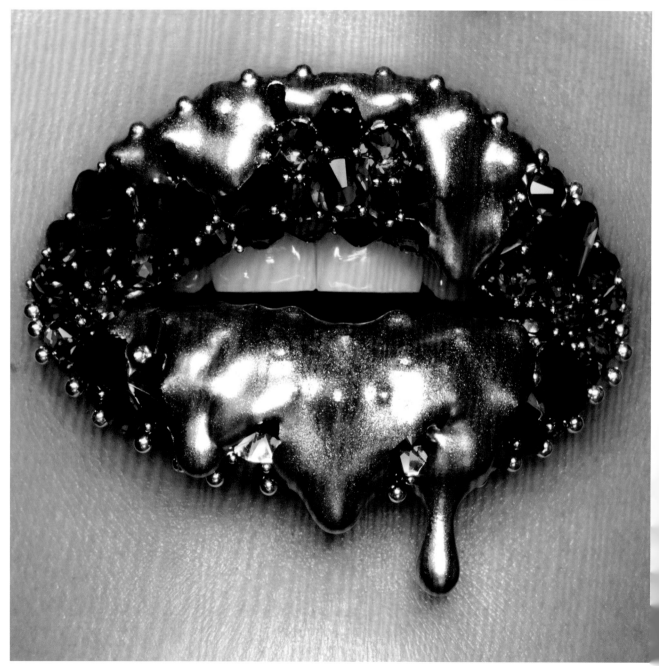

2018 GILDED SAPPHIRE
Liquid lipstick · glass crystals · caviar beads ·
gold pigment · clear lip gloss

96

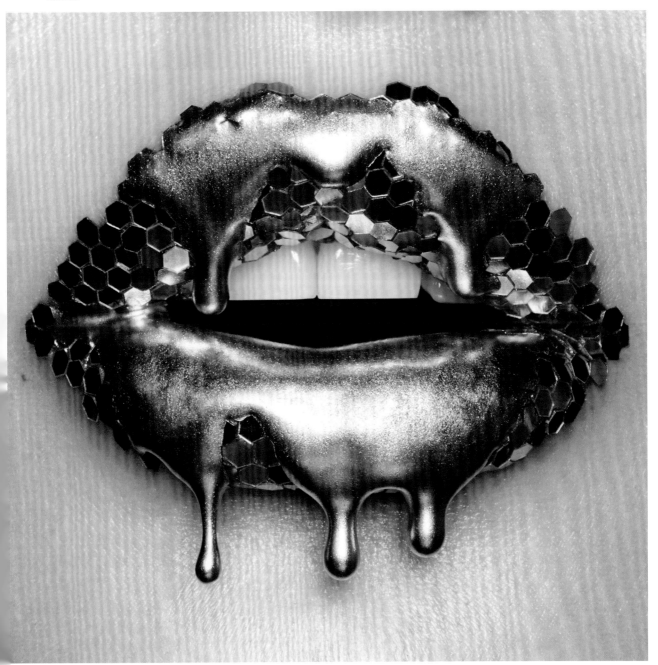

2018 GOLDEN HONEY
Lliquid lipstick · large glitter ·
gold pigment · clear lip gloss

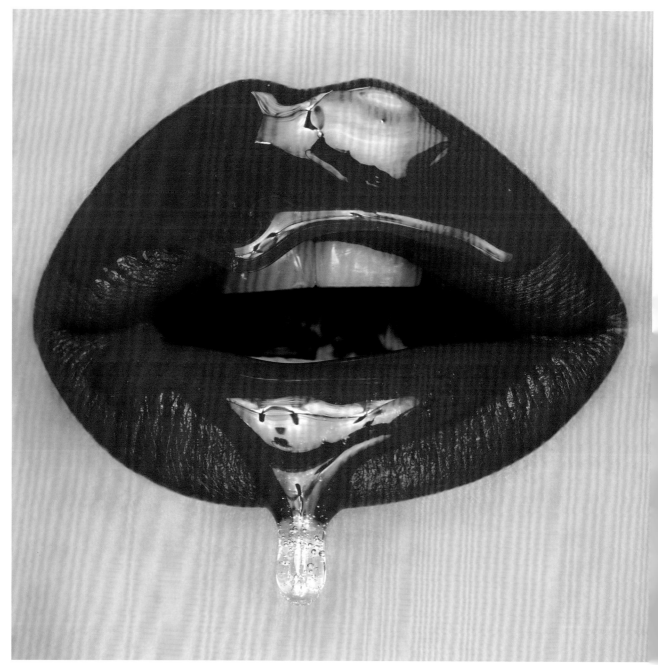

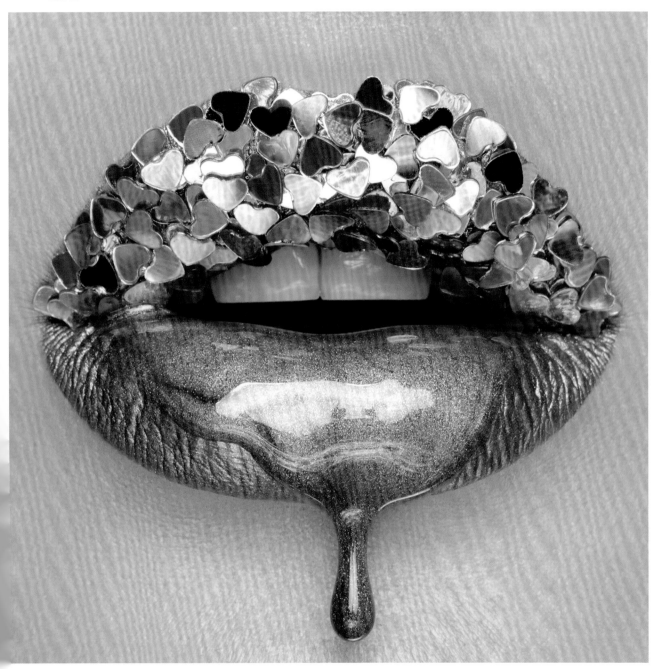

99

2017 XO, VLADA
Liquid lipstick · large glitter ·
lip gloss

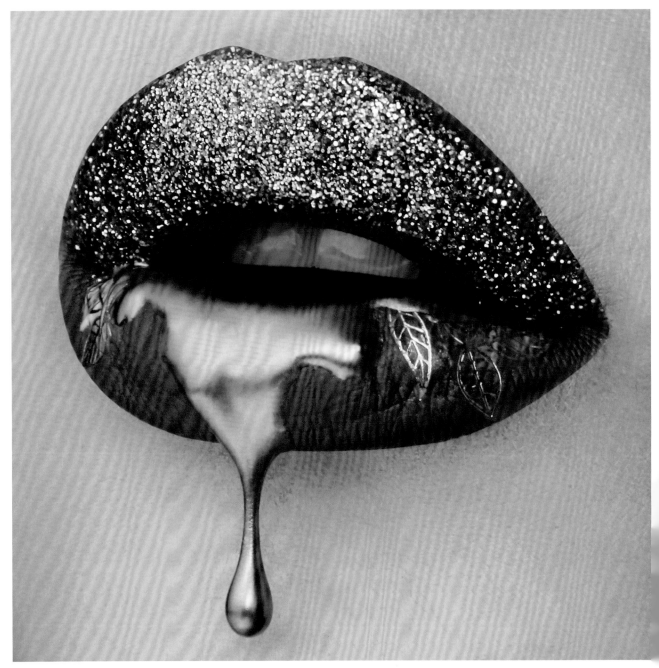

2015 FALL
Liquid lipstick · glitter · nail art stickers ·
rose gold pigment · clear lip gloss

100

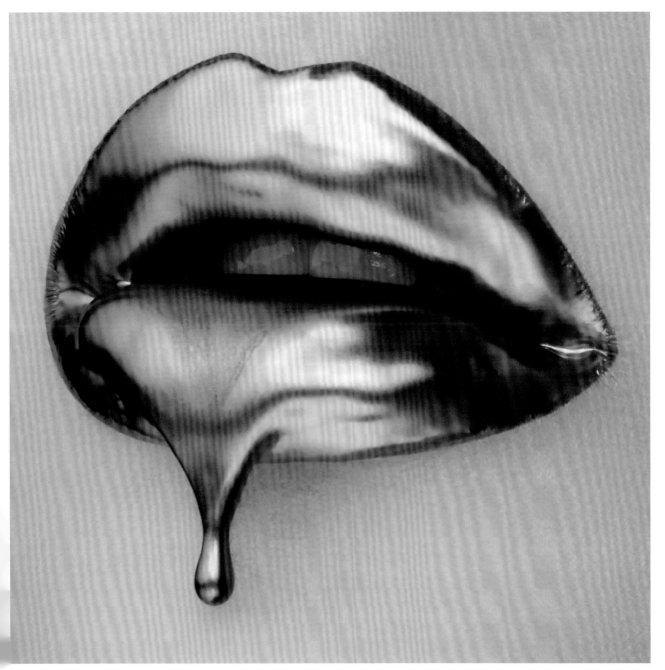

101

2015 ROSE GOLD
Rose gold pigment ·
clear lip gloss

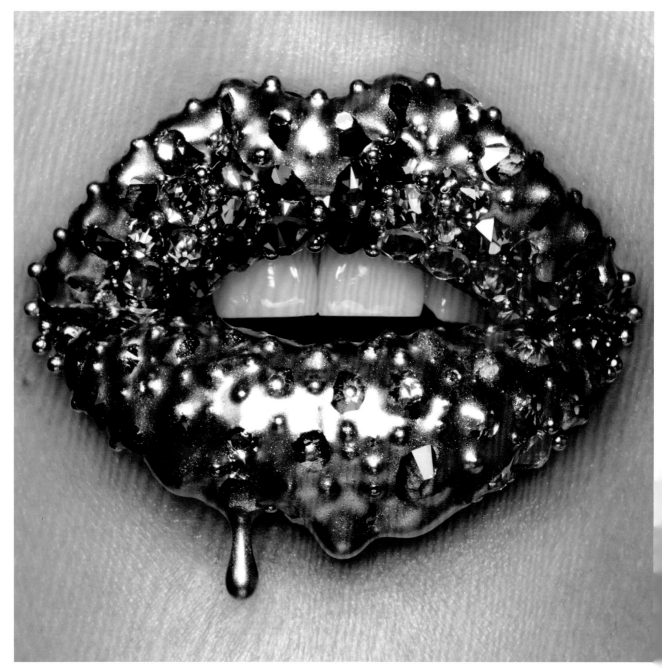

2018 MELTING RAINBOW
Liquid lipstick · glass crystals · caviar beads ·
gold pigment · clear lip gloss

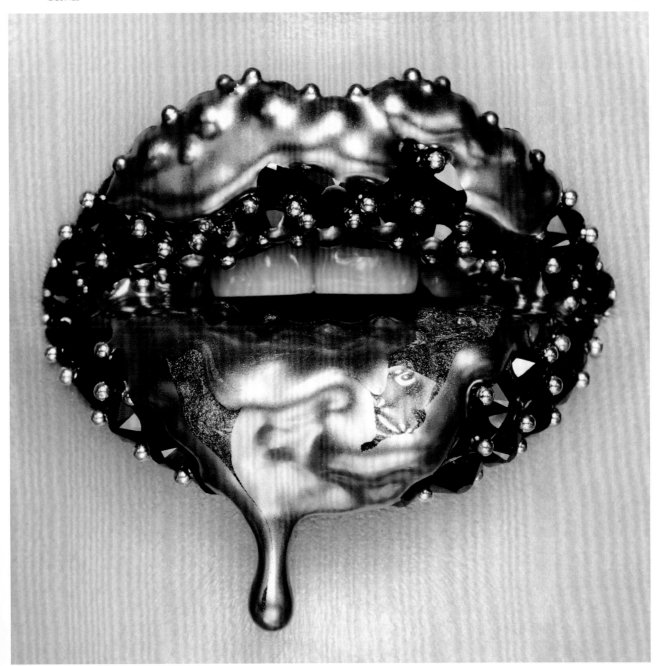

2018 ROSE GOLD MELTING CARAT
Lliquid lipstick · glass crystals · caviar beads ·
rose gold pigment · clear lip gloss

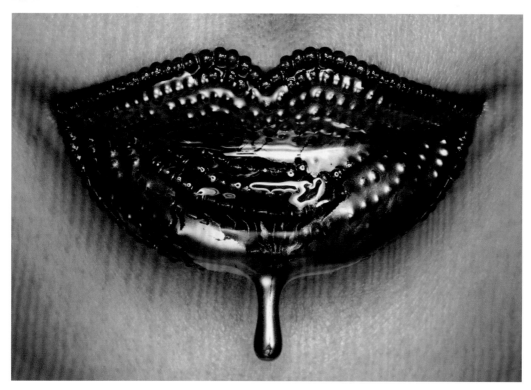

TIP To create a custom metallic liquid I combine two-parts clear lip gloss and one-part pure metallic pigment and mix really well. You can add more lip gloss to create a thinner mixture. My favourite pigments are Graftobian Cosmetic Powdered Metal and Mehron Metallic Powder.

2020 GILDED RUBY ↑
Liquid lipstick · glass seed beads ·
gold pigment · clear lip gloss

2020 GARDEN →
Liquid lipstick · large glitter · caviar beads ·
gold pigment · clear lip gloss · brass bees

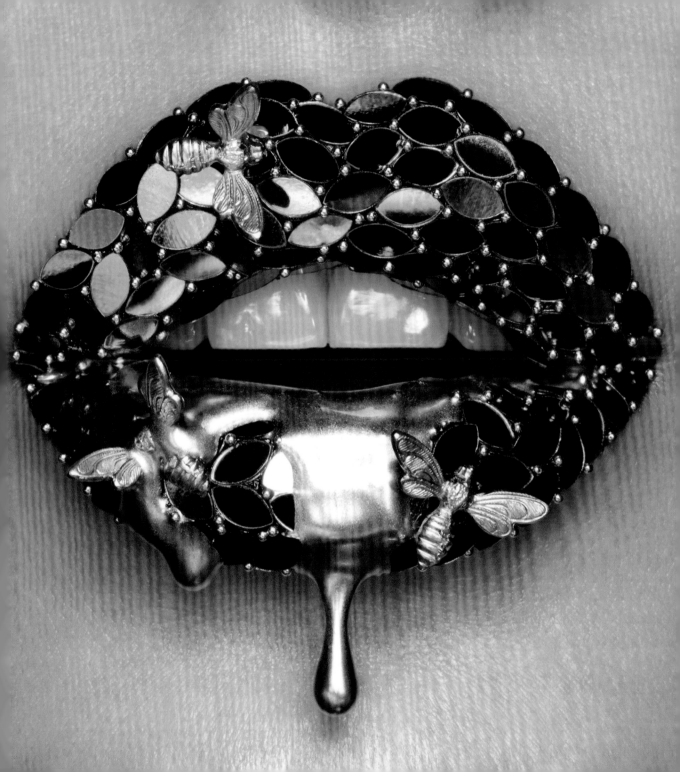

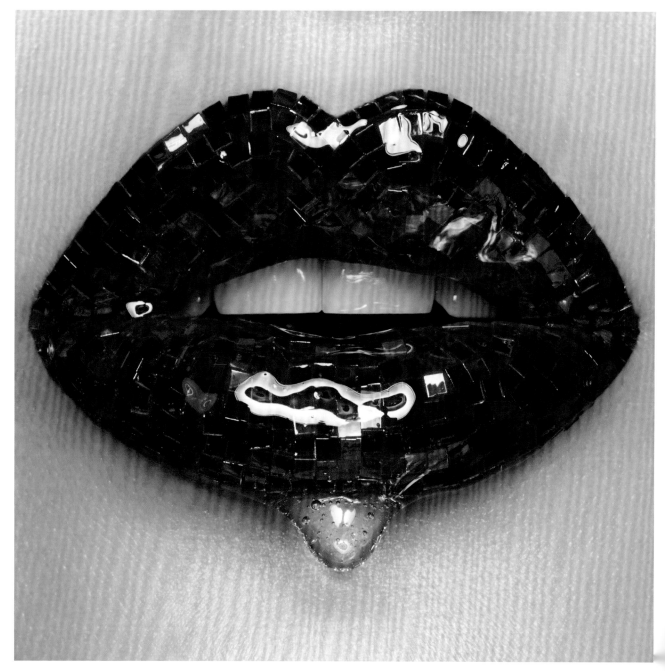

2018 FEVER
Liquid lipstick · large glitter ·
clear lip gloss

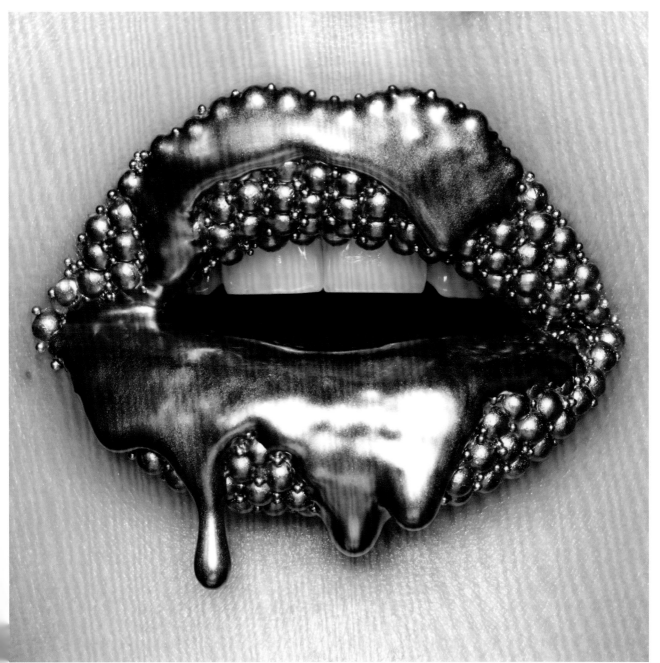

107

2018 ROSE GOLD PEARLS
Lliquid lipstick · glass half pearls · caviar beads ·
rose gold pigment · mixing medium · clear lip gloss

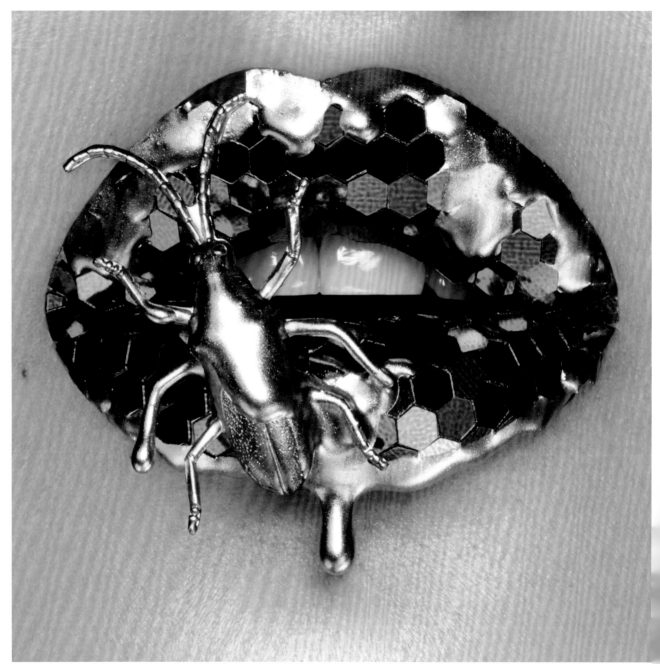

2018 GOLDEN HONEY BUG
Liquid lipstick · large glitter · gold pigment ·
clear lip gloss · metal bug

108

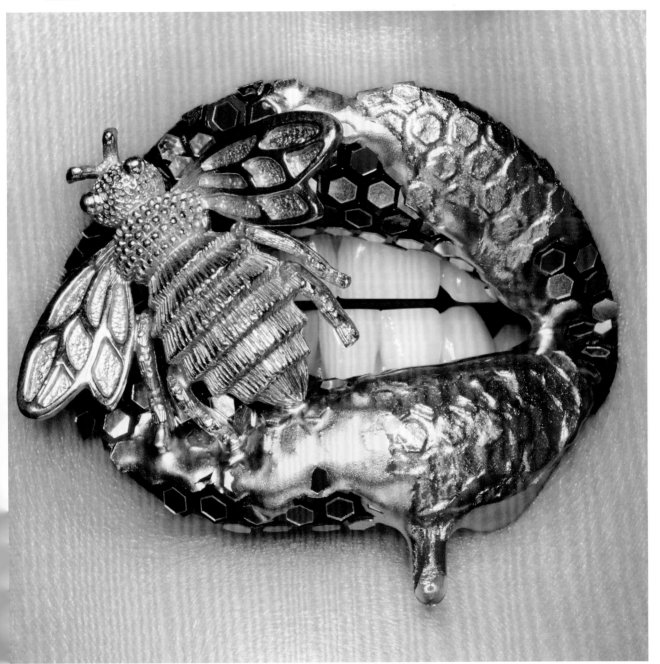

2018 SWEET
Liquid lipstick · large glitter · gold pigment ·
clear lip gloss · brooch

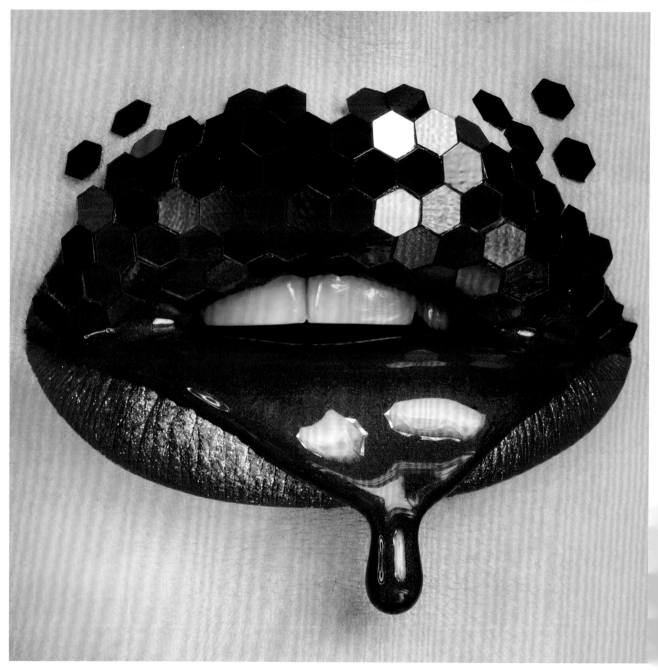

2017 PIXELS
Liquid lipstick · large glitter ·
metallic lip gloss · gold pigment

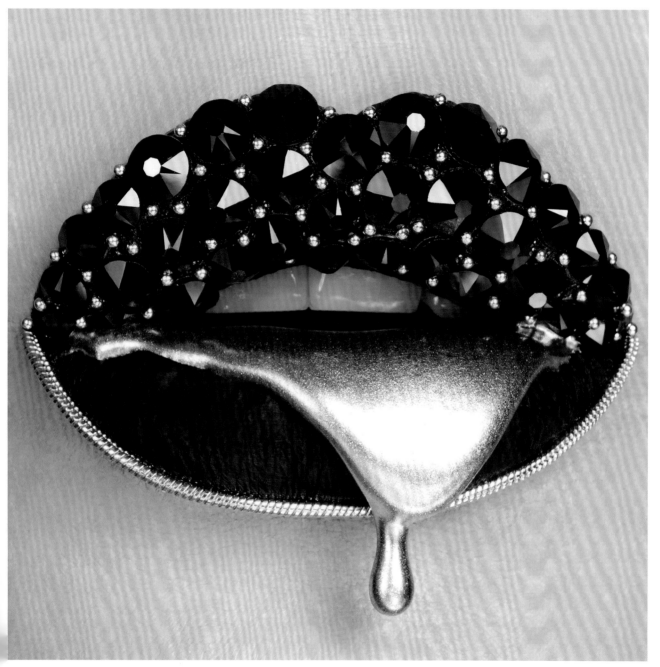

2017 GILDED ONYX
Liquid lipstick · glass crystals · caviar beads ·
gold pigment · clear lip gloss ·gold string

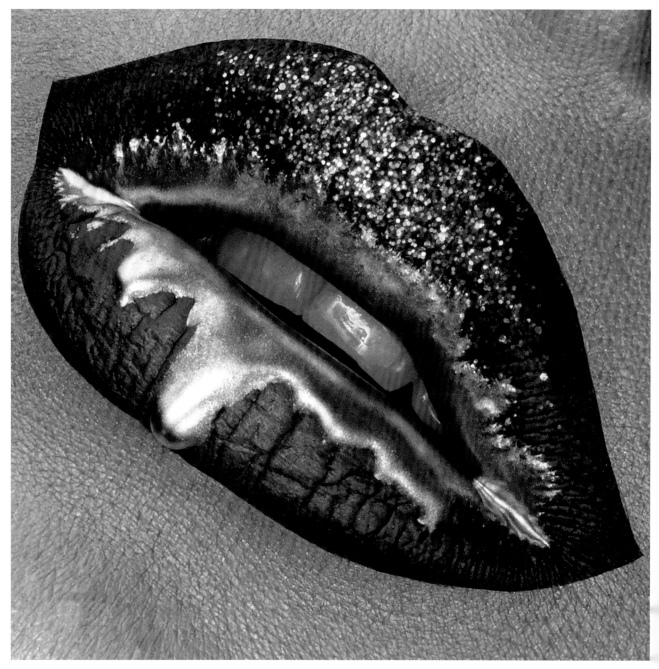

2015 BLUE GLITTER
Liquid lipstick · blue eyeshadow ·
glitter · gold pigment · clear lip gloss

112

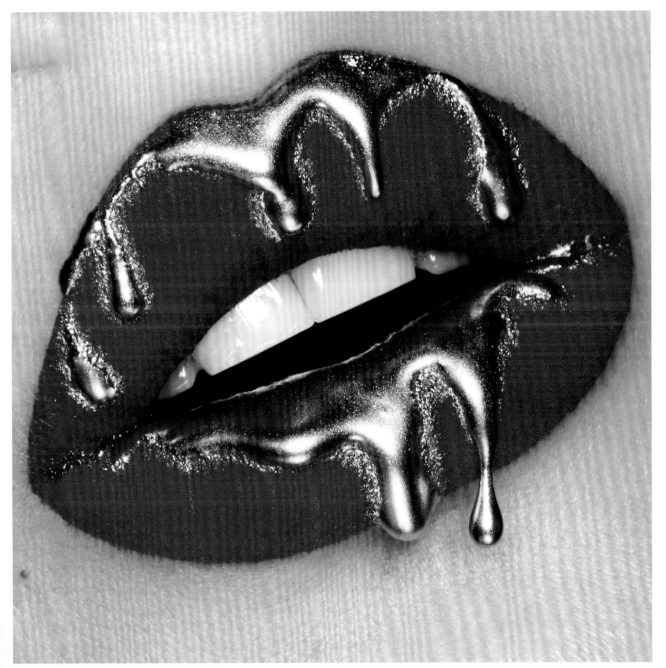

2018 RED VELVET
Liquid lipstick · flocking powder ·
gold pigment · clear lip gloss

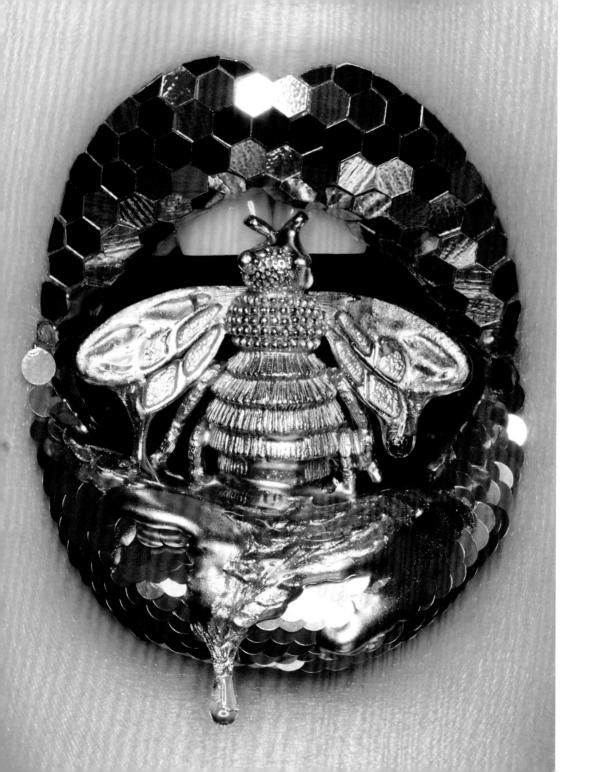

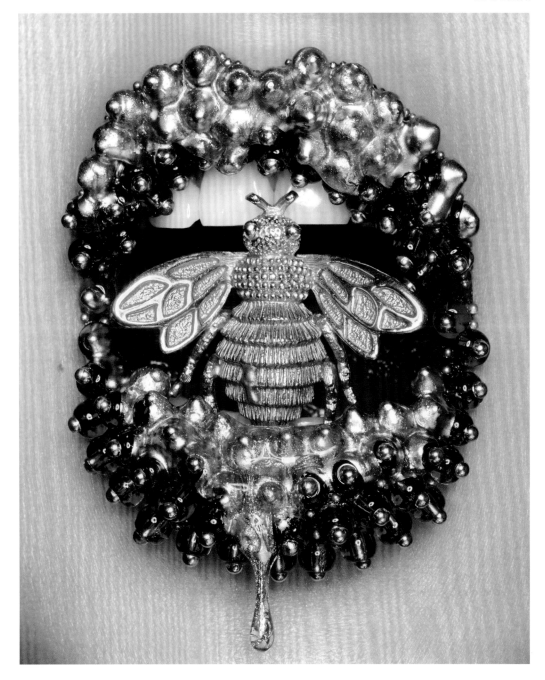

2018 STUCK ←
Liquid lipstick · large glitter ·
gold pigment · clear lip gloss · brooch

2018 GODDESS ↑
Liquid lipstick · glass beads · caviar beads ·
gold pigment · clear lip gloss · brooch

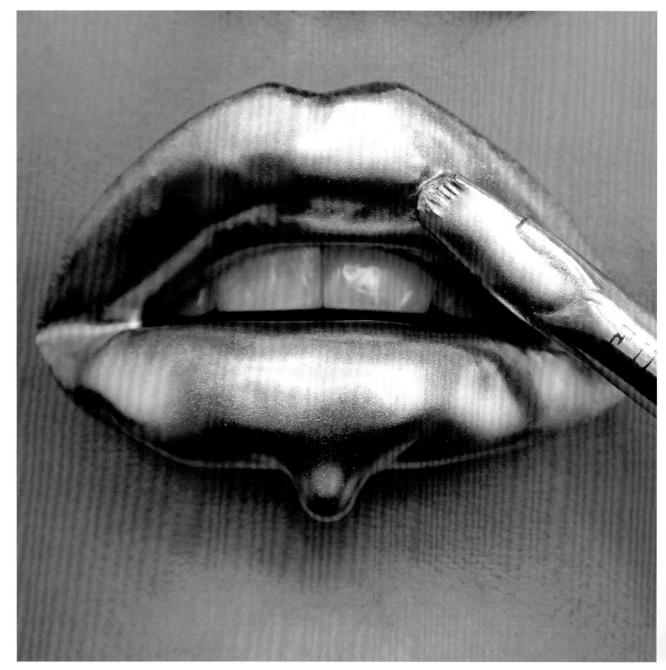

2015　LIQUID GOLD
Gold pigment · clear lip gloss

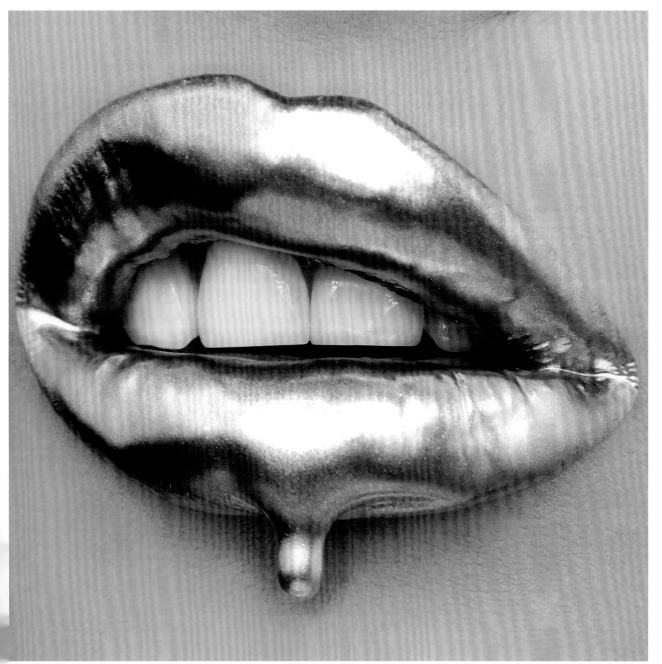

117

2016 GOLD ATTITUDE
Gold pigment · clear lip gloss

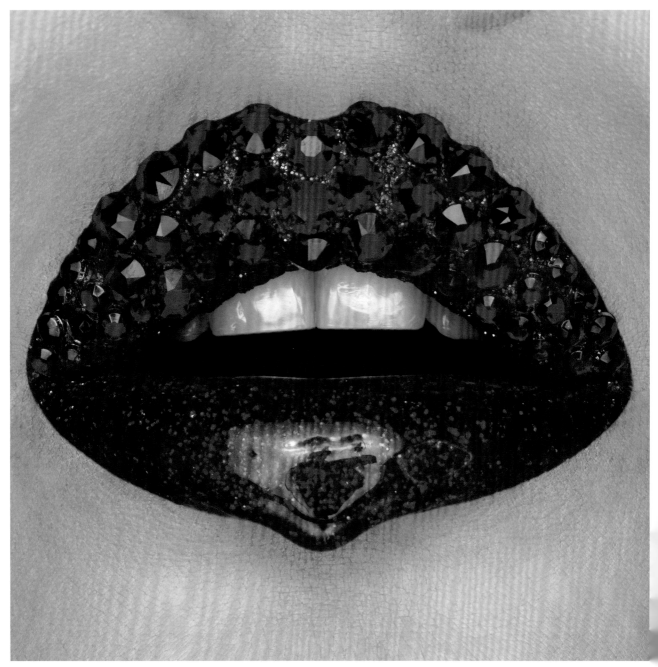

2016 RED GLITTER
Liquid lipstick · glass crystals ·
glitter · clear lip gloss

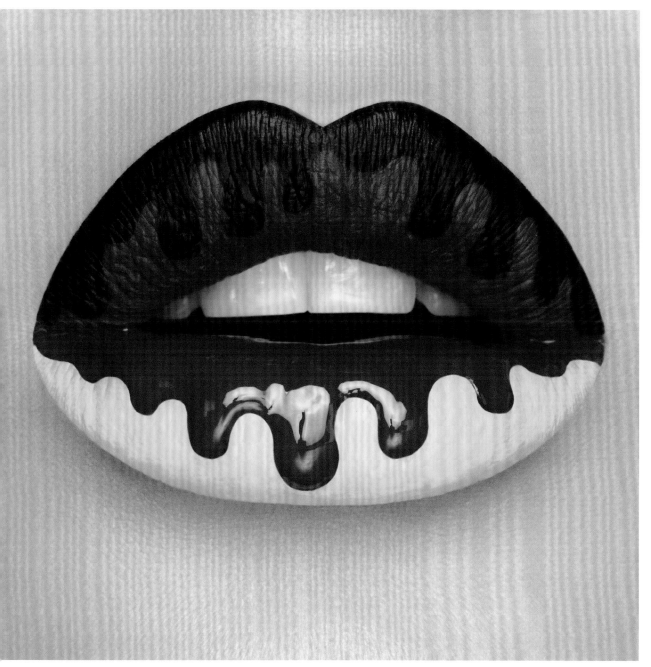

119

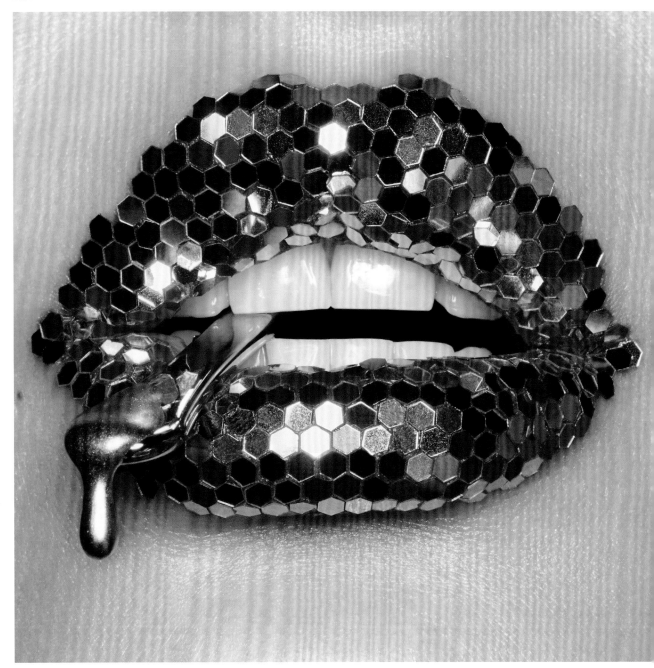

2018 SPOON
Liquid lipstick · large glitter · gold pigment ·
clear lip gloss · gold spoon

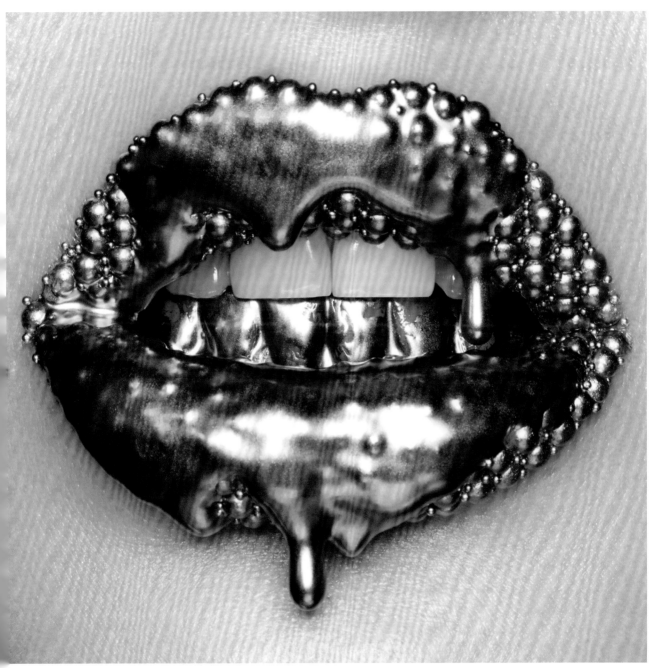

2018 ROSE GOLD ATTITUDE
Lliquid lipstick · glass half pearls · caviar beads ·
rose gold pigment · mixing medium · clear lip gloss

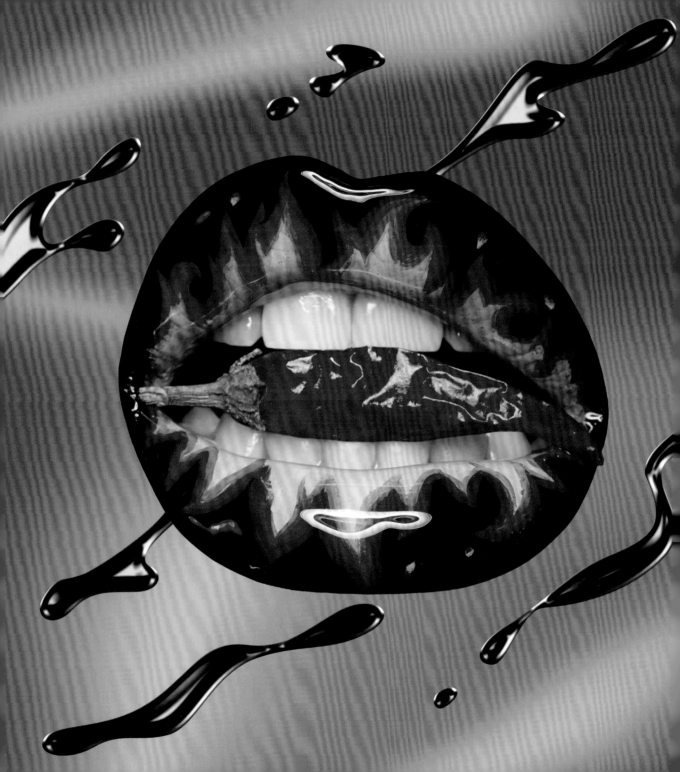

PAINTED

When I started creating lip art, I often used stickers and other embellishments to create my looks because I was convinced that I couldn't possibly paint those intricate details myself. Then one day I decided to take the challenge and paint a design on my lips. I was shocked and delighted to discover that it wasn't as difficult as I had imagined and the process was very much like painting on paper, just with a little more texture.

To create my painted lip art, I use liquid to matte lipsticks and water-activated body paint. For very small details I cut my own brushes to create extra fine tips. This kind of makeup takes a lot of skill and patience, because often I have to work against the uneven texture of the lips, but I always enjoy the challenge.

It's nearly impossible for me to choose a favorite from my painted designs, but if I had to, I would choose "Rainy Day" (2020) on page 197. Once I learned how to paint water droplets, I couldn't stop. It's funny to think that I learned how to paint them on my lips, but I've never painted them on a traditional medium like paper or canvas.

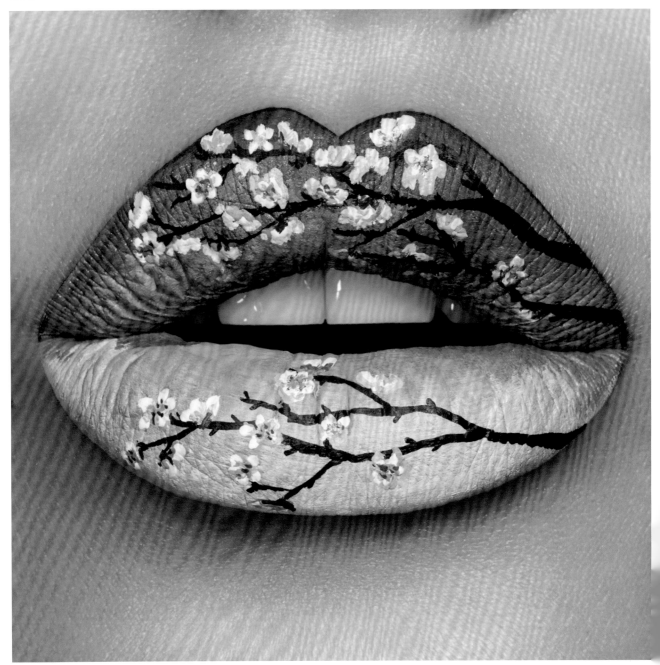

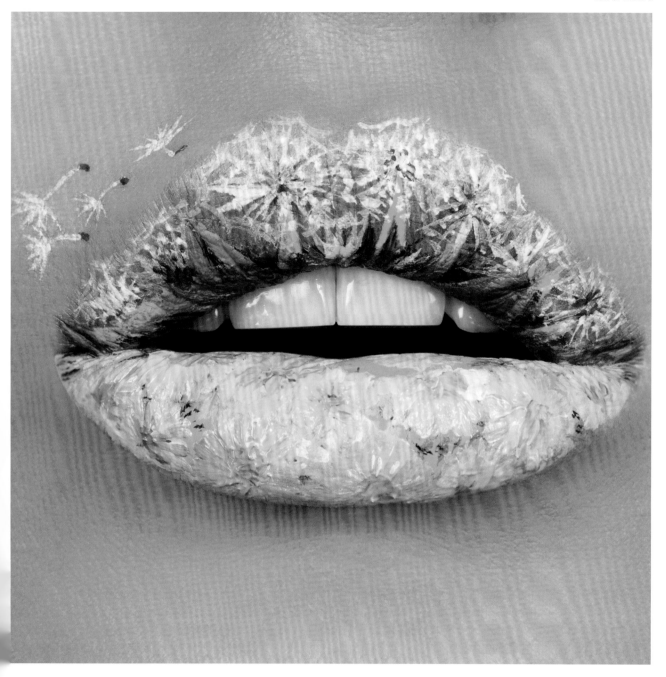

2016 DANDELIONS
Cream makeup · body paint ·
white eyeliner

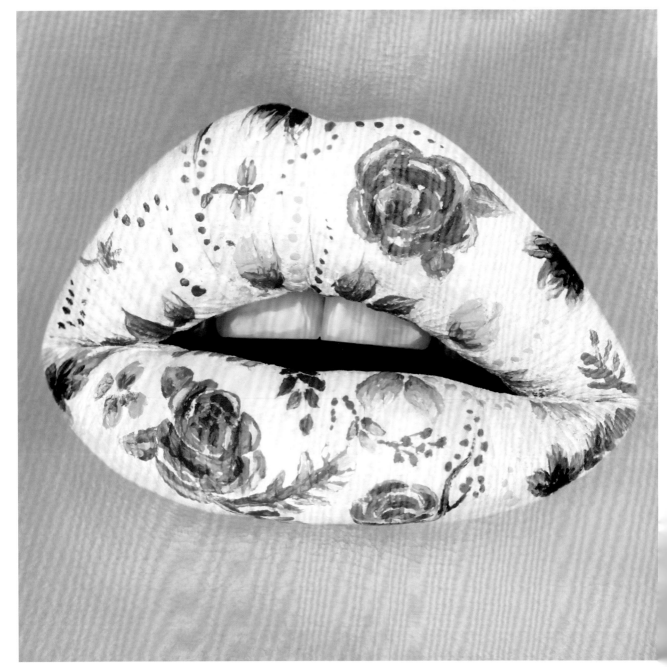

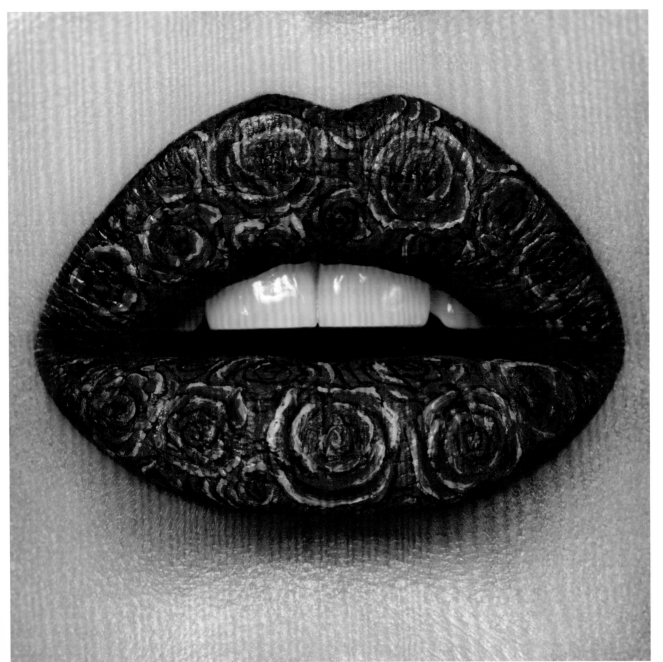

127

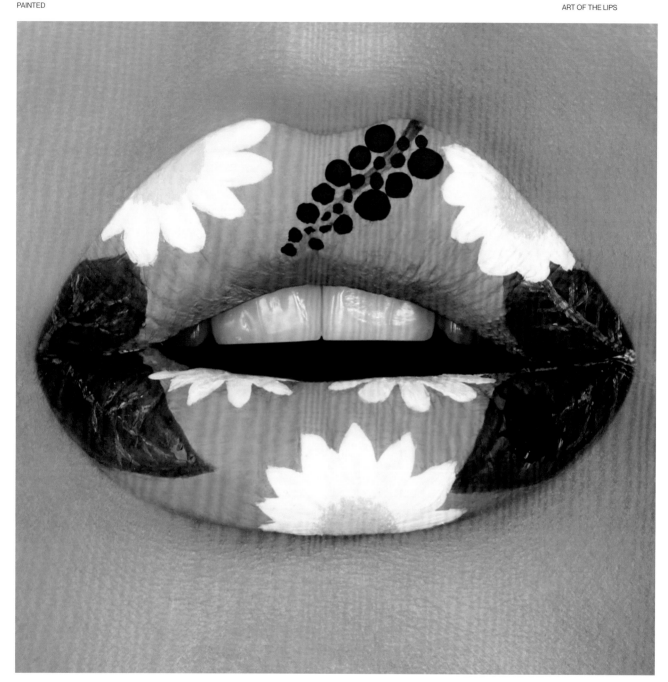

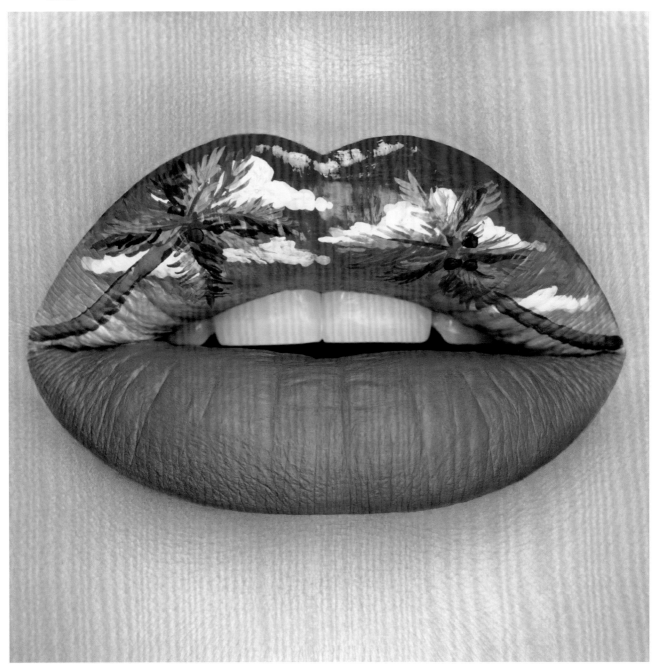

129

2017 TEAL WITH IT
Liquid lipsticks · body paint ·
clear lip gloss

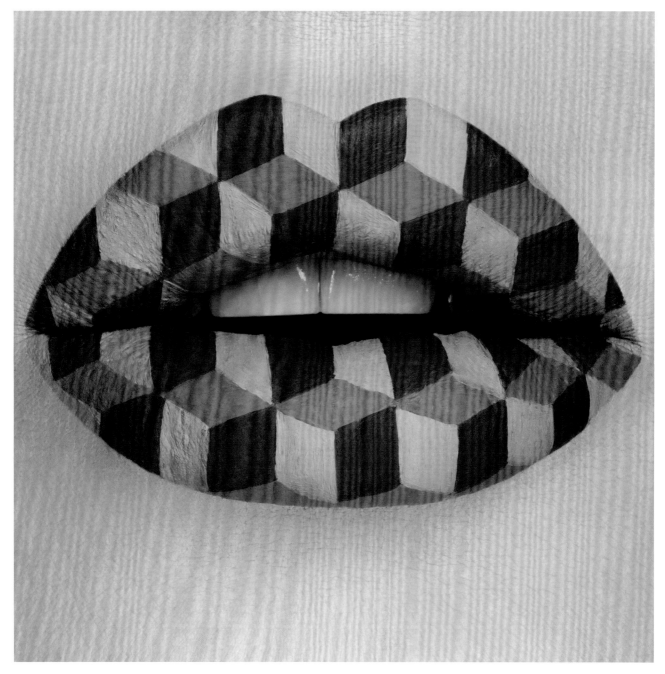

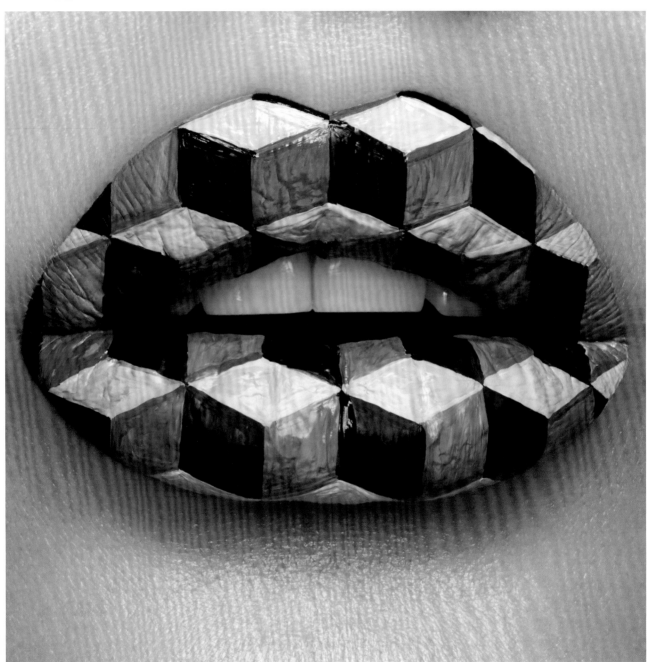

2018 CUBISM
Body paint

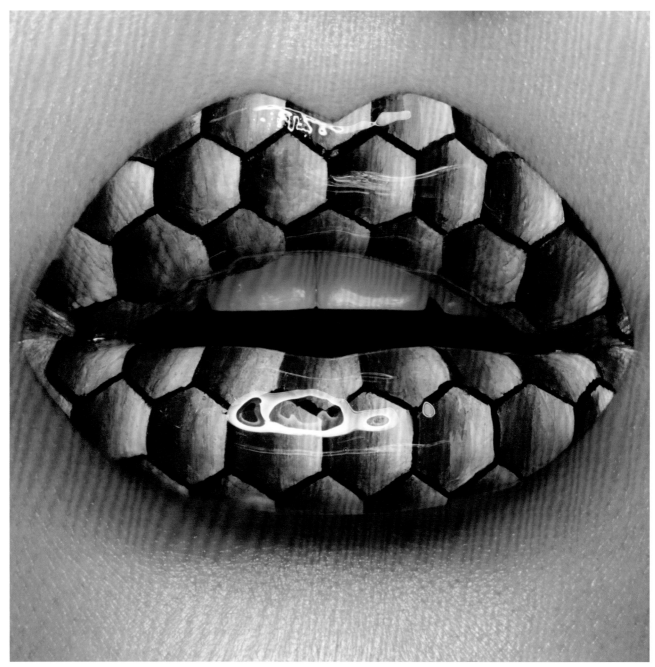

2018 HONEYCOMB
Liquid lipsticks · eye shadow ·
body paint · clear lip gloss

132

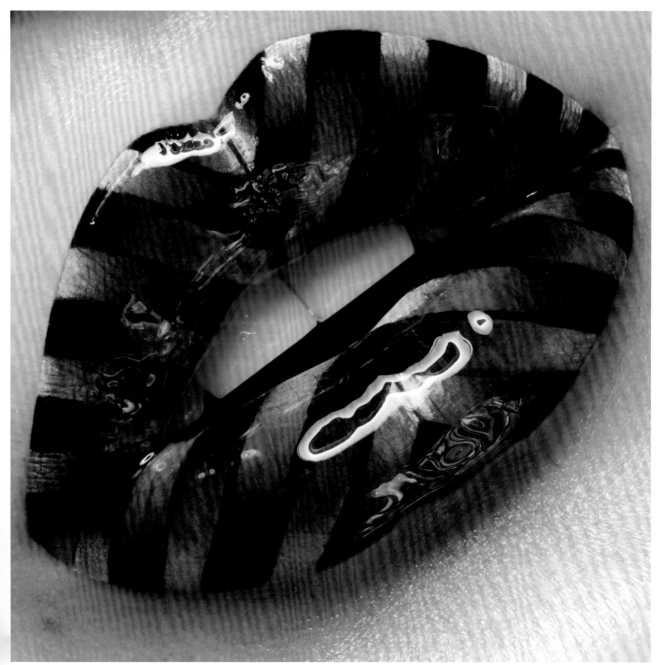

133

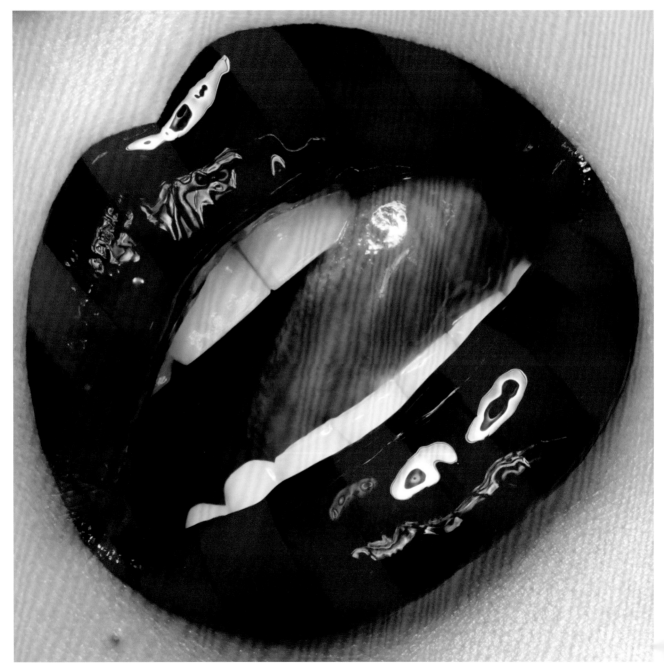

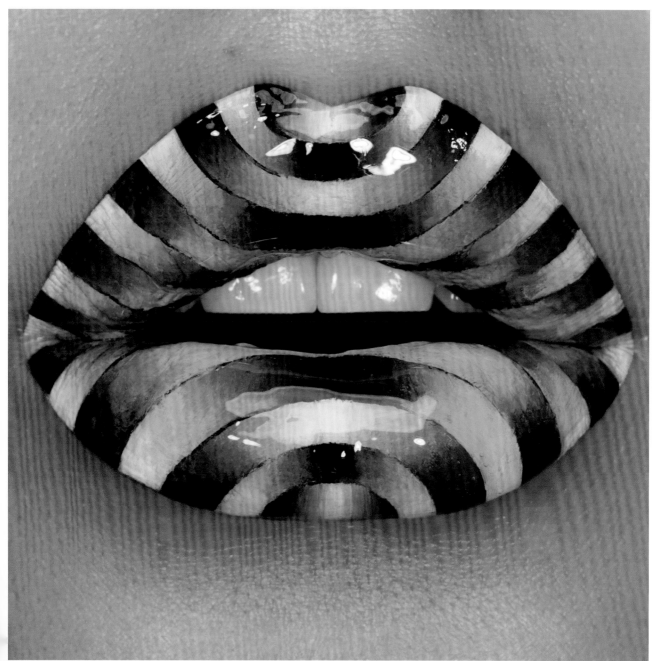

2019 WAVES GLOSSY
Liquid lipsticks · clear lip gloss

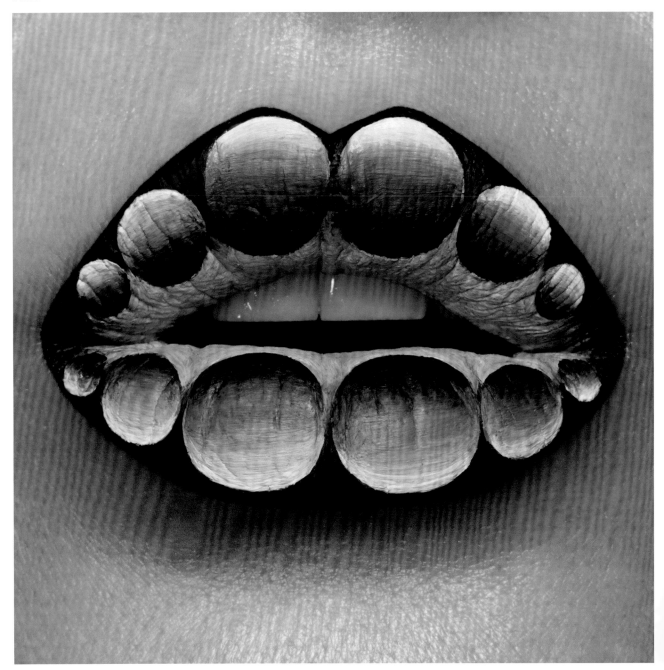

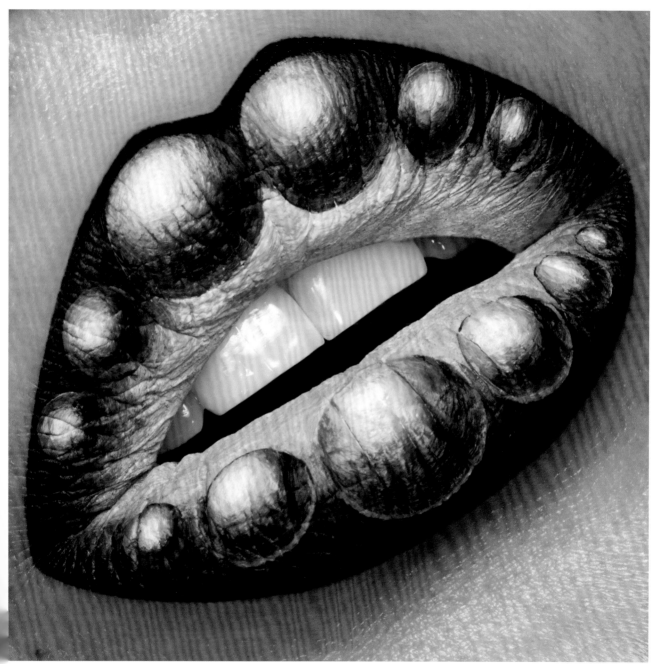

137

2020 RETROGRADE 3D
Liquid lipsticks

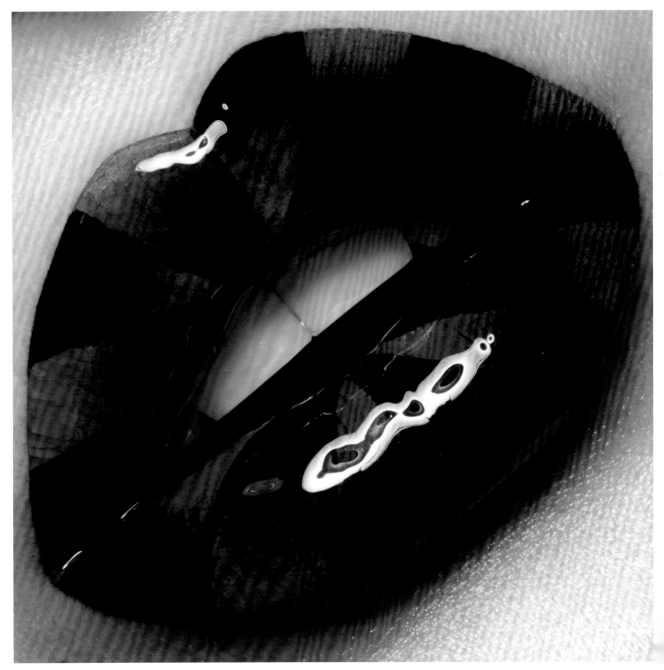

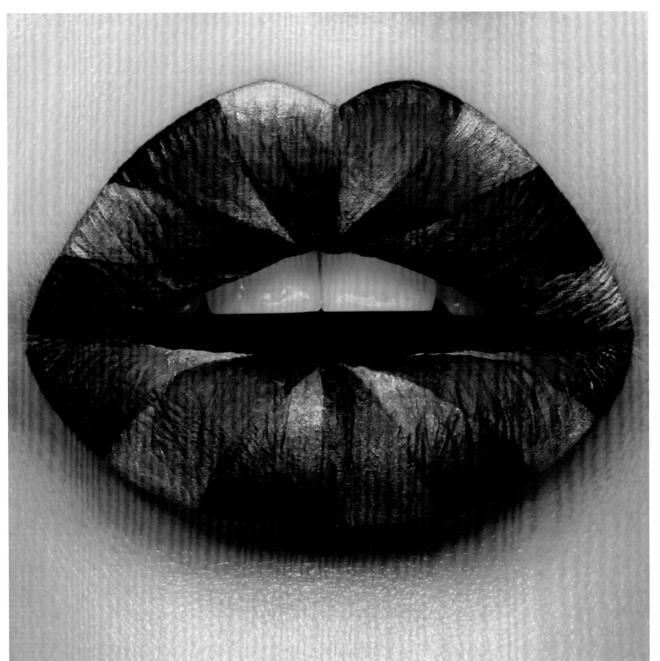

2018 HYPNOSIS MATTE
Liquid lipsticks

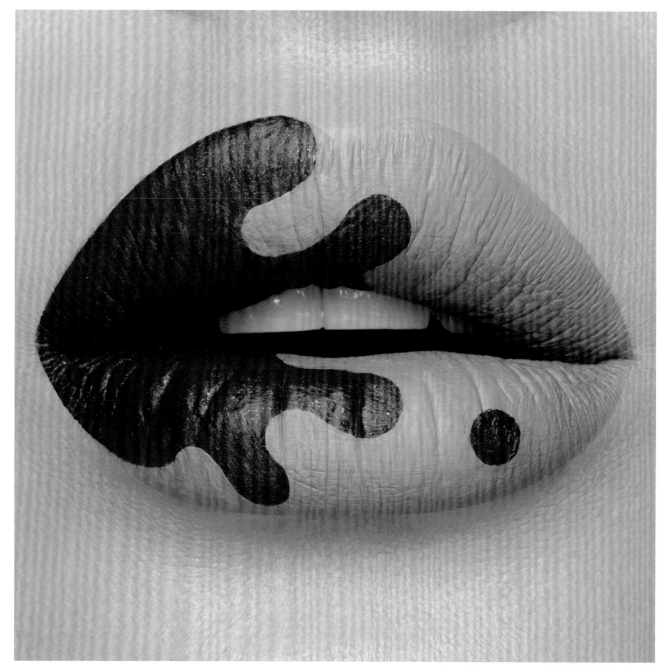

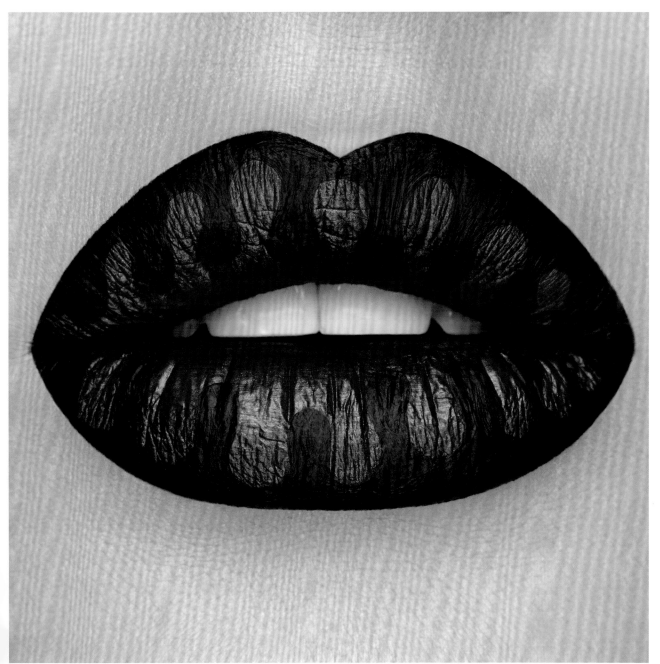

141

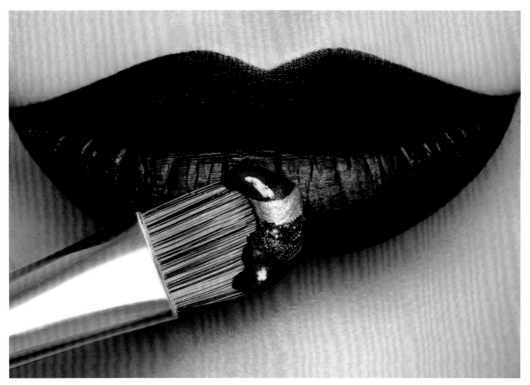

FACT I draw my inspiration from my memories and life experiences, from fabric patterns, paintings and art supplies. I like to go to craft stores for ideas – sometimes I find a pin or a charm that inspires a whole lip art creation.

2017 INSPIRATION SMILE ↑
Liquid lipstick · various lip gloss ·
pigments · clear lip gloss

2017 INSPIRATION →
Liquid lipstick · various lip gloss ·
pigments · clear lip gloss

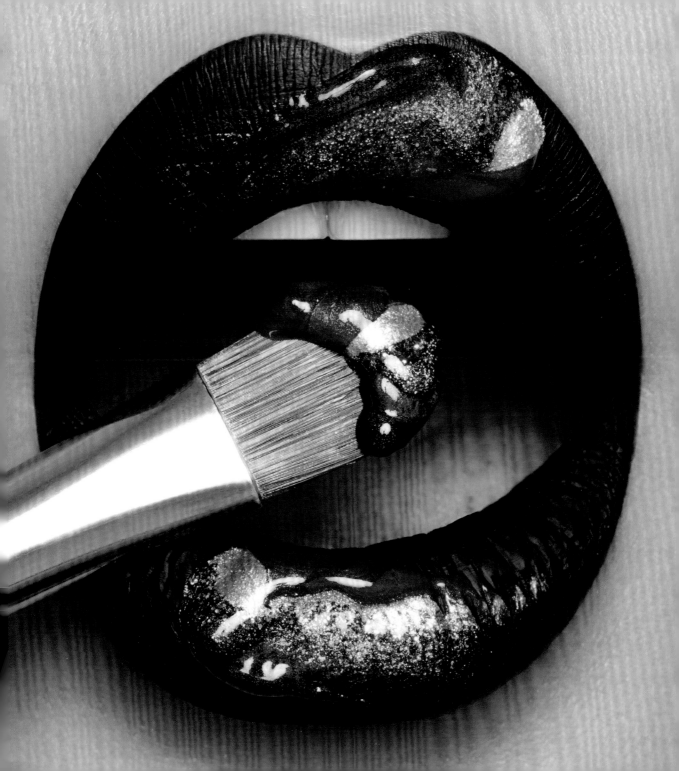

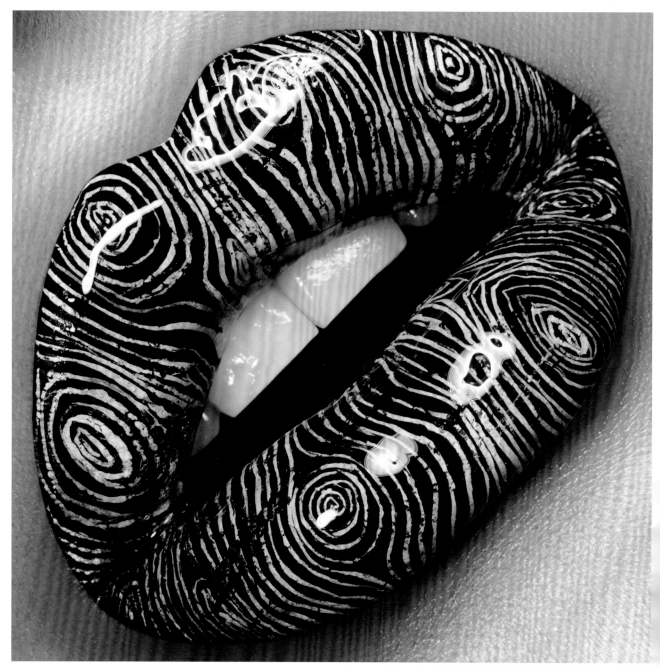

2019 WOOD YOU GLOSS
Liquid lipstick · body paint ·
clear lip gloss

144

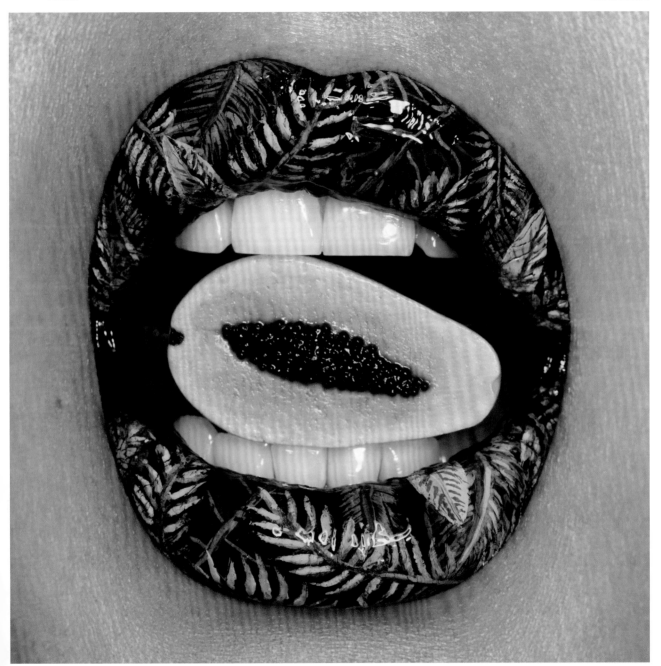

145

2021 PAPAYA
Liquid lipstick · body paint ·
clear lip gloss · doll house papaya

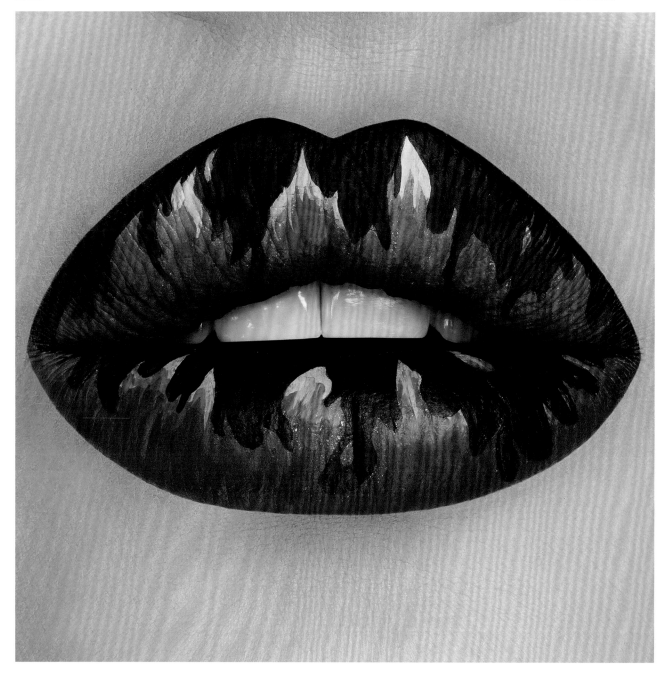

2017 FLAMES
Liquid lipstick · eye shadows

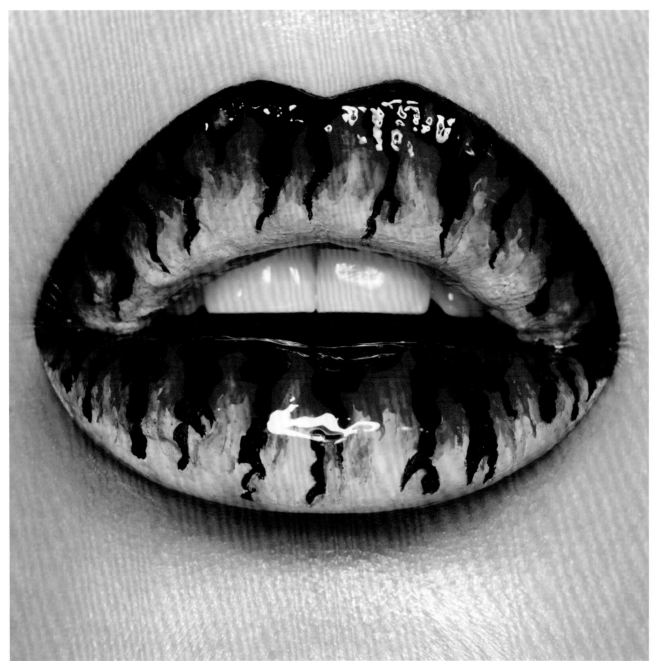

2021 FLAMES II
Liquid lipsticks · clear lip gloss

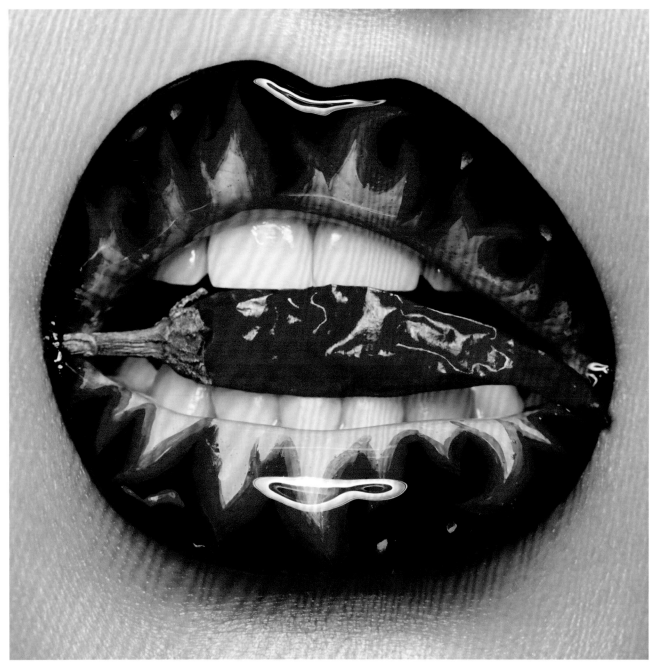

2019 HOT
Liquid lipsticks · clear lip gloss ·
chili pepper

148

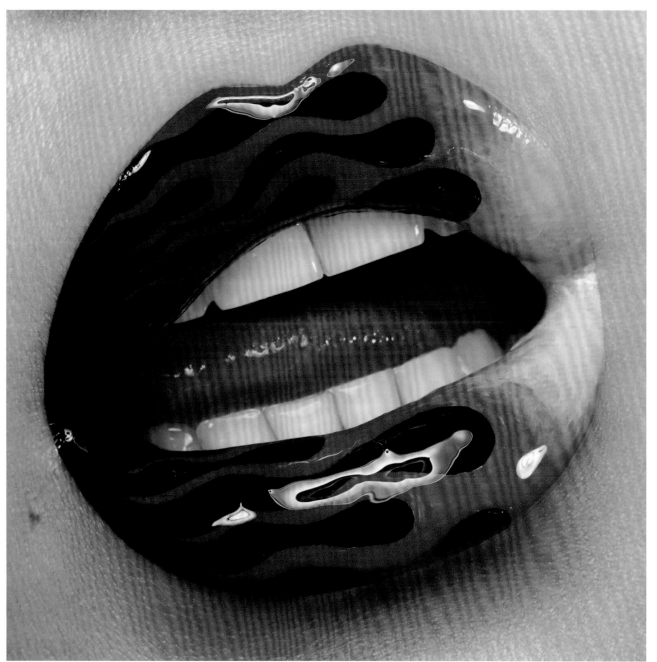

149

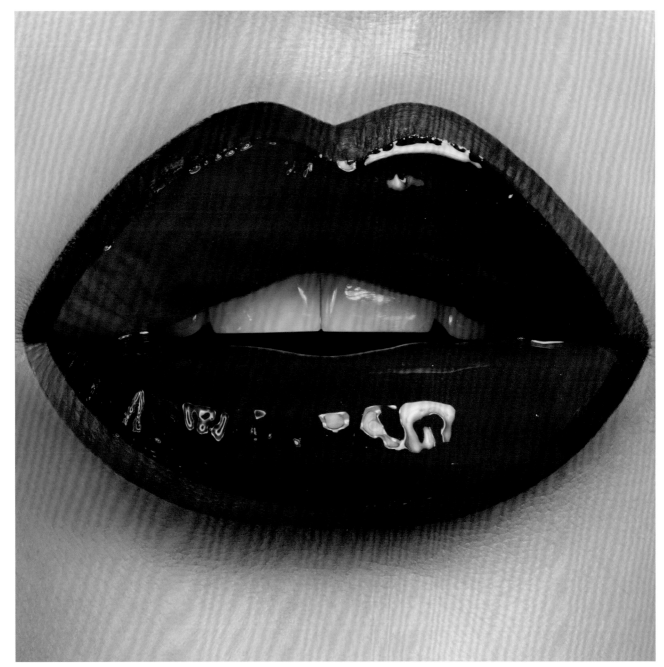

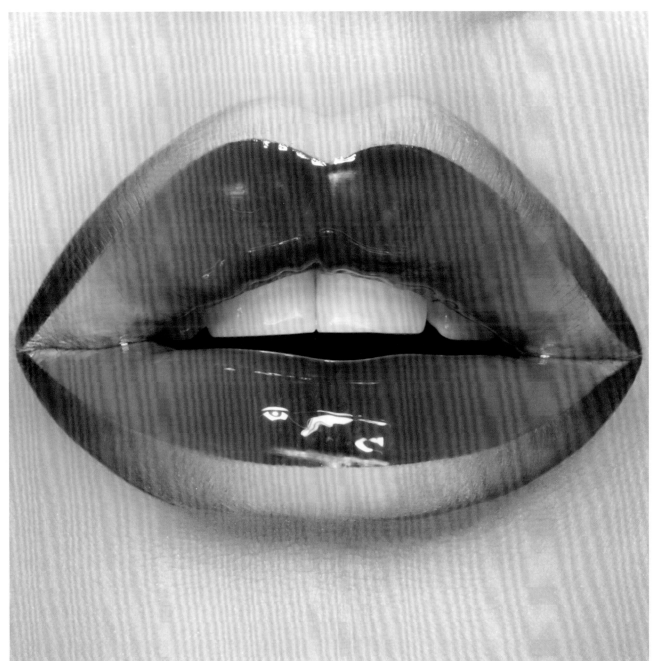

2017 OMBRE WITHIN OMBRE
Liquid lipsticks · clear lip gloss

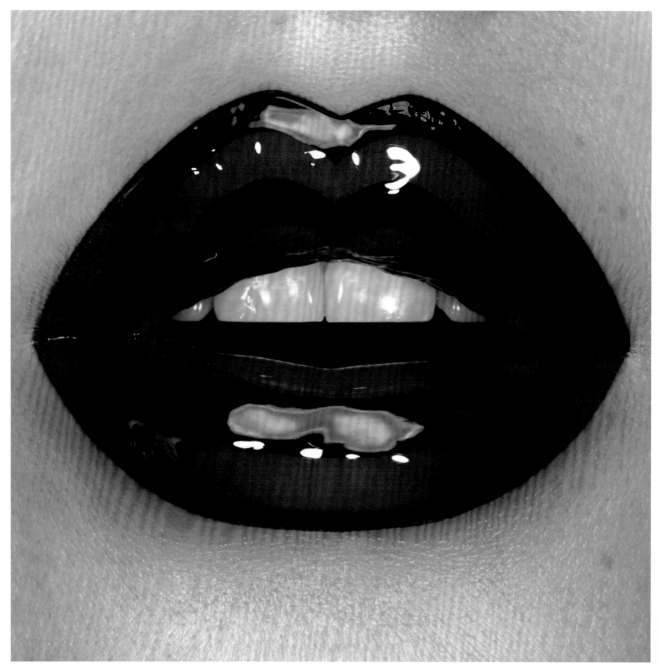

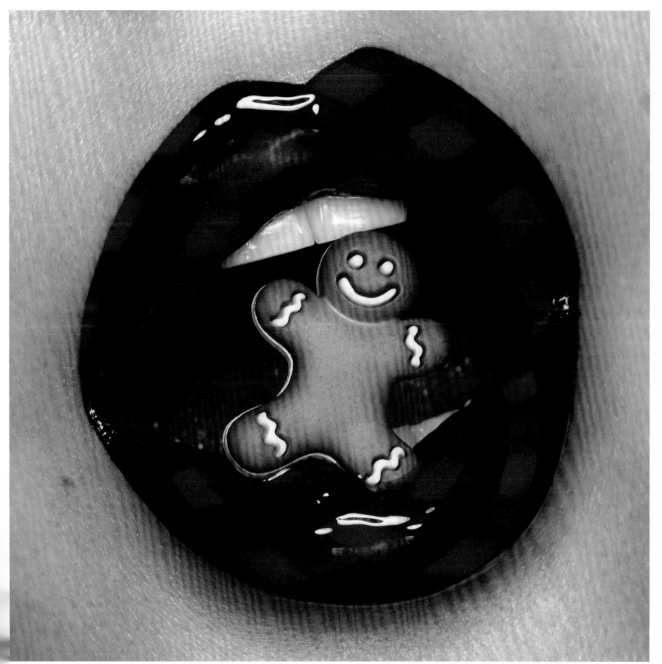

2019 GINGERBREAD PERSON
Liquid lipsticks · clear lip gloss ·
button

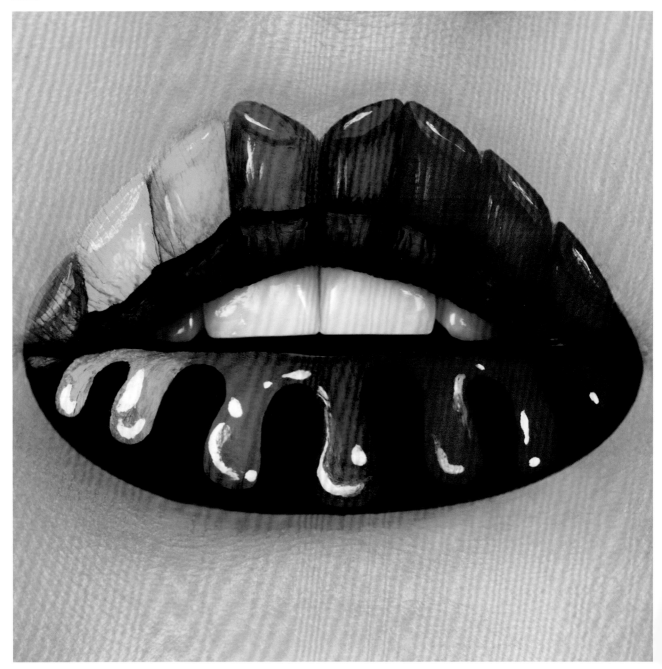

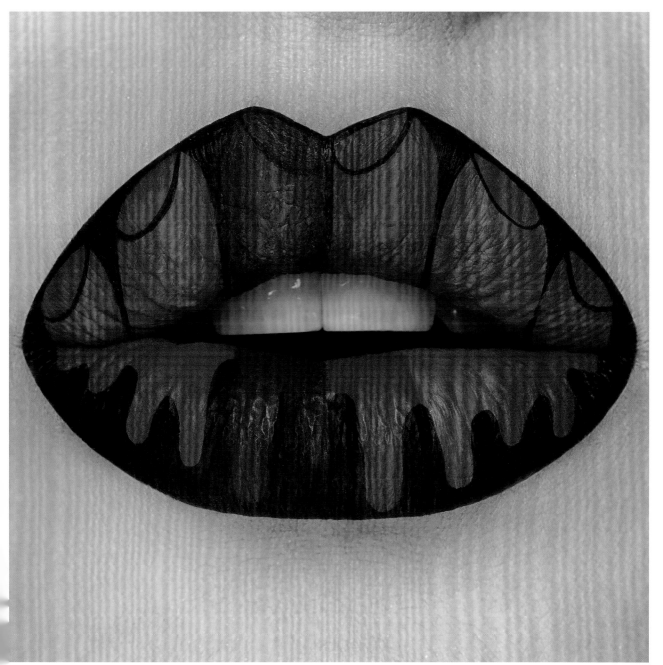

2017 LIPSTICK DAY II
Liquid lipsticks

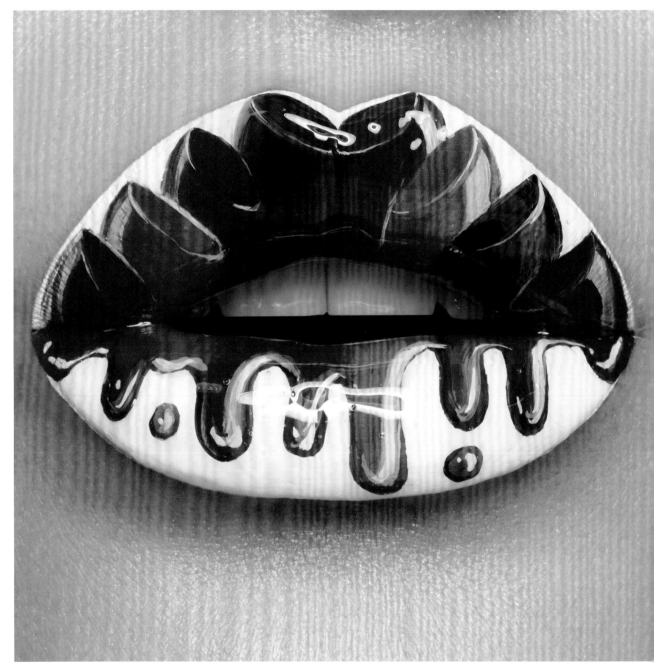

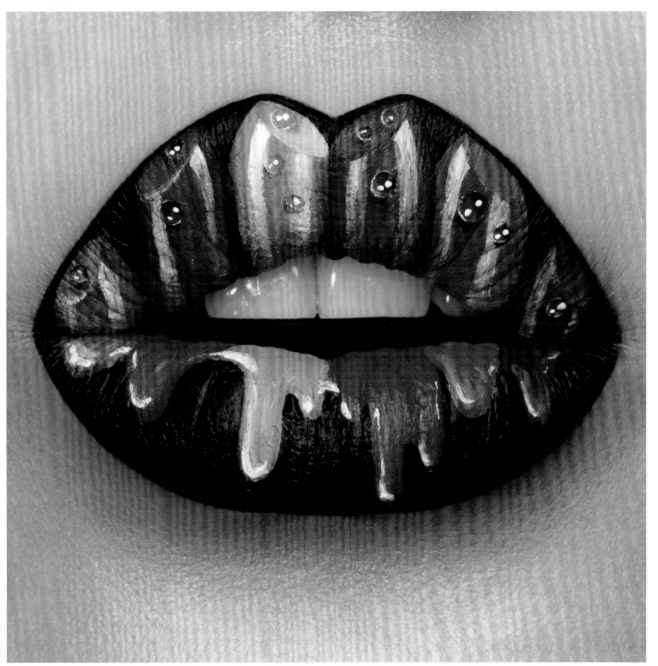

2019 LIPSTICK DAY IV
Liquid lipsticks

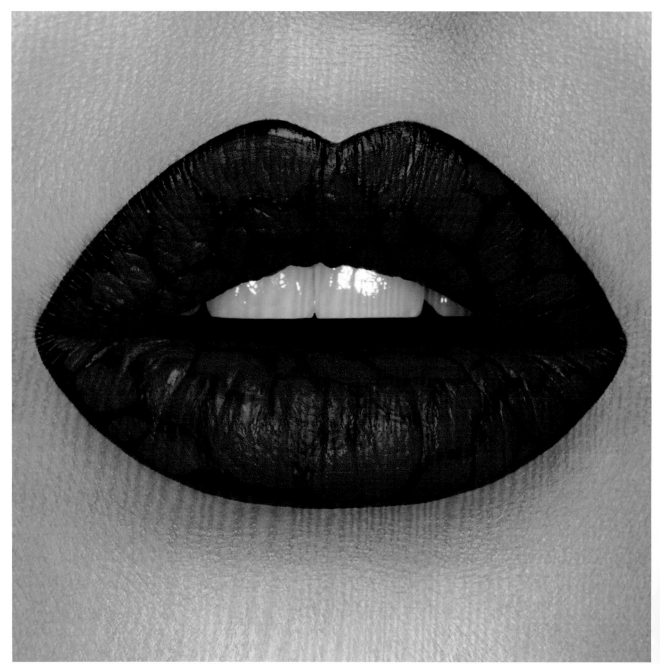

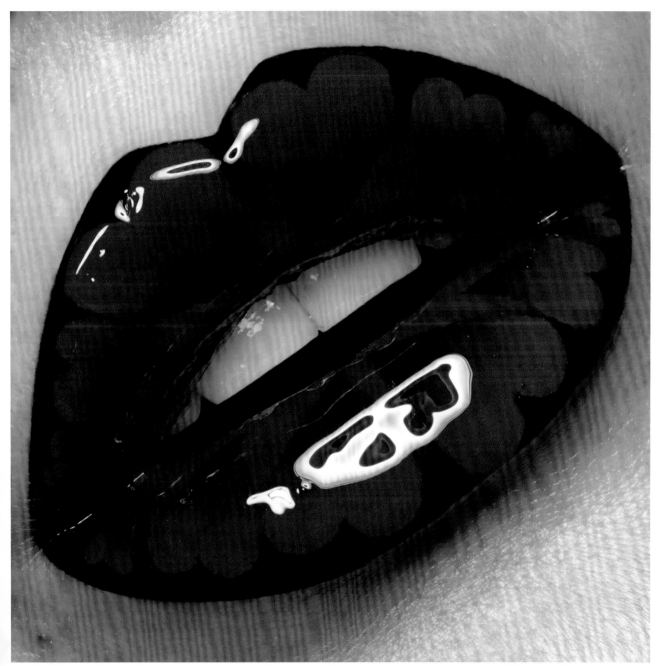

2020 SHADES OF LOVE
Liquid lipsticks · clear lip gloss

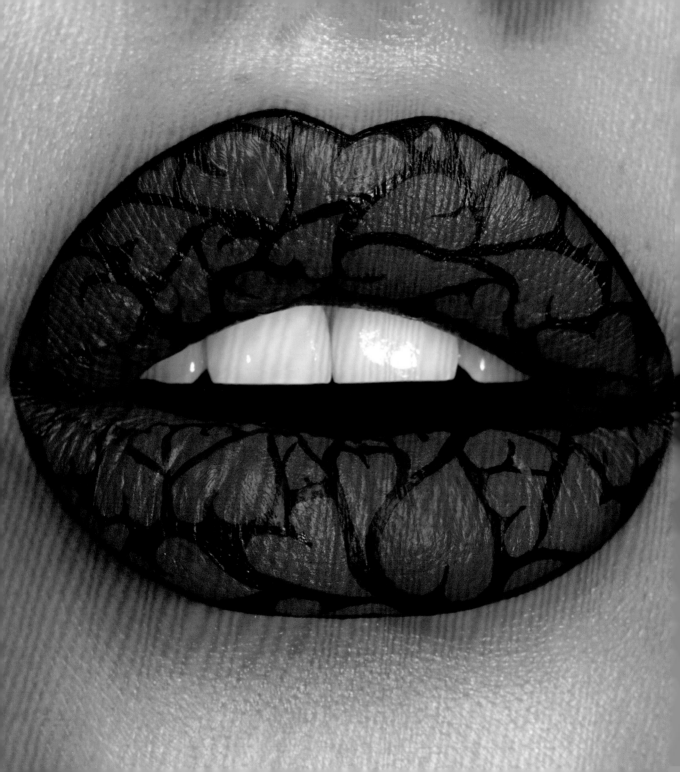

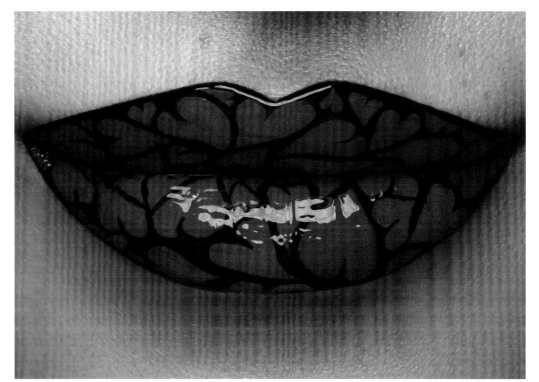

2020 LOVE ←
Liquid lipsticks

2018 VALENTINE'S SMILE ↑
Liquid lipsticks · clear lip gloss

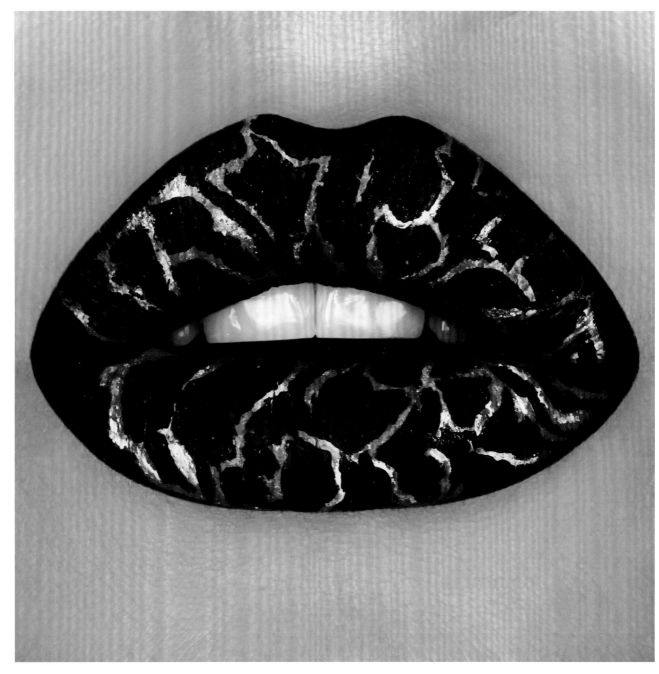

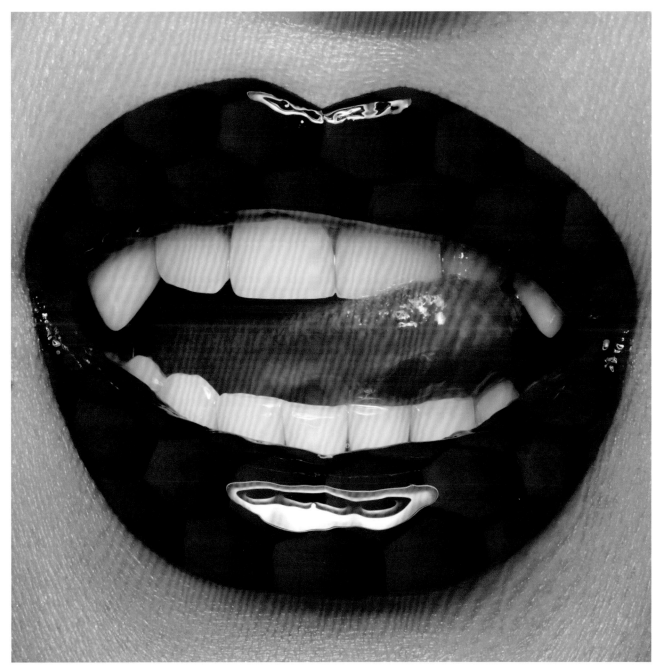

163

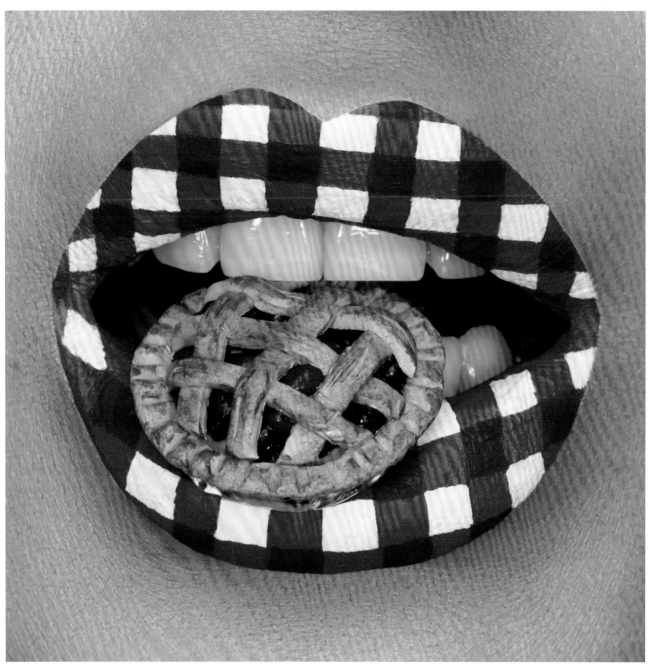

2019 THANKSGIVING
Liquid lipsticks · body paint ·
doll house pie

164

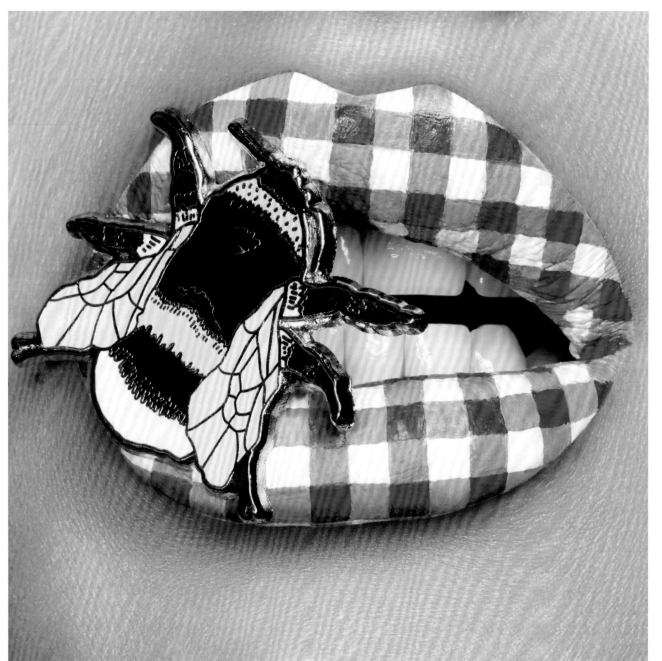

2019 MARKET
Liquid lipsticks · body paint ·
lapel pin

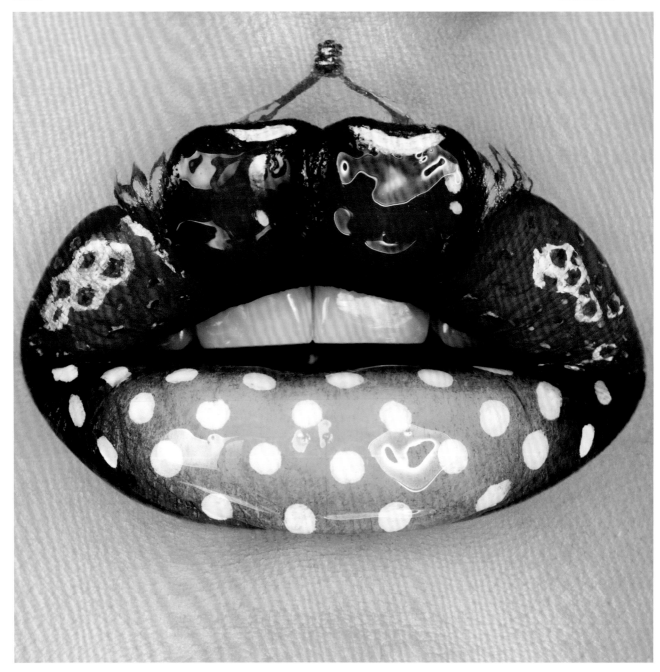

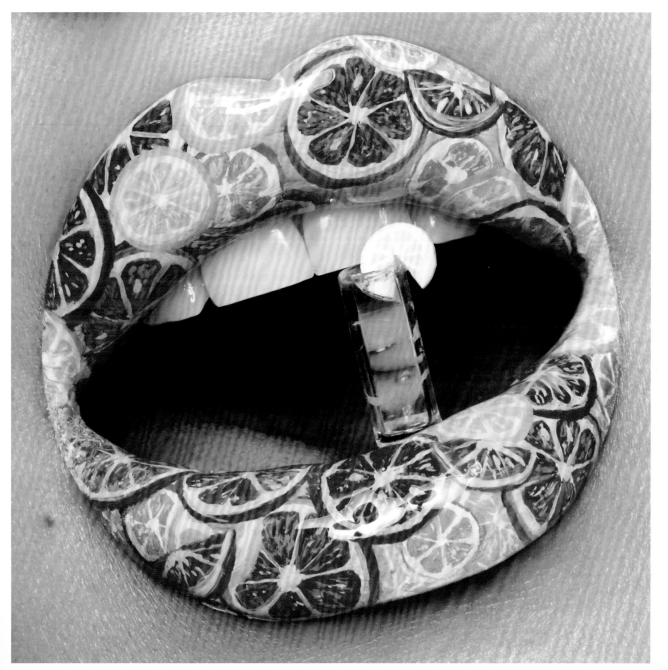

2018 LEMONADE
Body paint · clear lip gloss ·
doll house lemonade

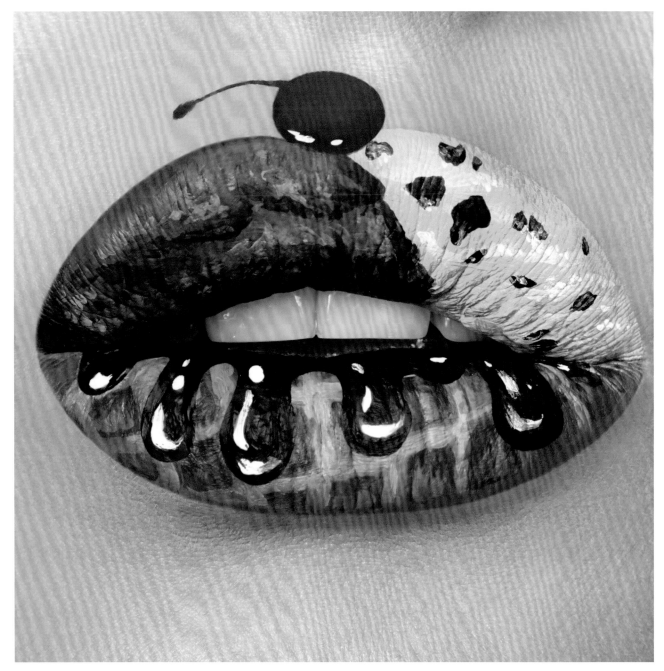

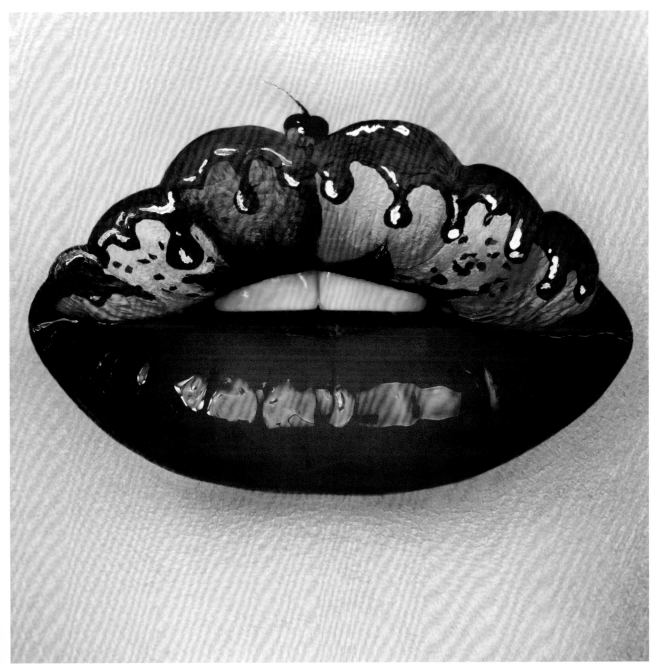

169

2016 CHERRY
Liquid lipsticks, clear lip gloss

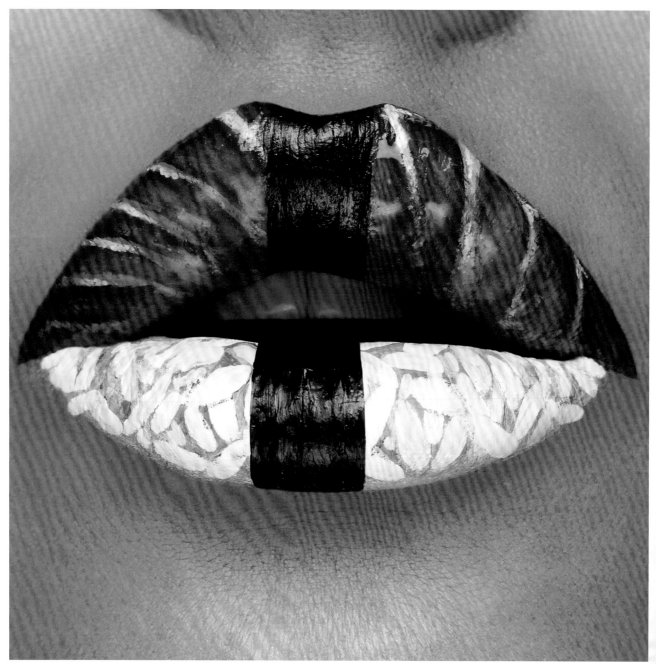

2016 SUSHI
Liquid lipsticks · body paint ·
clear lip gloss

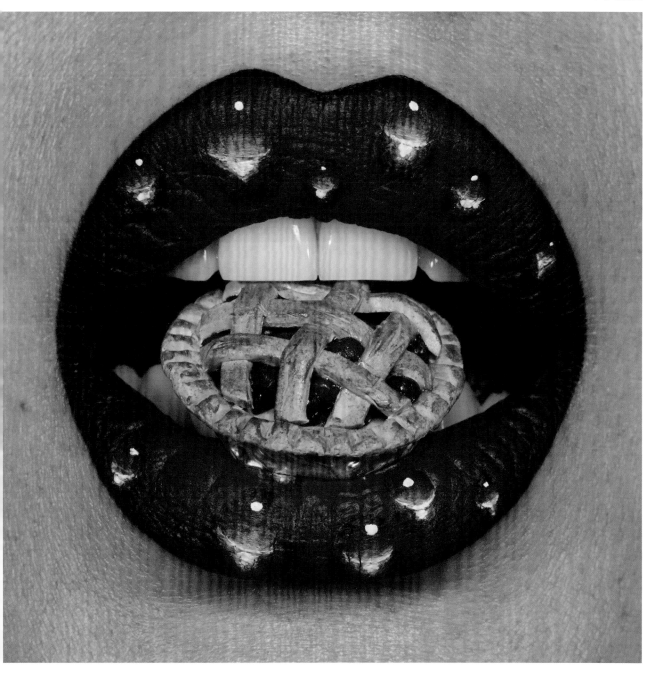

2020 CHERRY PIE
Liquid lipsticks · body paint ·
doll house pie

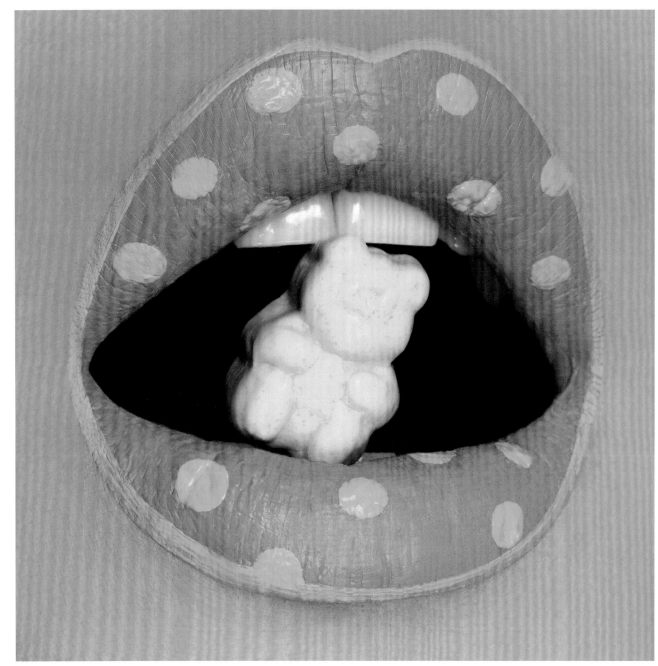

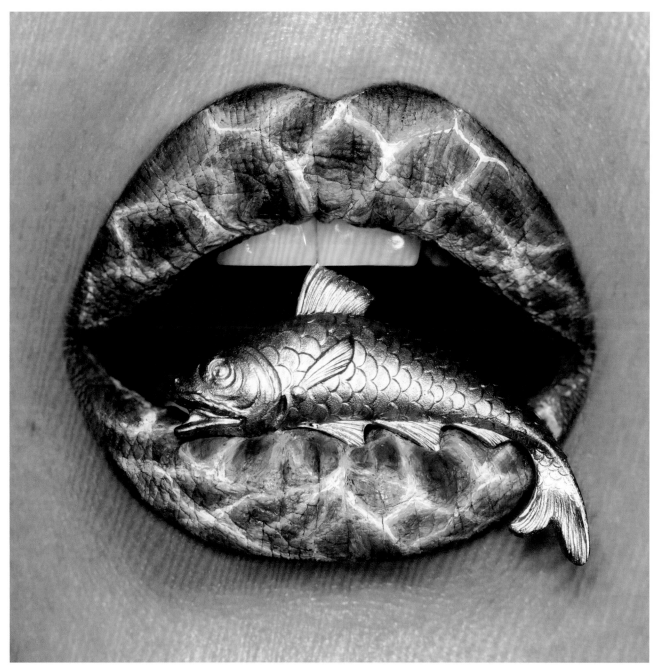

2021 MAKE A WISH
Body paint · brass fish

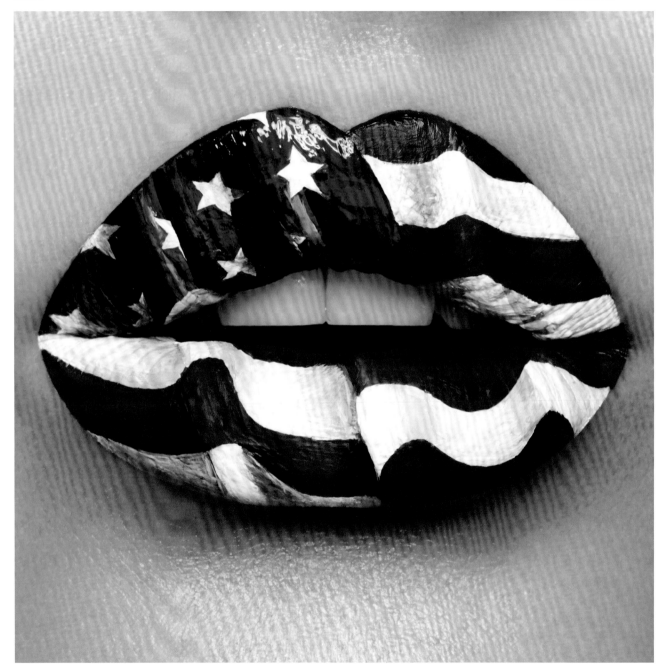

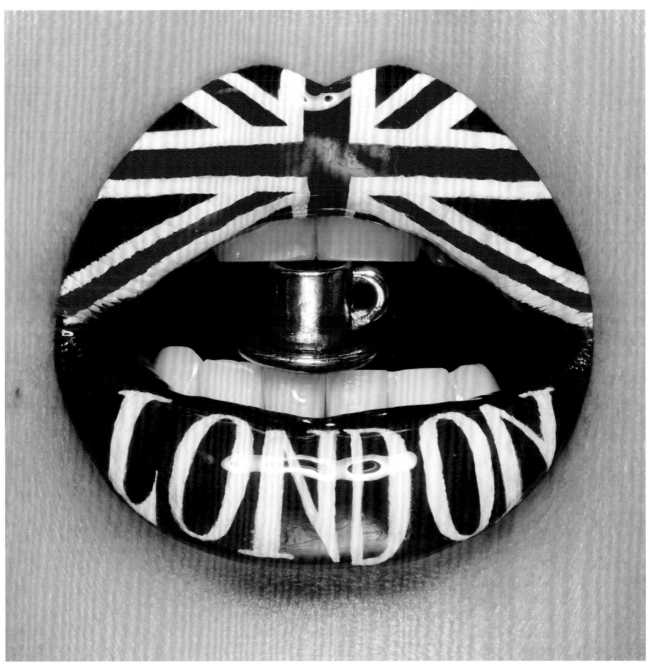

175

2018 LONDON
Liquid lipsticks · body paint ·
clear lip gloss · doll house tea cup

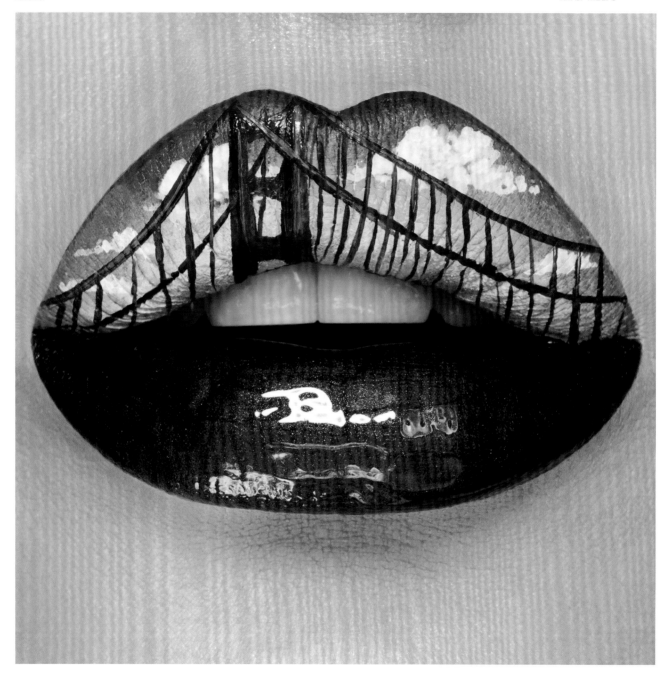

2017 SAN FRANCISCO
Metallic lip gloss · body paint ·
clear lip gloss

176

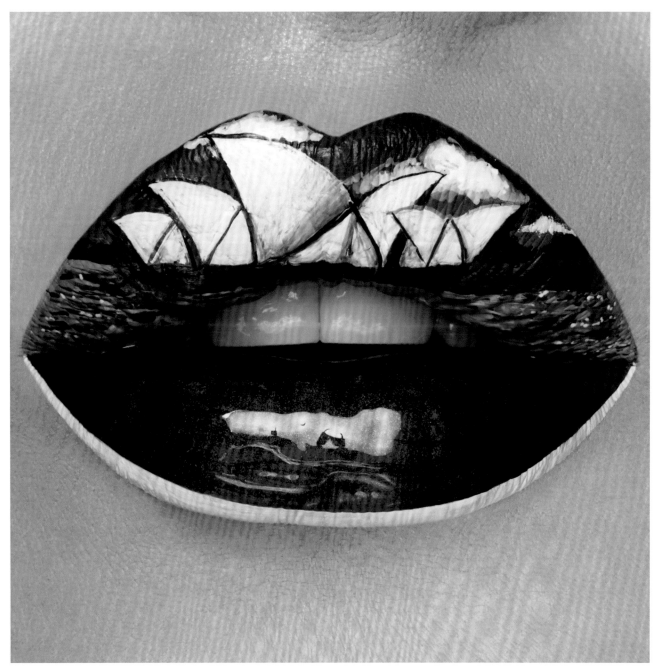

2017 SYDNEY
Metallic lip gloss · body paint ·
clear lip gloss

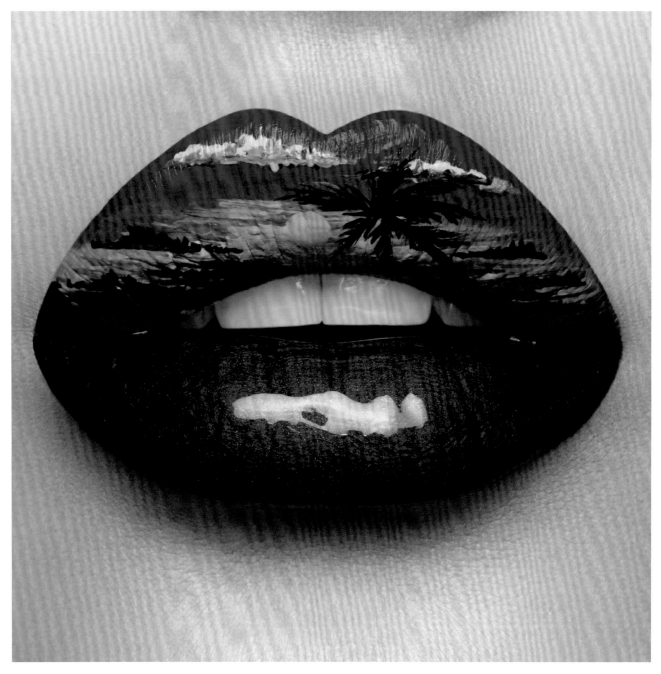

2017 FIJI SUNSET
Liquid lipsticks · body paint ·
clear lip gloss

178

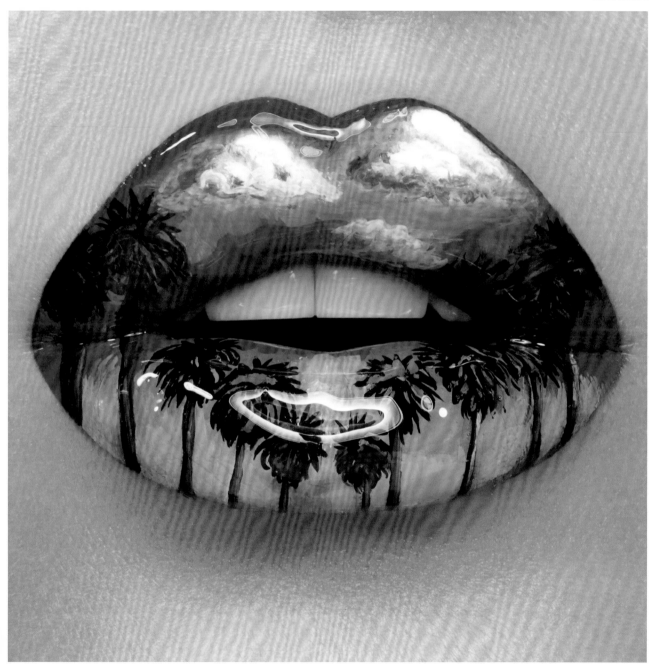

2018 BEVERLY HILLS
Liquid lipsticks · clear lip gloss

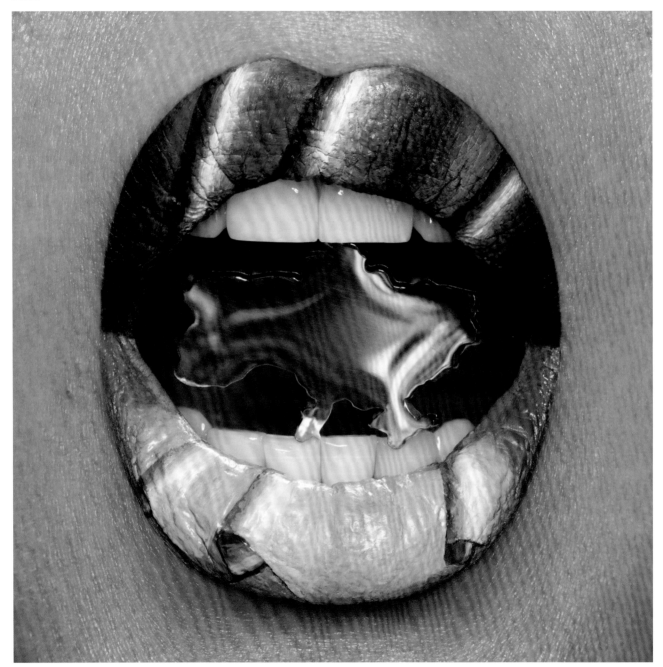

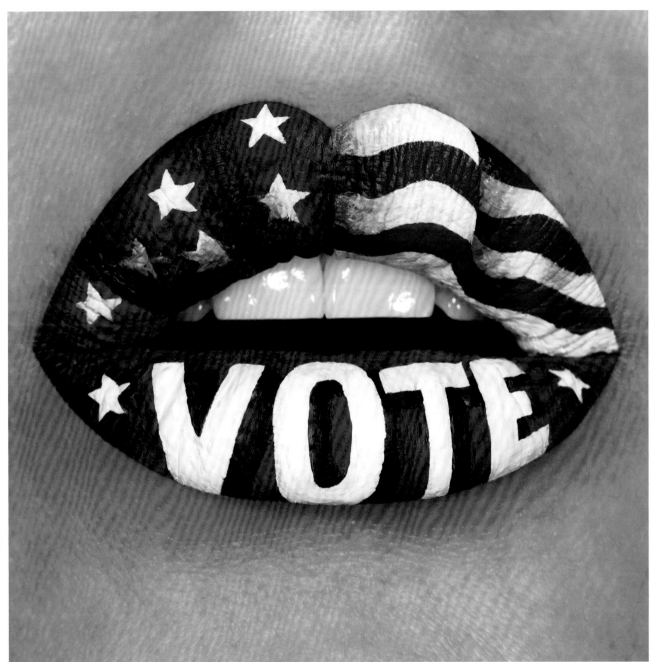

181

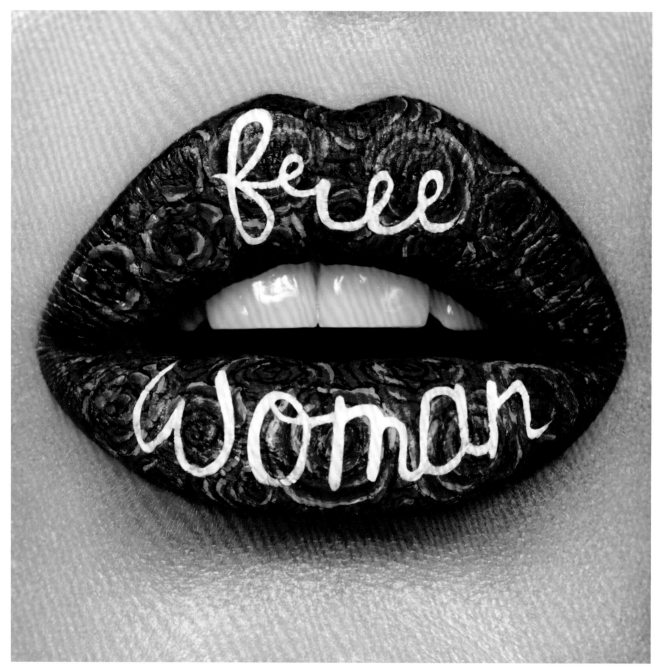

2021 FREE WOMAN
Liquid lipsticks · body paint
(Dedicated to Britney Spears)

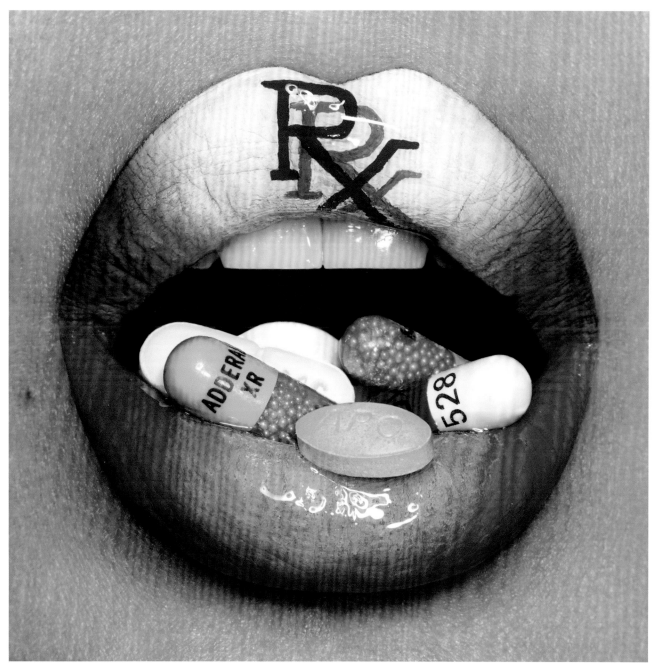

2020 RX
Liquid lipsticks · body paint ·
clear lip gloss · pills

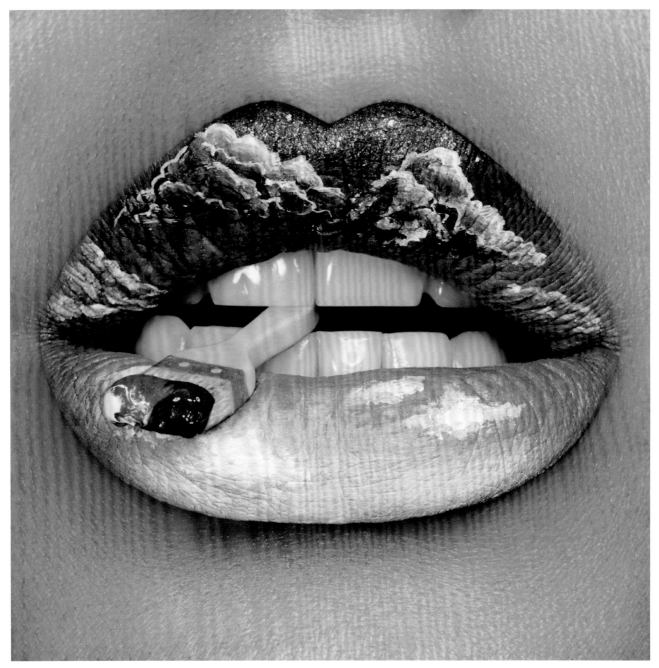

2019 SKY LIMIT
Liquid lipsticks · body paint ·
doll house paint brush

184

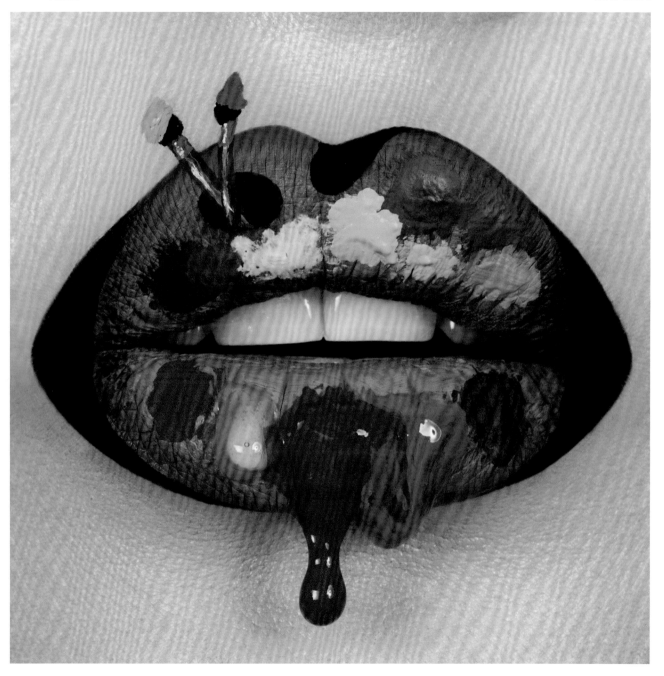

185

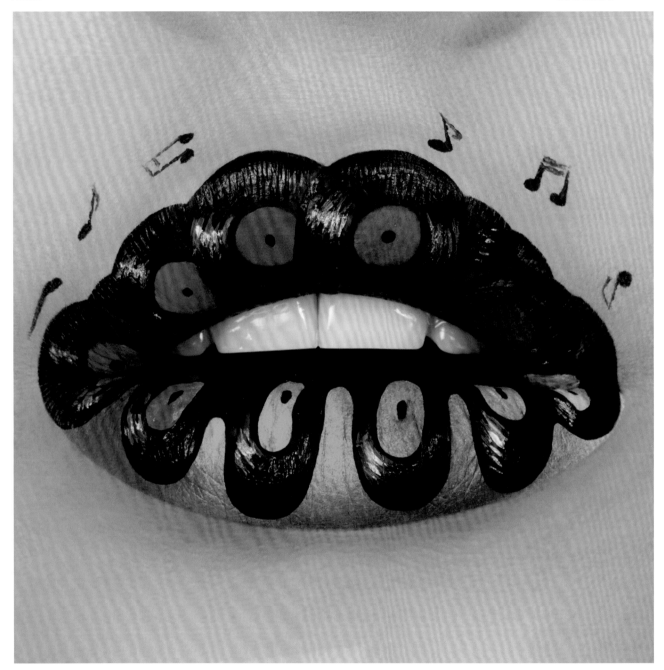

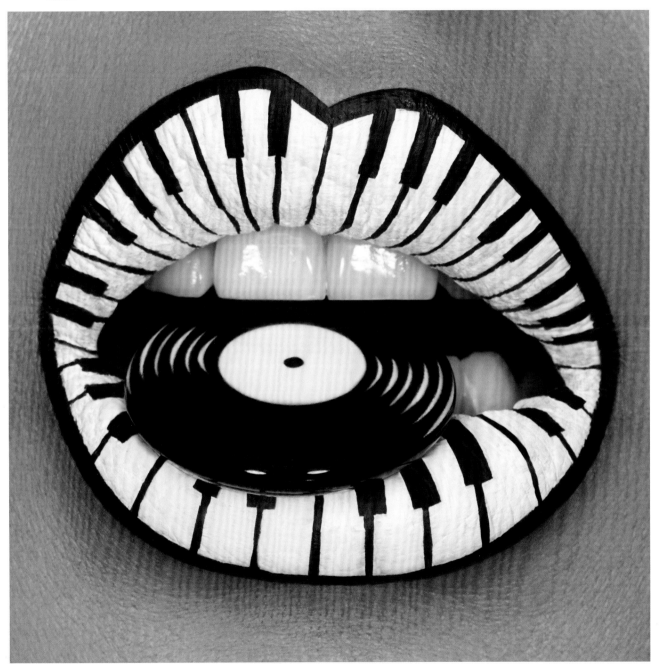

2020 WHITE LABEL
Liquid lipsticks · body paint ·
record pin

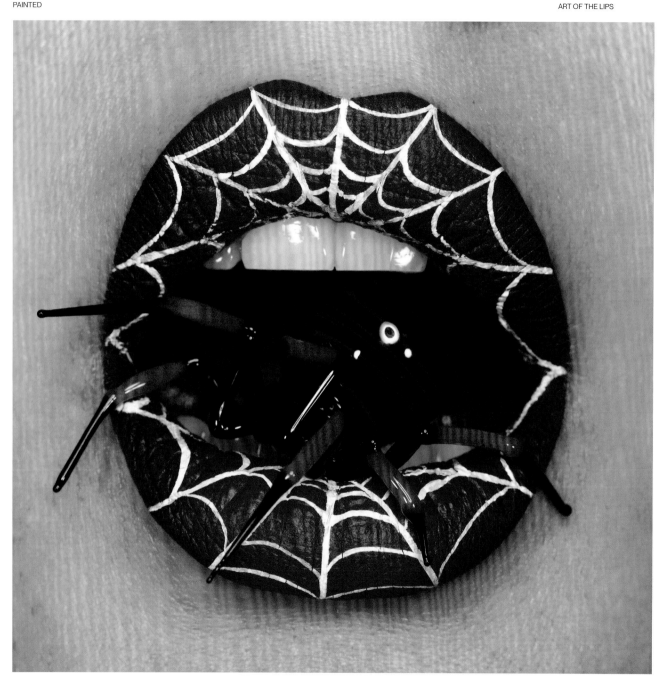

2020 BLACK WIDOW
Liquid lipsticks · body paint ·
glass spider

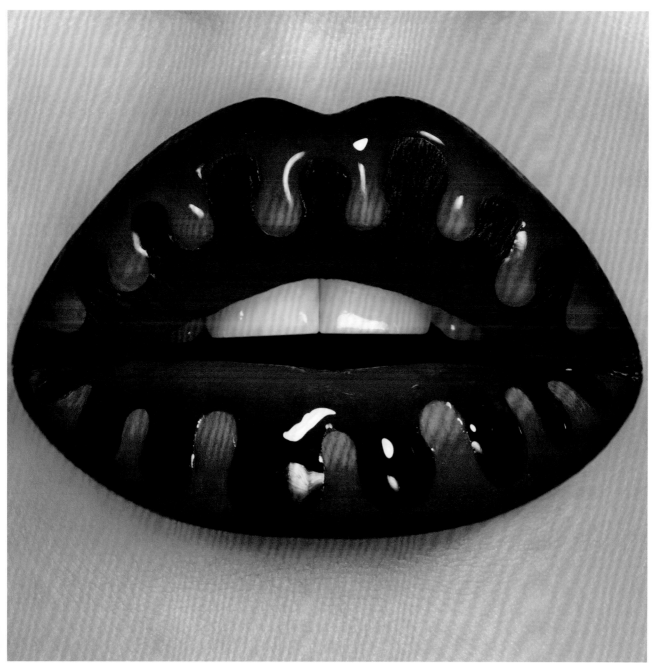

189

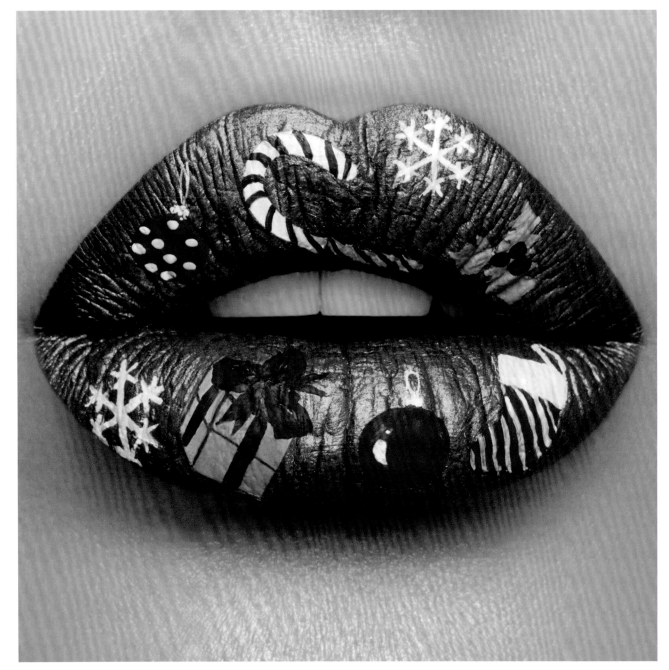

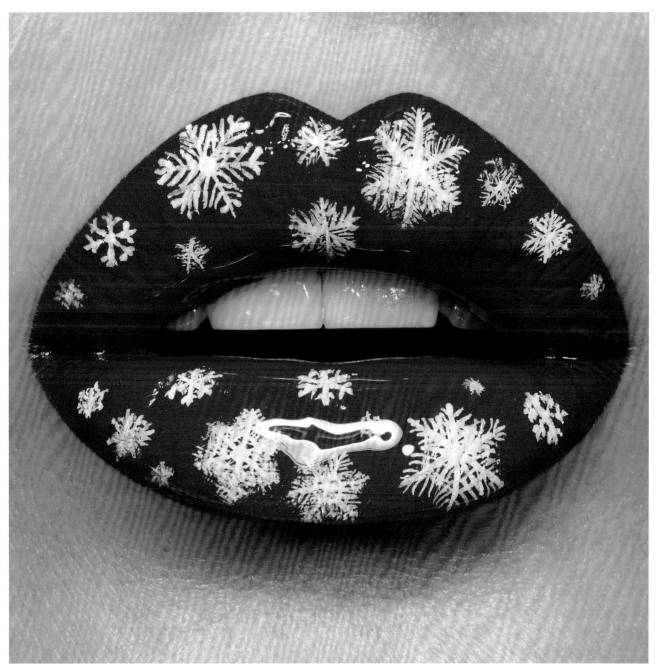

191

2020 SNOWFLAKES
Liquid lipsticks · body paint ·
clear lip gloss

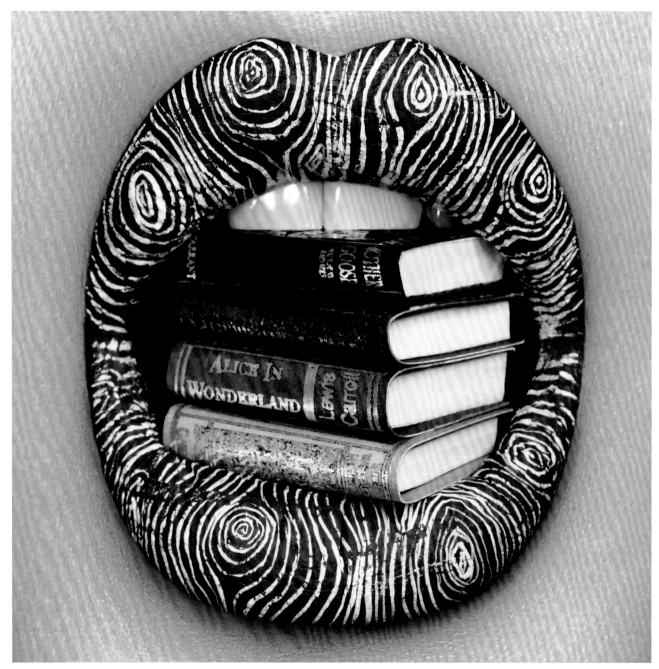

2019 BOOK SHELF
Liquid lipsticks · body paint ·
doll house books

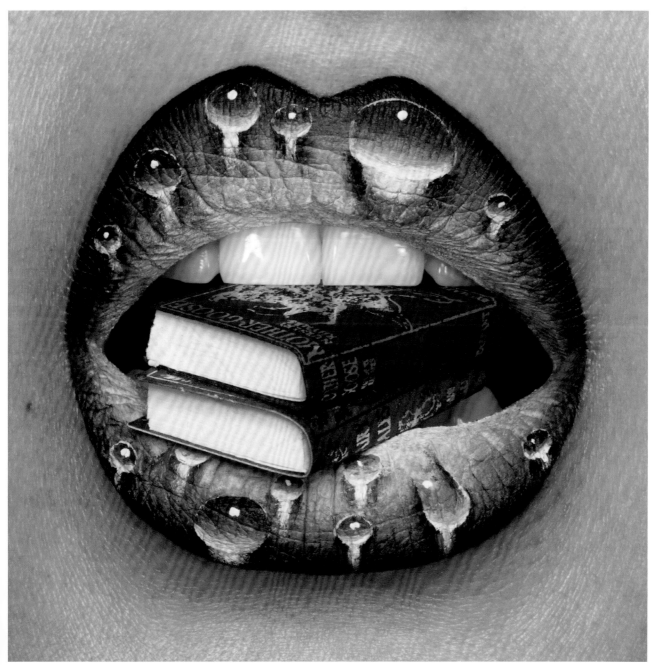

193

2020 RAINY DAY BOOKS
Liquid lipsticks · body paint ·
doll house books

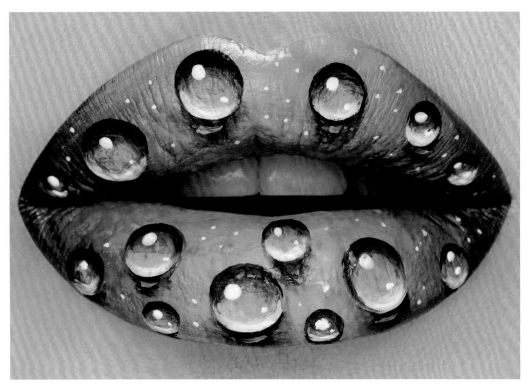

2017 GREEN DROPS ↑
Liquid lipsticks · body paint

2020 LADY BUG →
Liquid lipsticks · body paint ·
metal lady bug

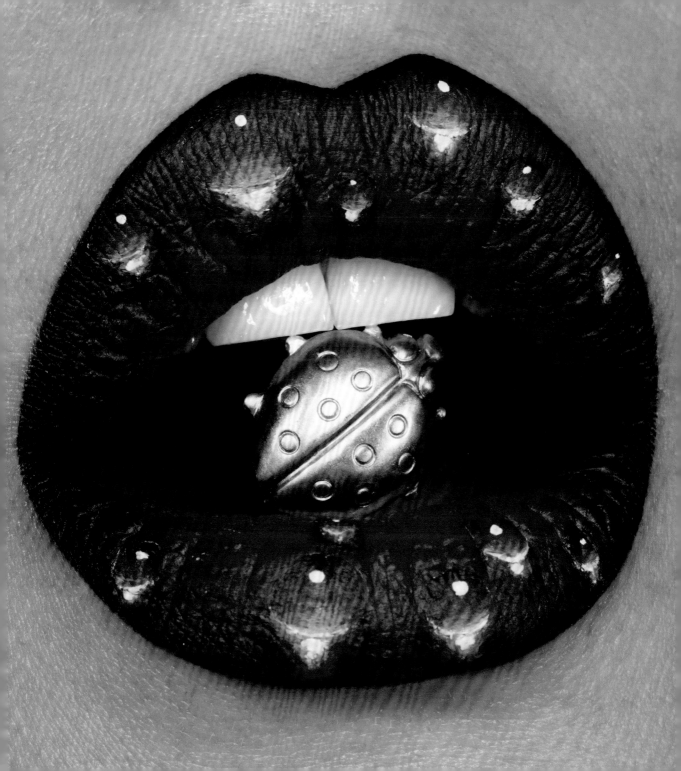

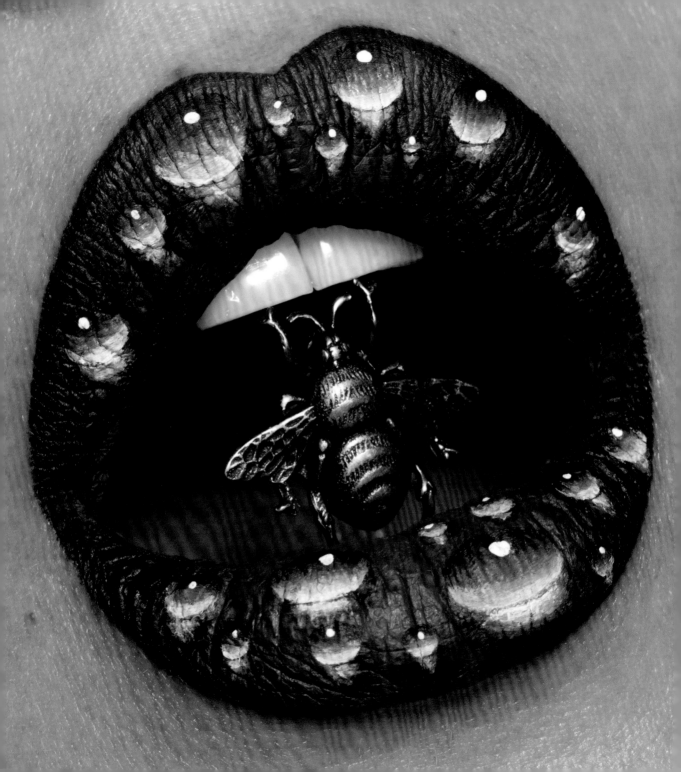

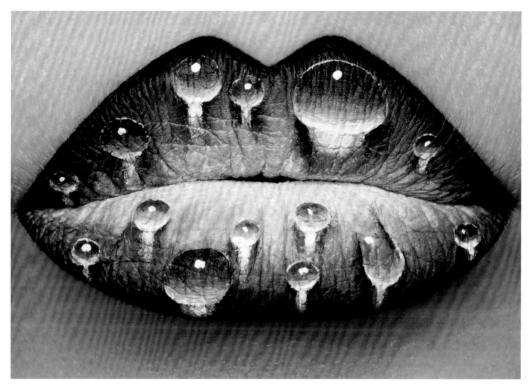

FACT It took me five years to perfect this technique of painting water droplets on the lips. Each time
I recreate this lip art I learn something new. I love the realistic look that my latest technique gives.

2020 DEWY ←
Liquid lipsticks · body paint ·
brass bee

2020 RAINY DAY ↑
Liquid lipsticks · body paint

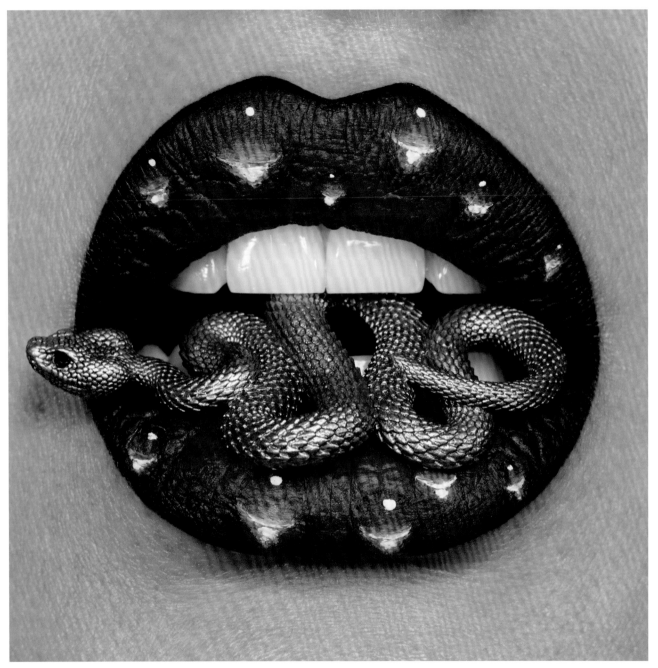

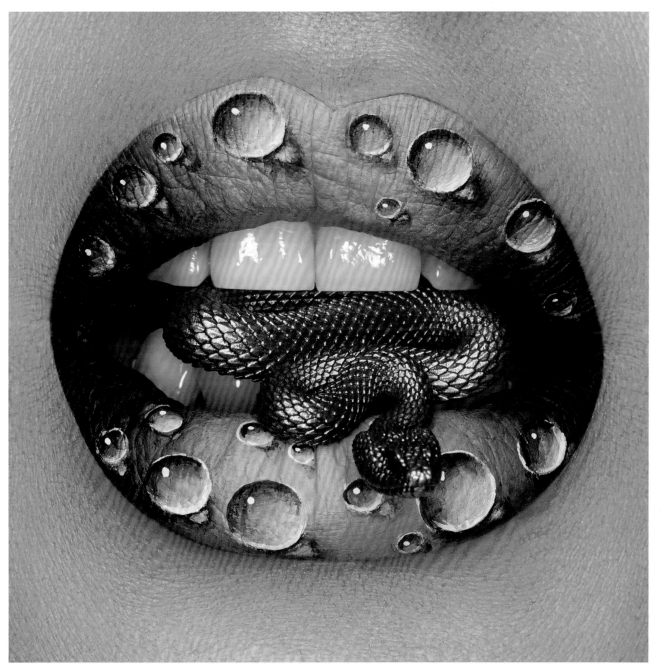

199

2020 EDEN
Liquid lipsticks · body paint ·
pendant

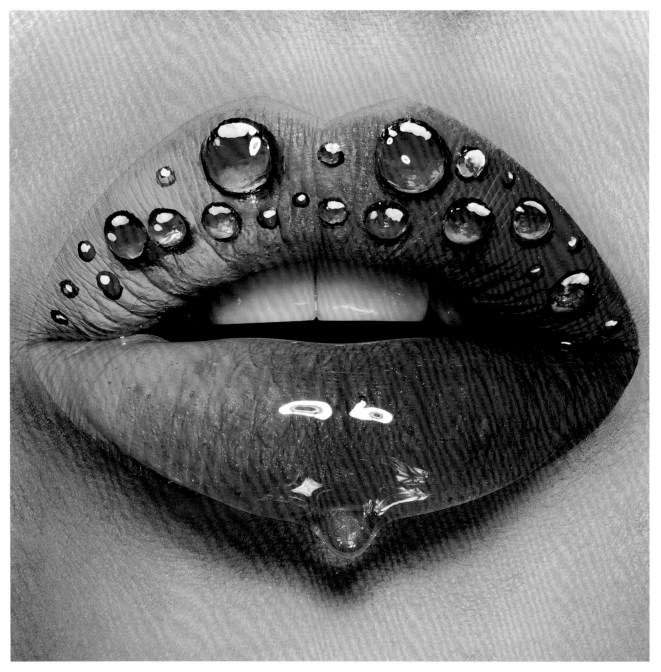

2017 DEW
Liquid lipsticks · body paint ·
clear lip gloss

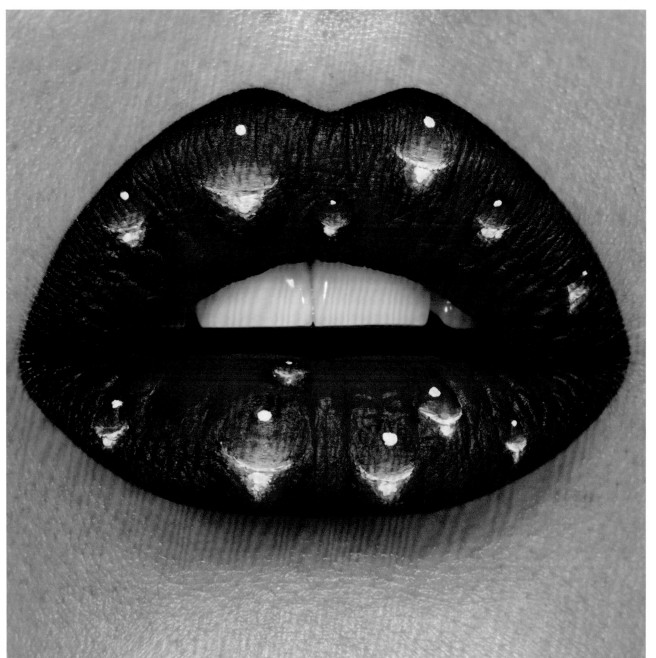

201

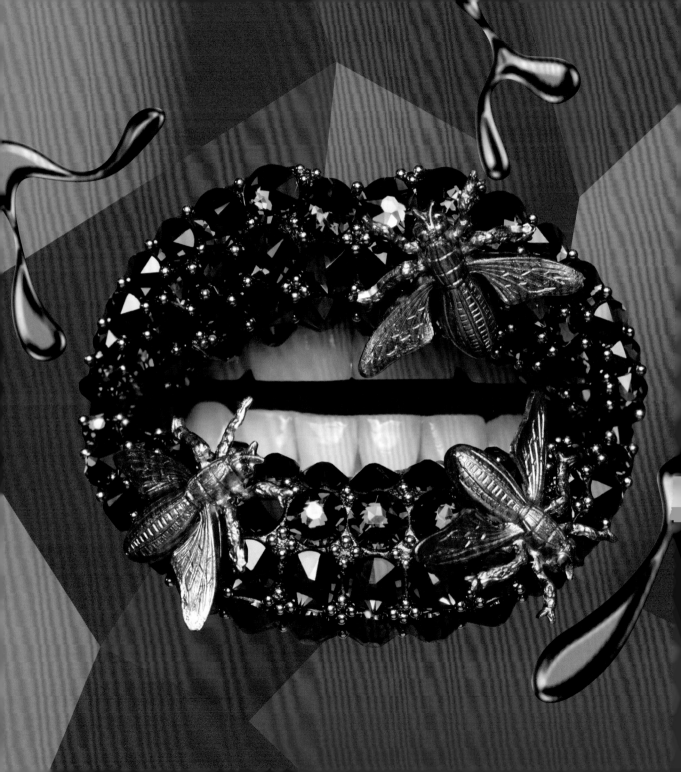

BEJEWELED

My bejeweled lip art is inspired by the beautiful jewelry designed by Salvador Dalí and the runway looks of makeup artist Pat McGrath. I first started experimenting with crystals back in 2015, but it took me a couple of years to develop my own take on it. My first bejeweled lip art was created in 2017 and from then on it has become one of my signature styles.

The thing that makes my bejeweled lip art different from other crystal makeup looks is my use of tiny caviar beads placed in between and around each crystal to create a jewelry-like effect on the lips. The process can be very tedious and time consuming, but it is surprisingly therapeutic.

Each bejeweled look takes approximately an hour and a half to create and a few hours to shoot and retouch. Every little detail matters since I always shoot with a macro lens, which sees more than the human eye does. One of the most popular questions about this type of lip art is, "Can you eat/drink/smile with it?" and to that I always reply that, while it is possible, this type of creative makeup is an art form and is mostly intended for video and photo shoots.

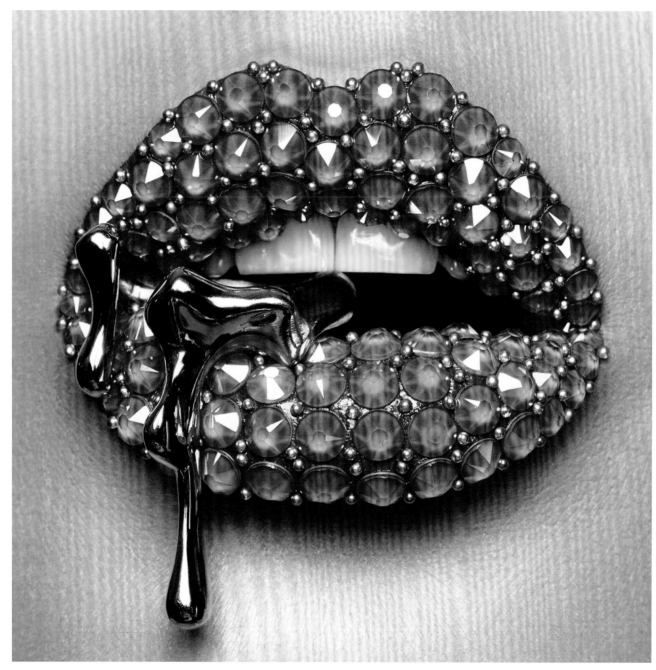

2020　FJORD PEACH
Liquid lipstick · glass crystals ·
caviar beads · ring

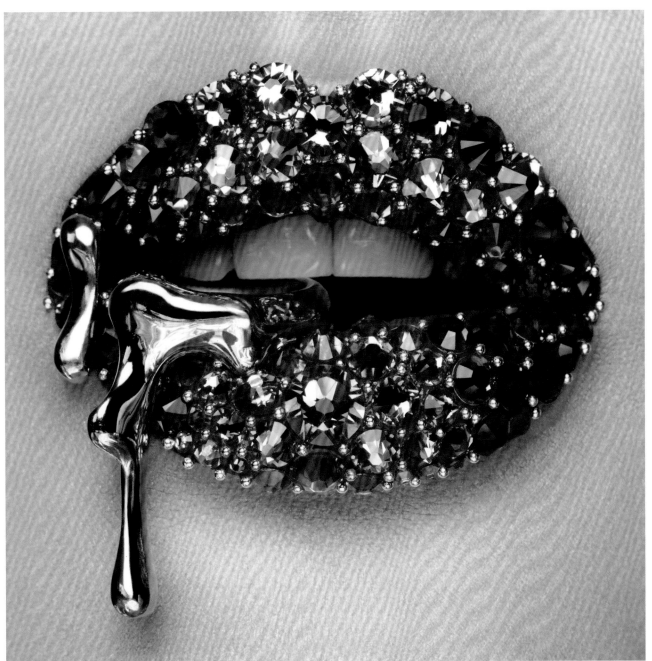

205

2017 FJORD PINK
Liquid lipstick · glass crystals ·
caviar beads · ring

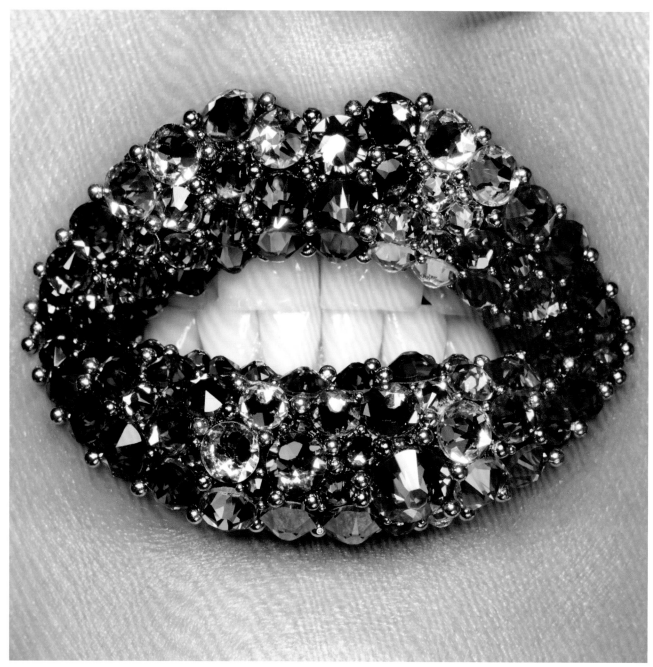

2018 EQUALITY
Liquid lipsticks · glass crystals ·
caviar beads

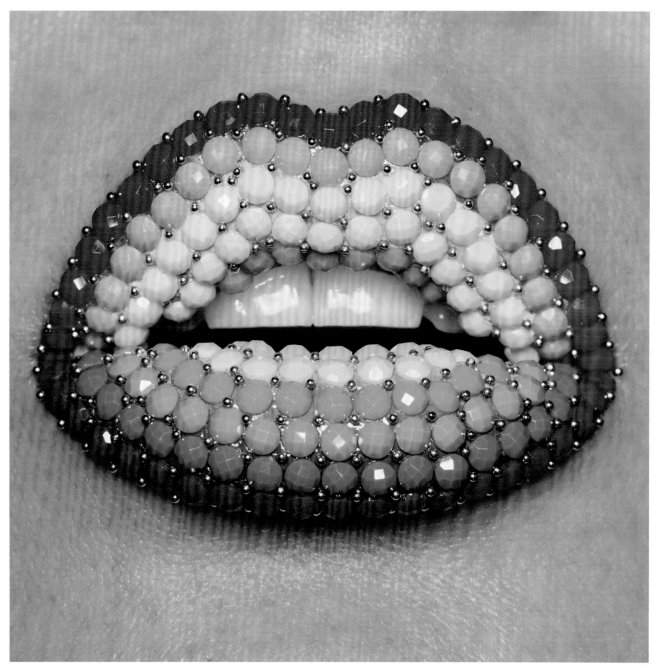

2021 SPECTRUM
Liquid lipsticks · plastic gems ·
caviar beads

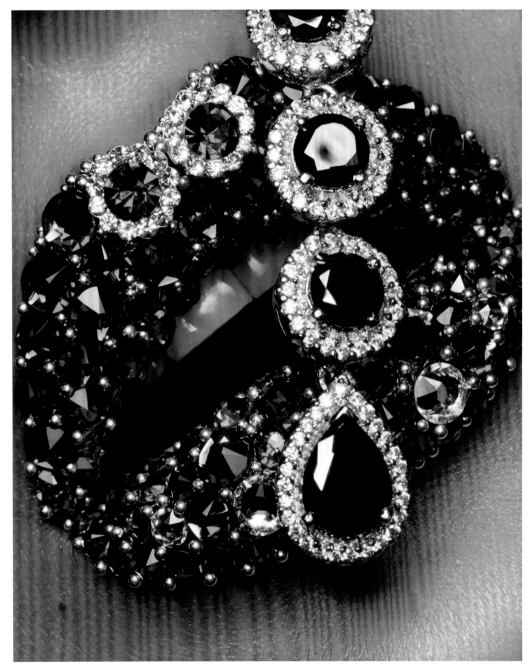

2019 MATCH
Liquid lipstick · glass crystals ·
caviar beads · earring

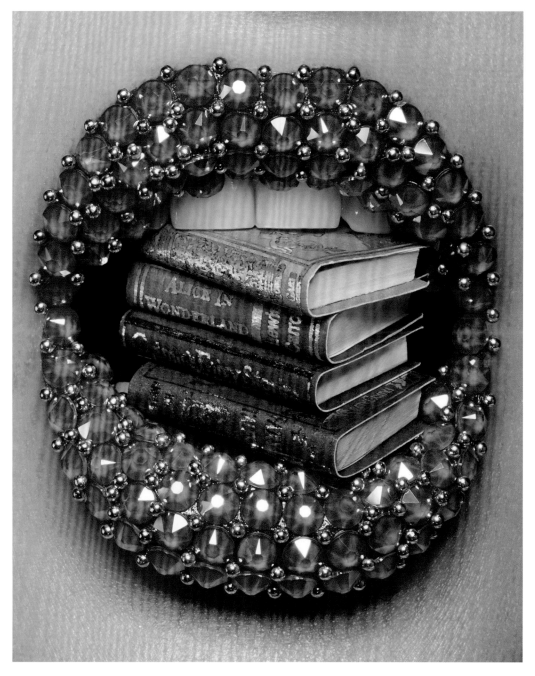

2018 BOOK SHELF PINK
Liquid lipstick · glass crystals ·
caviar beads · doll house books

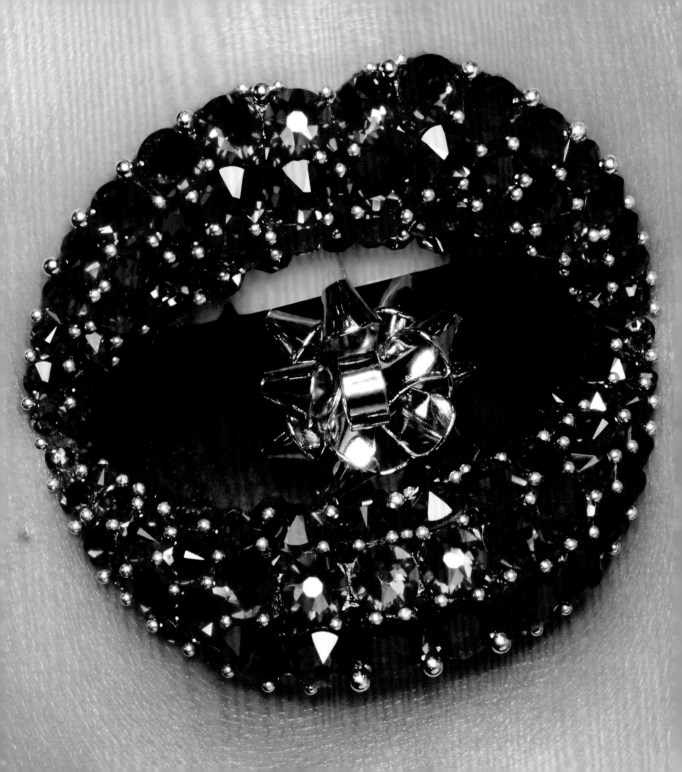

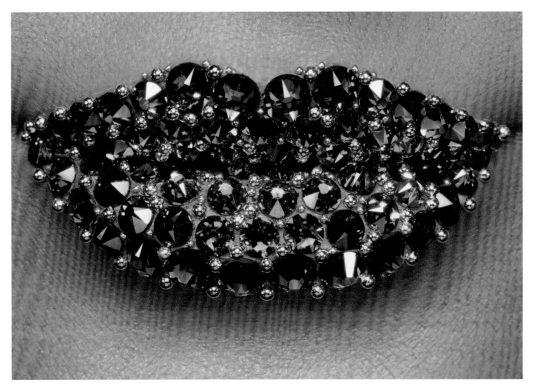

TIP The best eye makeup to pair with a statement lip like this is a neutral eye with only mascara or wing liner and some individual false lashes. Lip art is like wearing a piece of statement jewelry: it should be the center of attention.

2018 BIRTHDAY GIFT ←
Liquid lipstick · glass crystals ·
caviar beads · pendant

2020 TEAL II ↑
Liquid lipstick · plastic gems ·
caviar beads

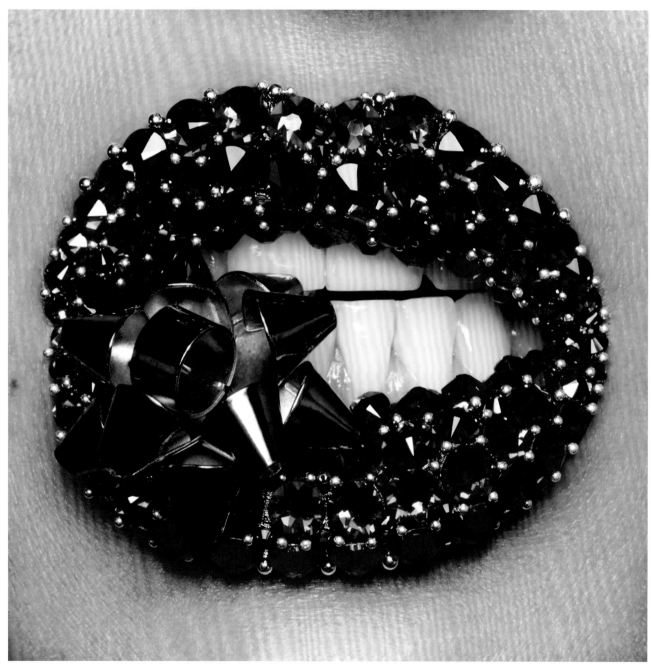

2018 CHRISTMAS GIFT
Liquid lipstick · glass crystals ·
caviar beads · charm

212

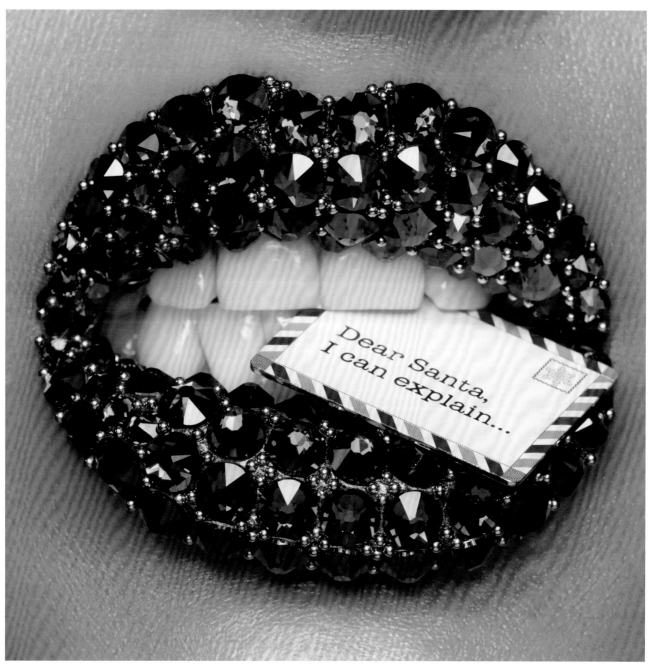

Dear Santa,
I can explain...

2018 DEAR SANTA
Liquid lipstick · glass crystals ·
caviar beads · charm

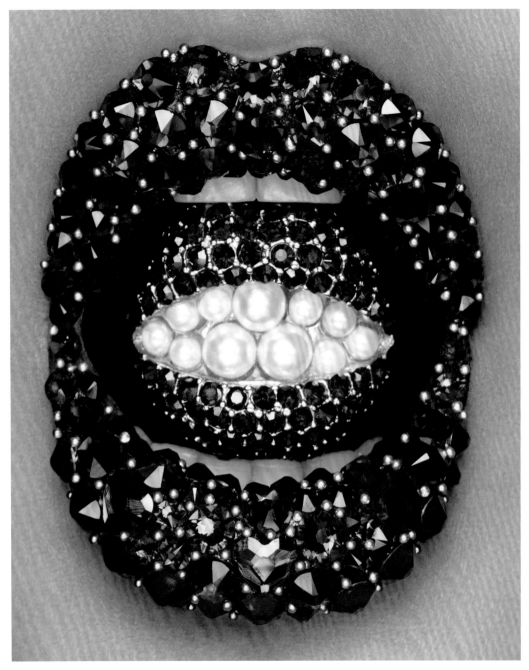

2017 DALÍ WITHIN
Liquid lipstick · glass crystals · caviar
beads · Salvador Dali–inspired ring

214

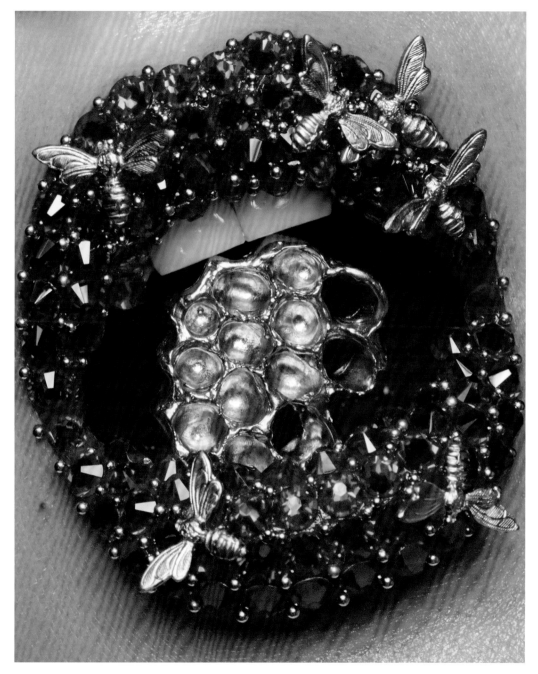

2018 POMEGRANATE BUZZ
Liquid lipsticks · glass crystals ·
caviar beads · brass bees · pendant

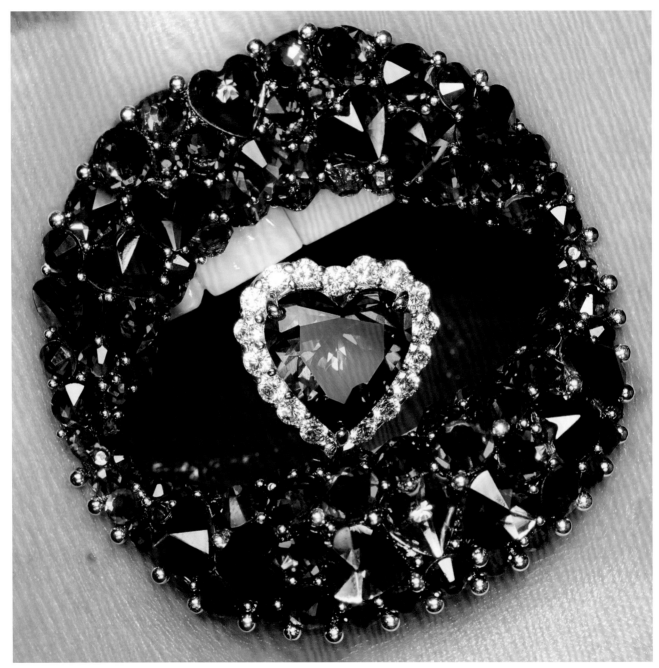

2018 HEART OF THE OCEAN
Liquid lipstick · glass crystals ·
caviar beads · pendant

216

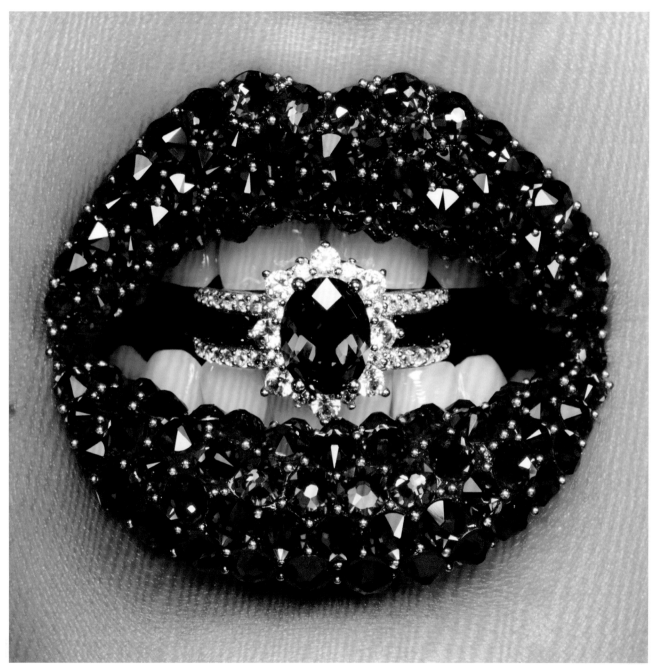

217

2019 SAPPHIRE RING
Liquid lipstick · glass crystals ·
caviar beads · ring

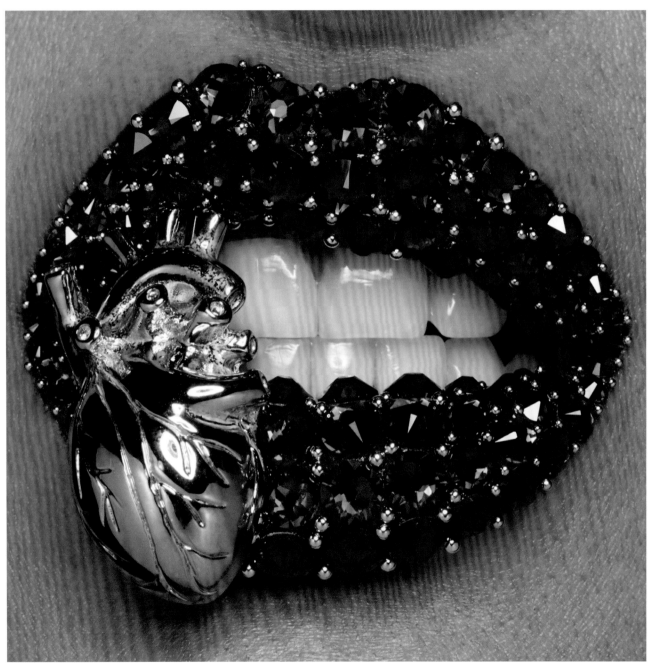

2020 BE MINE
Liquid lipstick · glass crystals ·
caviar beads · brooch

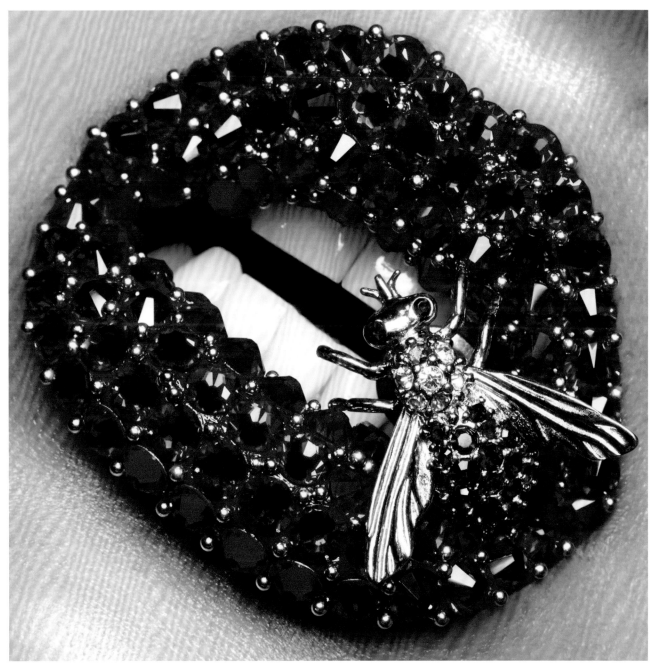

2018 CRIMSON BEE
Liquid lipstick · glass crystals ·
caviar beads · vintage brooch

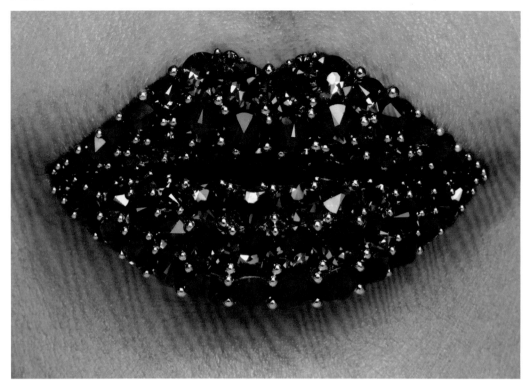

TIP I like to use three or four different sizes of crystals. Larger ones in the center of the lips, gradually getting smaller towards the corners. It creates a beautiful illusion of a fuller lip.

2020 SEALED ↑
Liquid lipstick · glass crystals ·
caviar beads

2018 ICE →
Liquid lipstick · glass crystals ·
caviar beads · ring

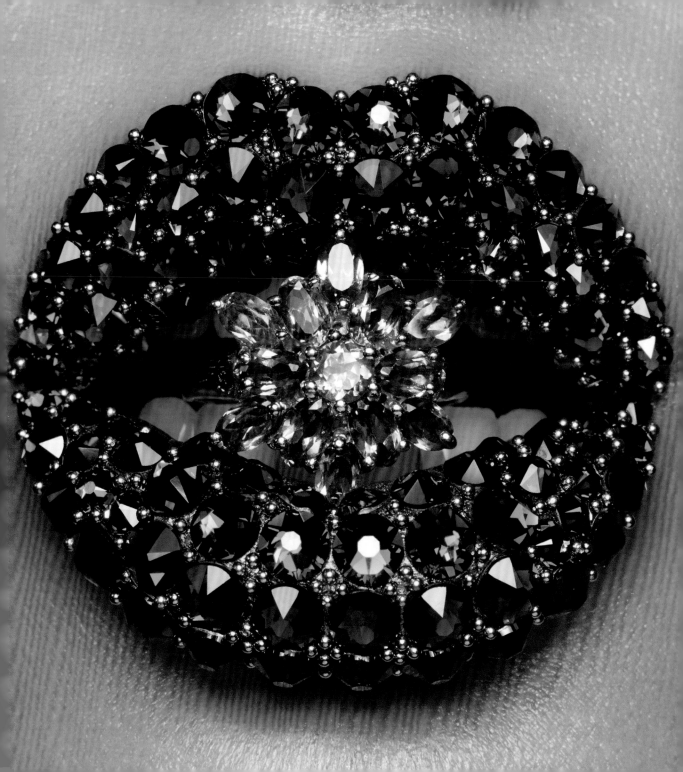

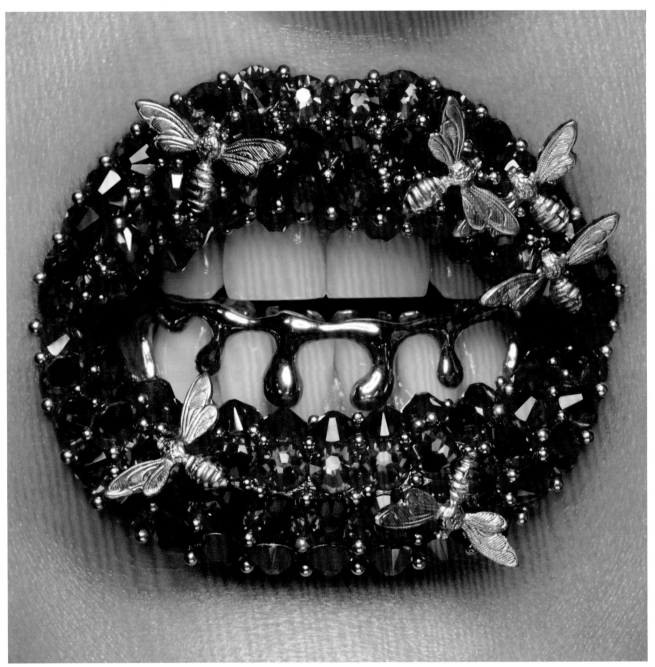

2018 BEE HIVE
Liquid lipstick · glass crystals ·
caviar beads · grillz · brass bees

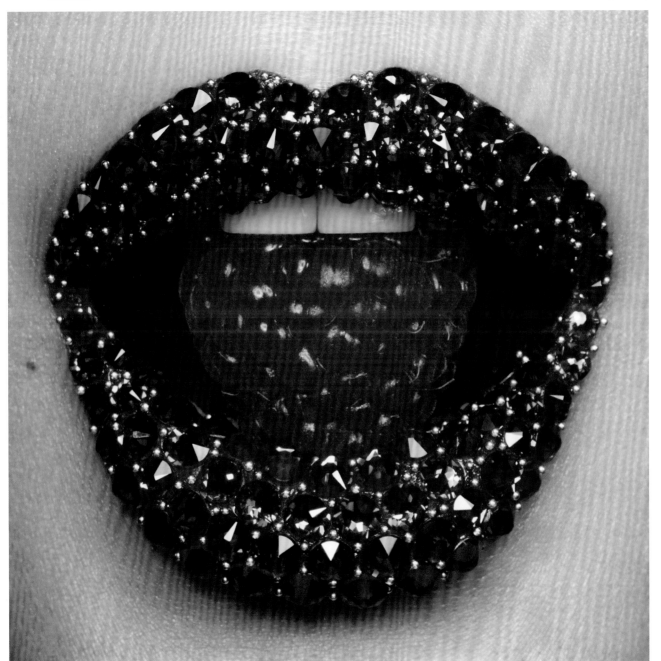

223

2019 GLASSBERRY
Liquid lipstick · glass crystals ·
caviar beads · raspberry

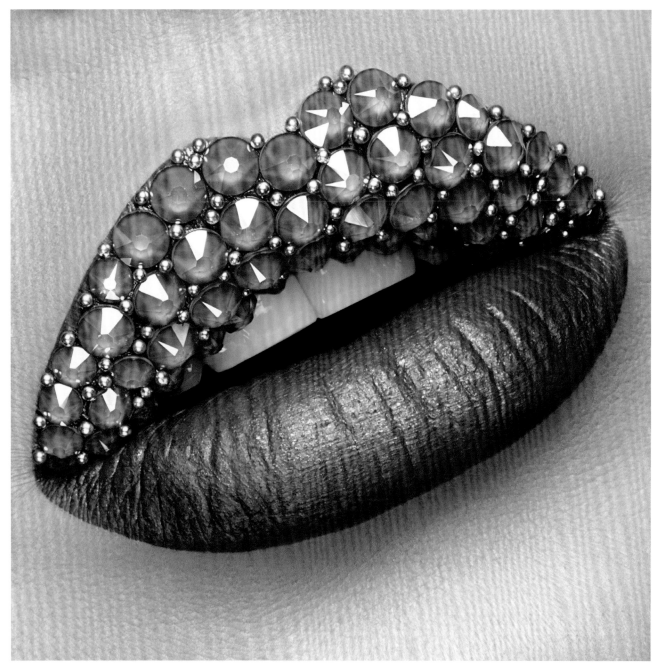

2017 CARAT STICK
Liquid lipstick · glass crystals ·
caviar beads

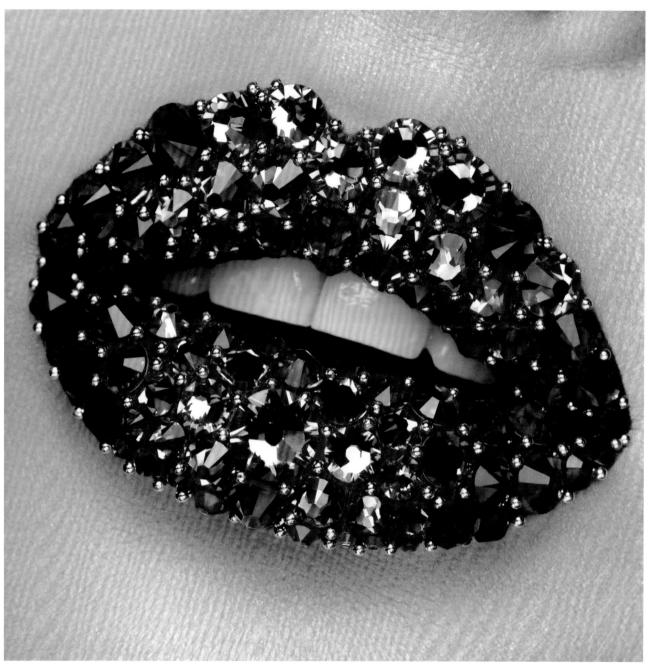

225

2018 PINK KISS
Liquid lipstick · glass crystals ·
caviar beads

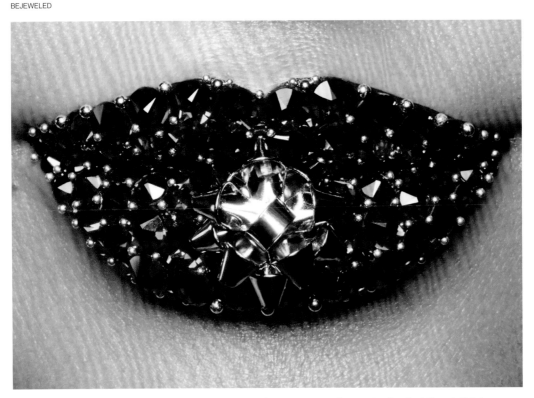

TIP I never use tweezers to apply crystals. I use a rhinestone applicator tool called Crystal Katana.
It has a wax tip and is so useful for precise crystal application. Bonus: the other tip of the tool
is perfect for applying caviar beads.

2018 GIFT ↑
Liquid lipstick · glass crystals ·
caviar beads · pendant

2020 POISON →
Liquid lipstick · glass crystals ·
caviar beads · pendant

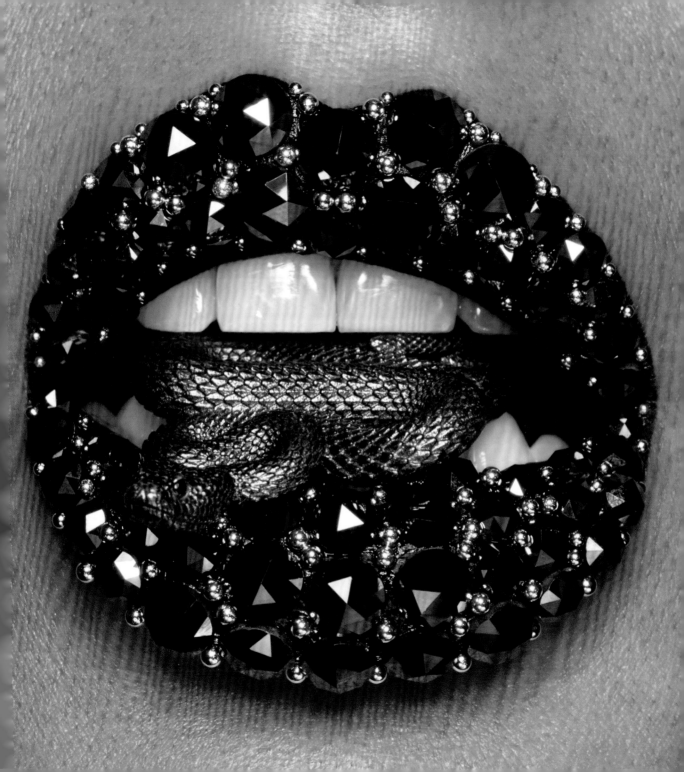

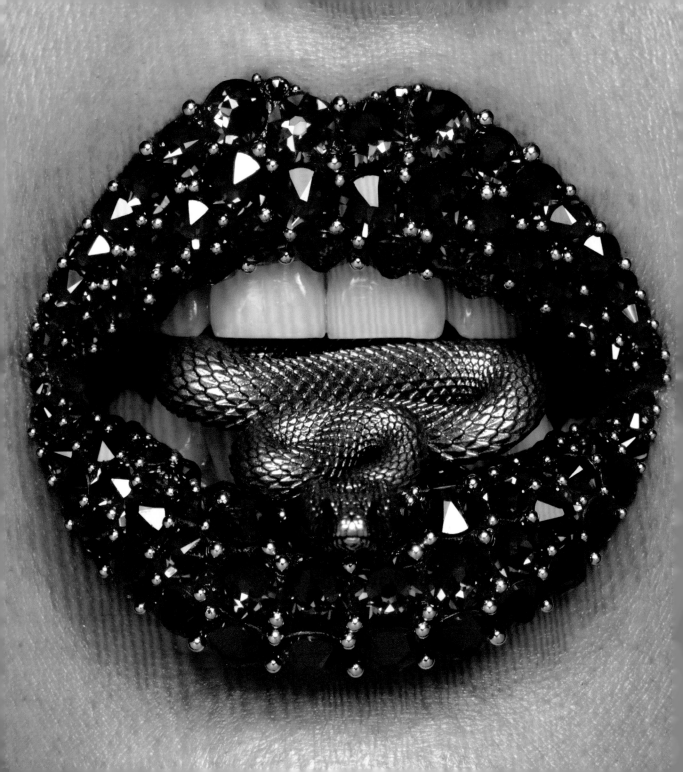

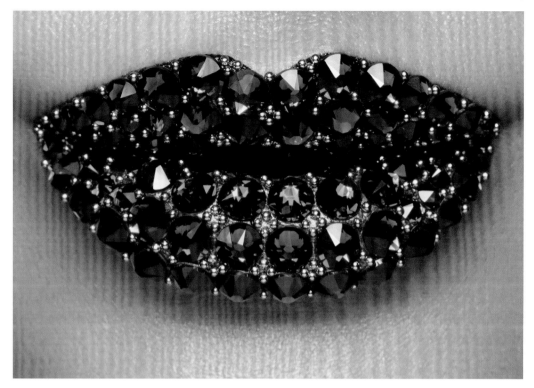

TIP When applying a base color, it's best to use a liquid lipstick in a similar shade to your crystals.

2020 RUBY SNAKE ←
Liquid lipstick · glass crystals ·
caviar beads · pendant

2020 ENVIOUS ↑
Liquid lipstick · glass crystals ·
caviar beads

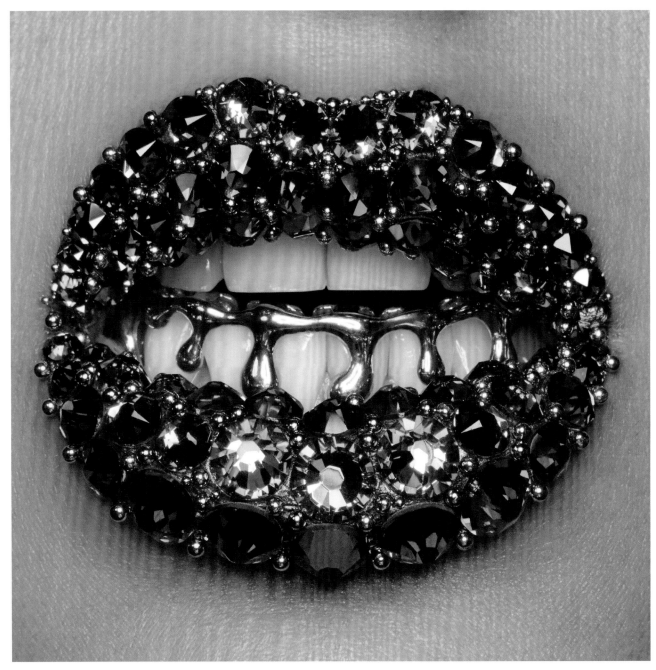

2018 GREEN
Liquid lipstick · glass crystals ·
caviar beads · grillz

230

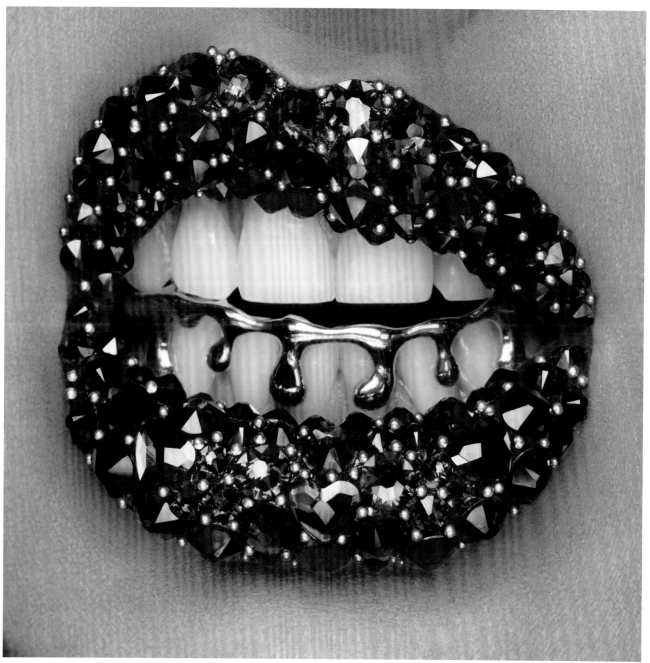

231

2017 SNARL
Liquid lipstick · glass crystals ·
caviar beads · grillz

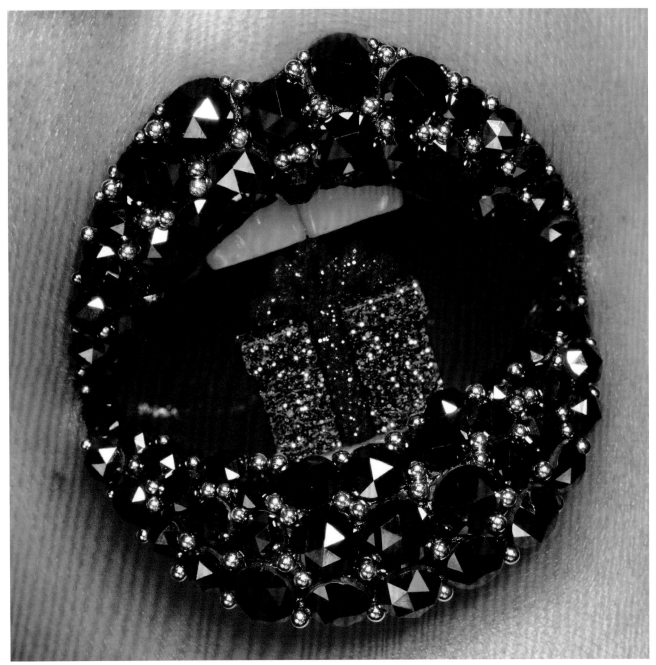

2019 PRESENT
Liquid lipstick · black diamonds ·
caviar beads · charm

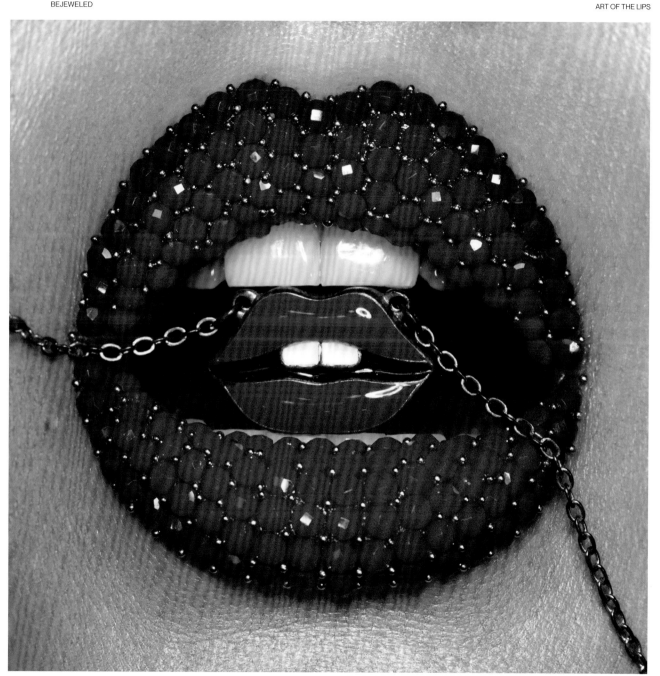

2018 LIPS I
Liquid lipstick · plastic gems ·
caviar beads · necklace

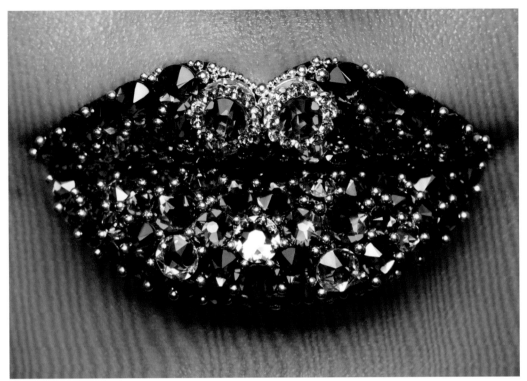

TIP Before I take any photographs, I always gently polish bejeweled lip art with a microfiber cloth, as I would with a piece of jewelry.

2021 OWL ↑
Liquid lipstick · glass crystals ·
caviar beads

2019 RINGS →
Liquid lipstick · glass crystals ·
caviar beads · rings

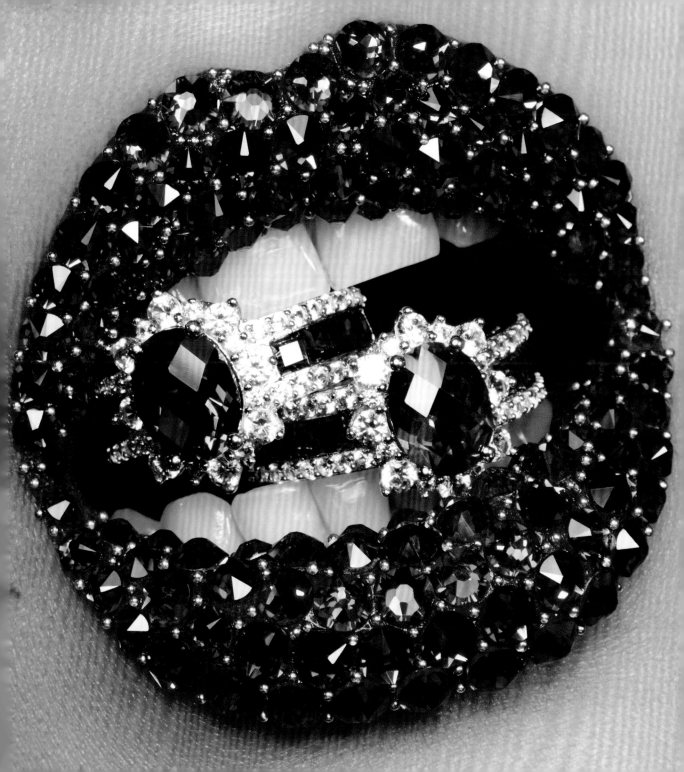

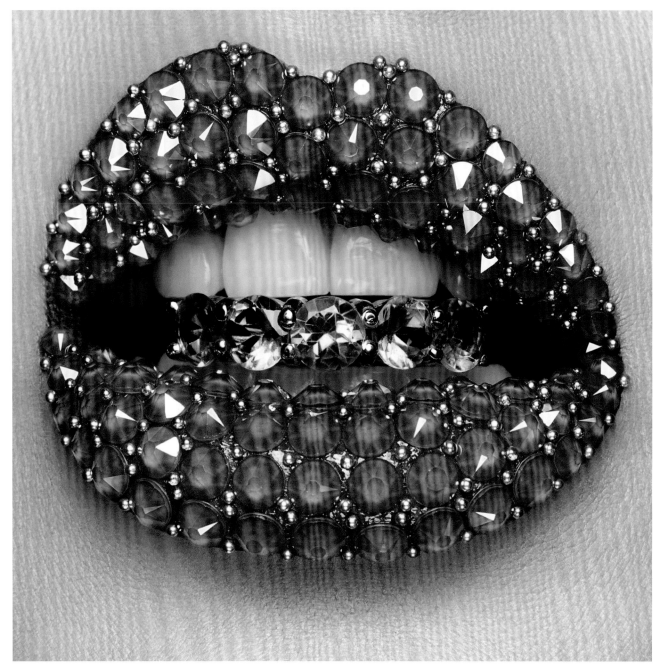

2017 PEACH
Liquid lipstick · glass crystals ·
caviar beads · ring

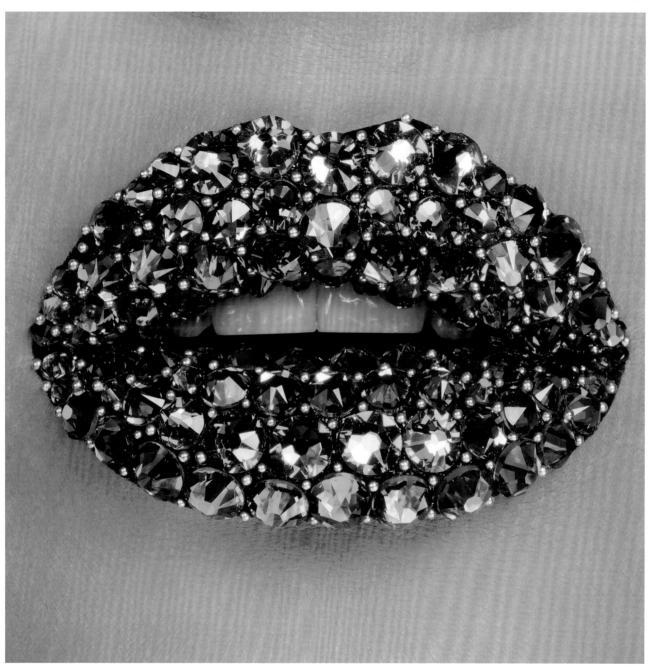

237

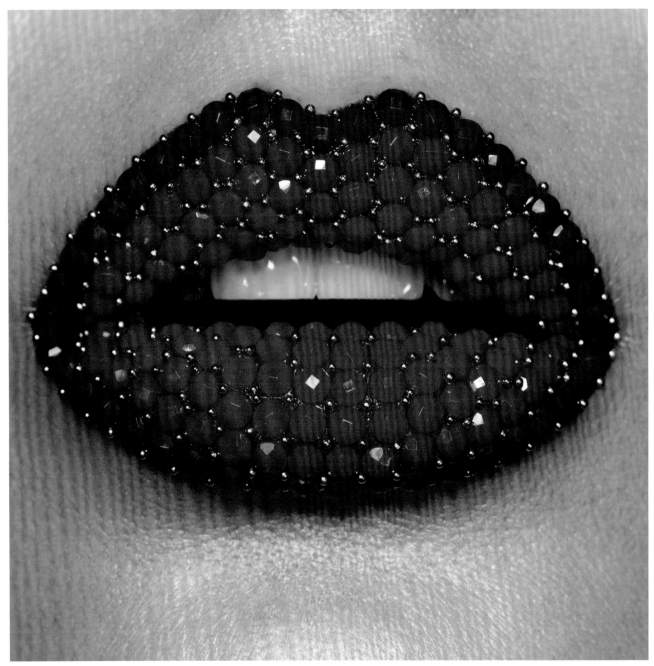

2021 RED
Liquid lipstick · plastic gems ·
caviar beads

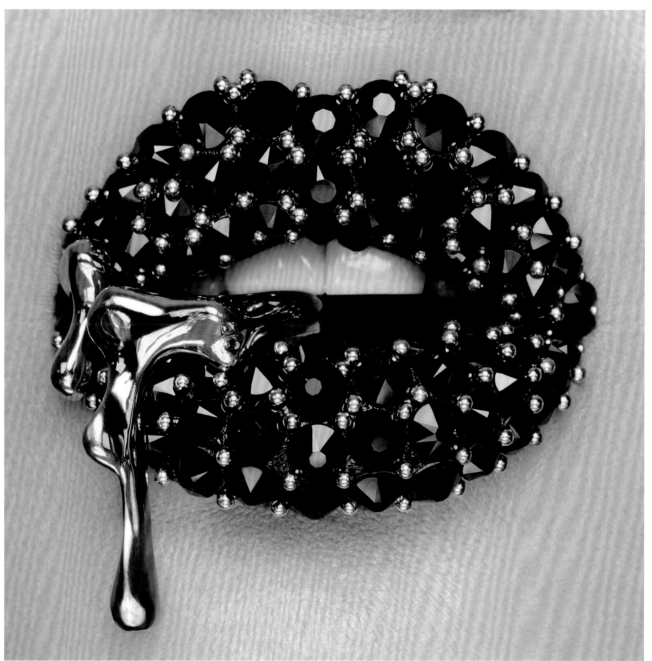

239

2018 BLACK ROSE
Liquid lipstick · glass crystals ·
caviar beads · ring

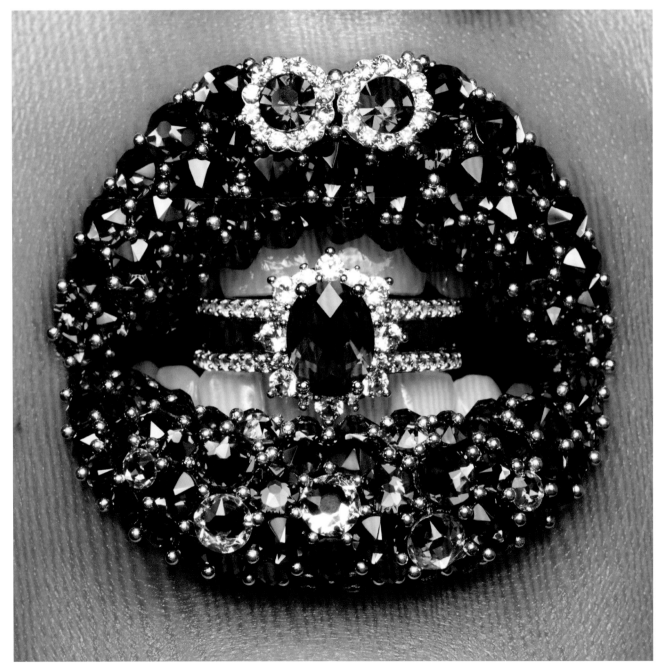

2018 ROYAL
Liquid lipstick · glass crystals ·
caviar beads · ring

240

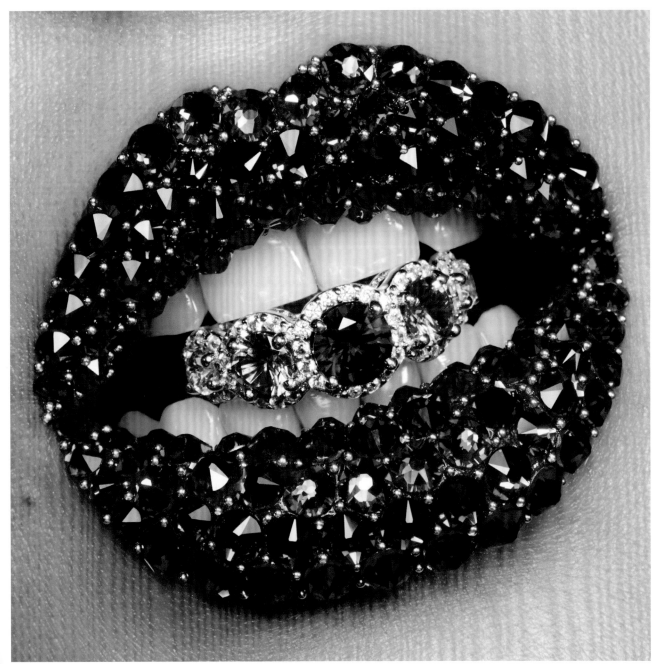

2019 RUBY RING
Liquid lipstick · glass crystals ·
caviar beads · ring

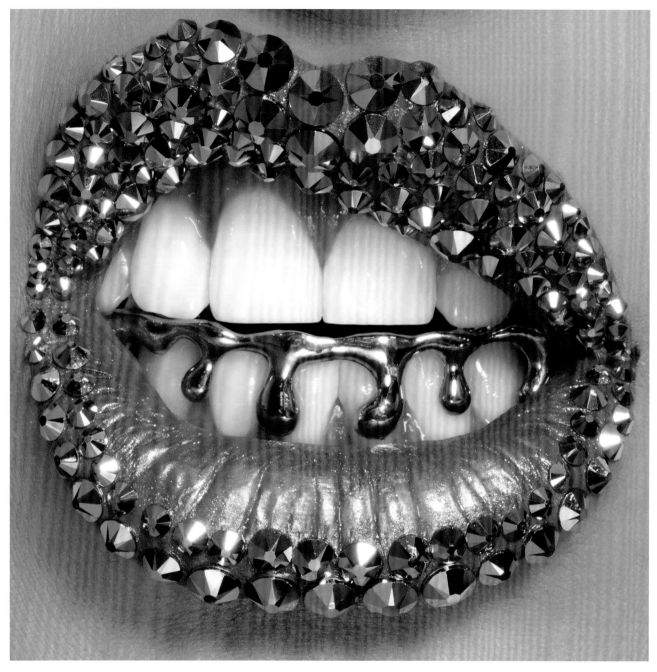

2017 TRIBUTE
Liquid lipsticks · glass crystals ·
grillz

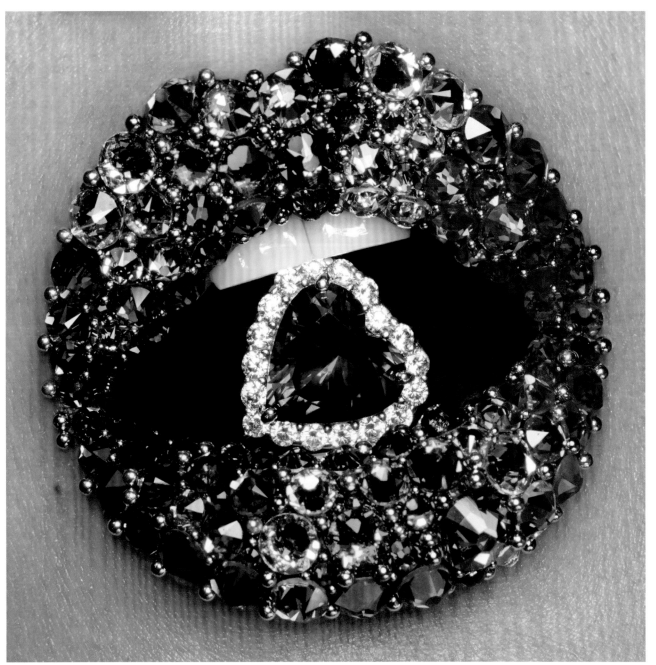

243

2018 LOVE IS LOVE
Liquid lipsticks · glass crystals ·
caviar beads · pendant

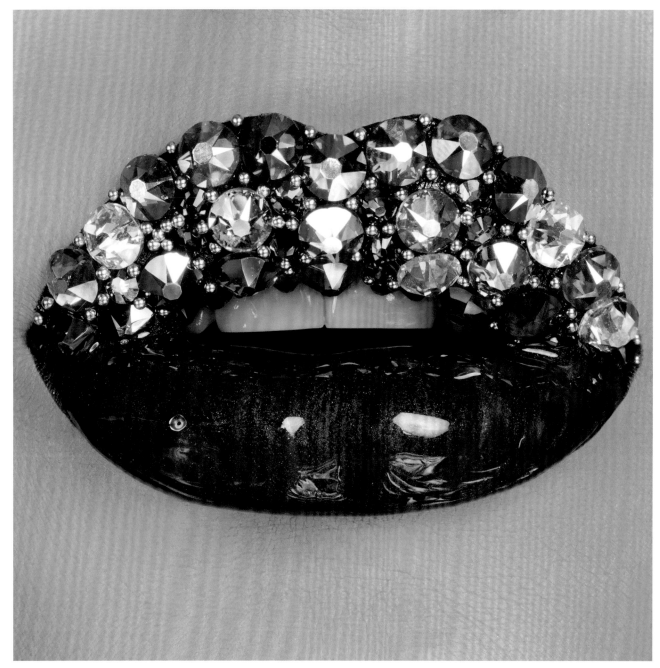

2017 DARK RAINBOW
Liquid lipsticks · glass crystals ·
caviar beads · various metallic lip gloss

244

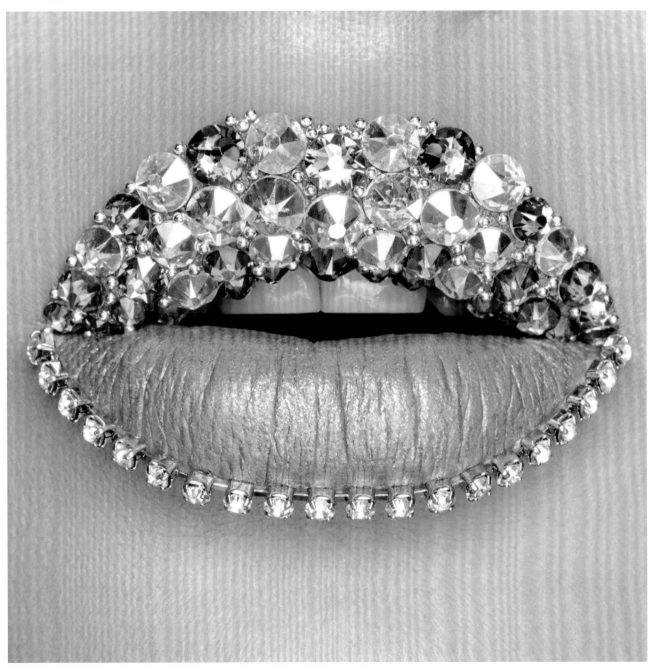

245

2017 CRYSTAL BALLER
Liquid lipstick · glass crystals ·
caviar beads · crystal chain

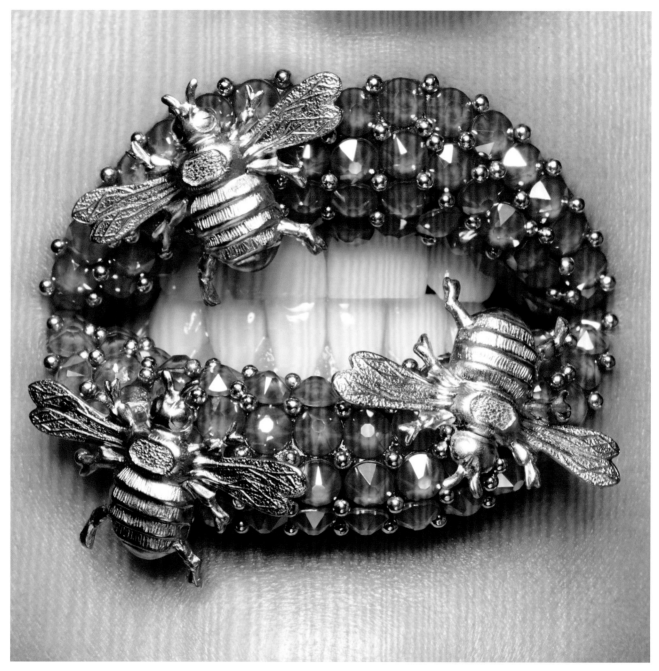

2018 BUMBLE BEES
Liquid lipstick · glass crystals ·
caviar beads · brass bees

246

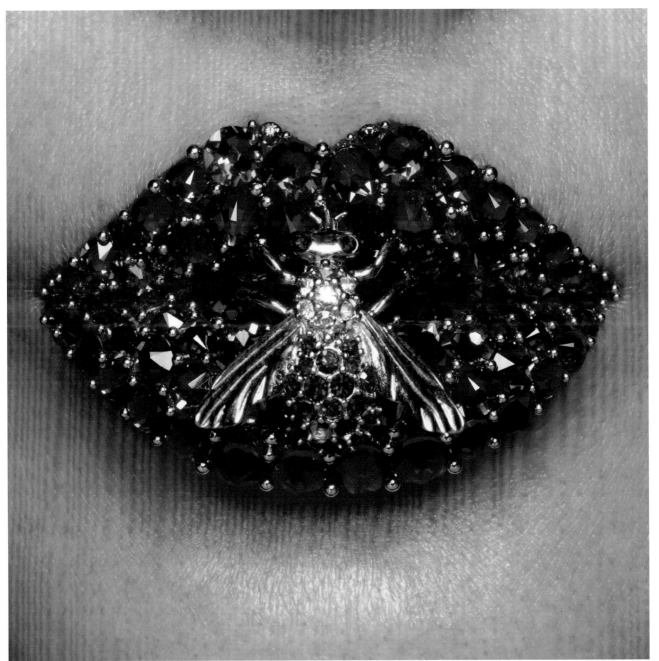

247

2020 RU-BEE
Liquid lipstick · glass crystals ·
caviar beads · vintage brooch

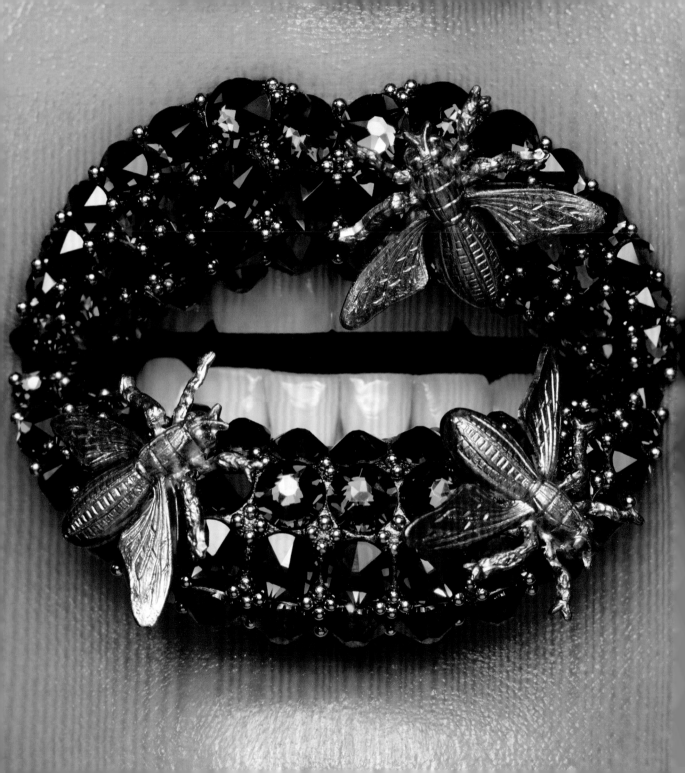

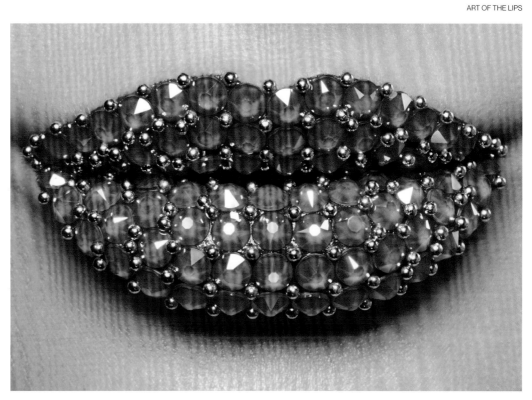

FACT Each bejeweled lip art is created with 80–100 crystals applied individually.

2019 SERPENTINE ←
Liquid lipstick · glass crystals ·
caviar beads · brass flies

2018 ROCK CANDY ↑
Liquid lipstick · glass crystals ·
caviar beads

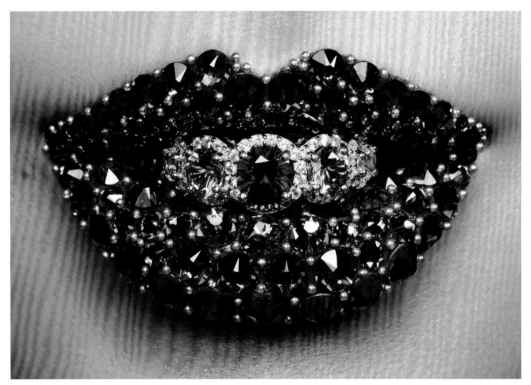

FACT Lip Art is my own form of meditation.

2019 GARNET ↑
Liquid lipsticks · glass crystals ·
caviar beads · ring

2017 FJORD RED →
Liquid lipstick · glass crystals ·
caviar beads · ring

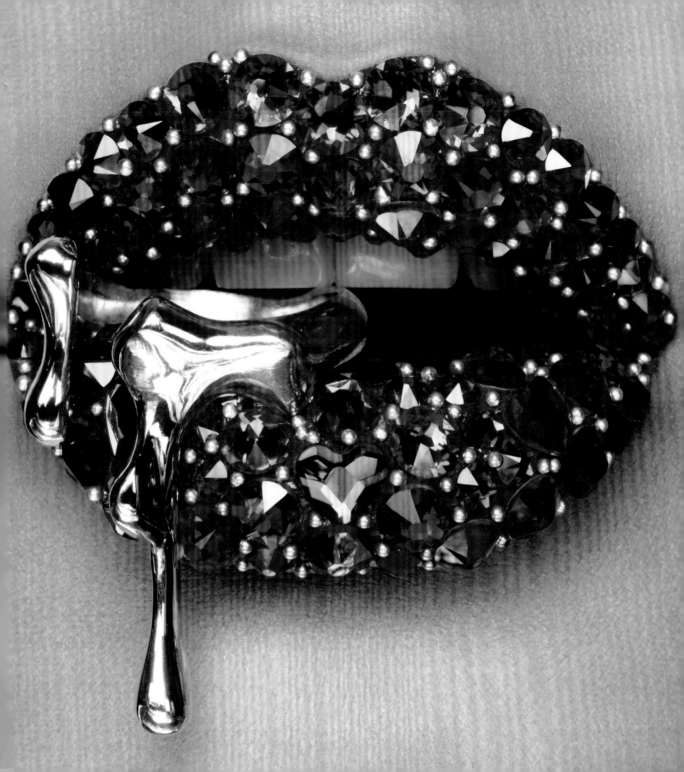

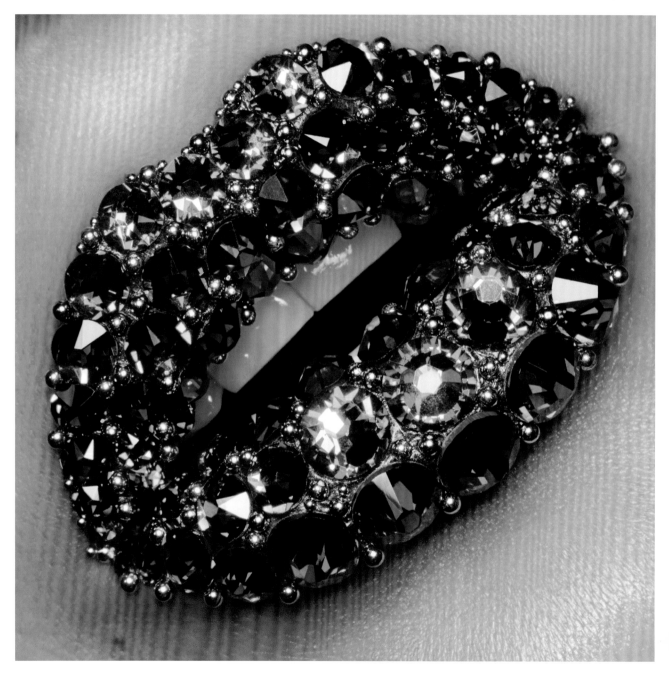

2018 PERIDOT
Liquid lipstick · glass crystals ·
caviar beads

252

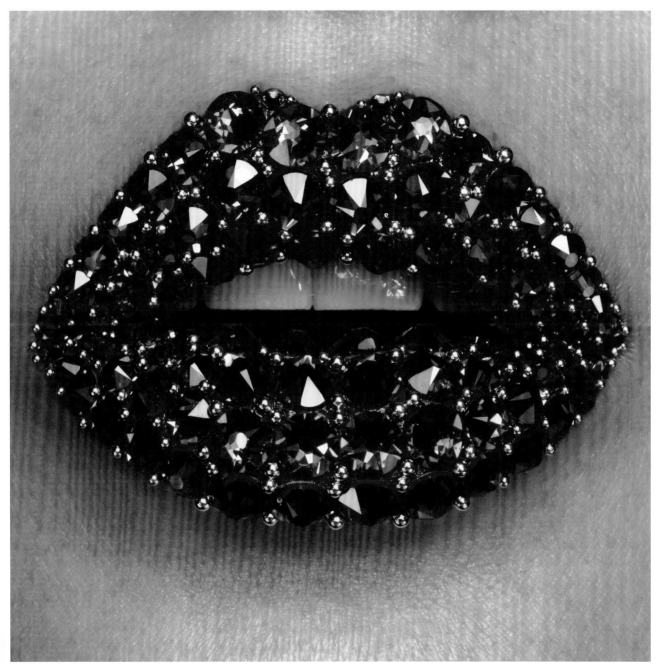

253

2020 SALVADOR
Liquid lipstick · glass crystals ·
caviar beads

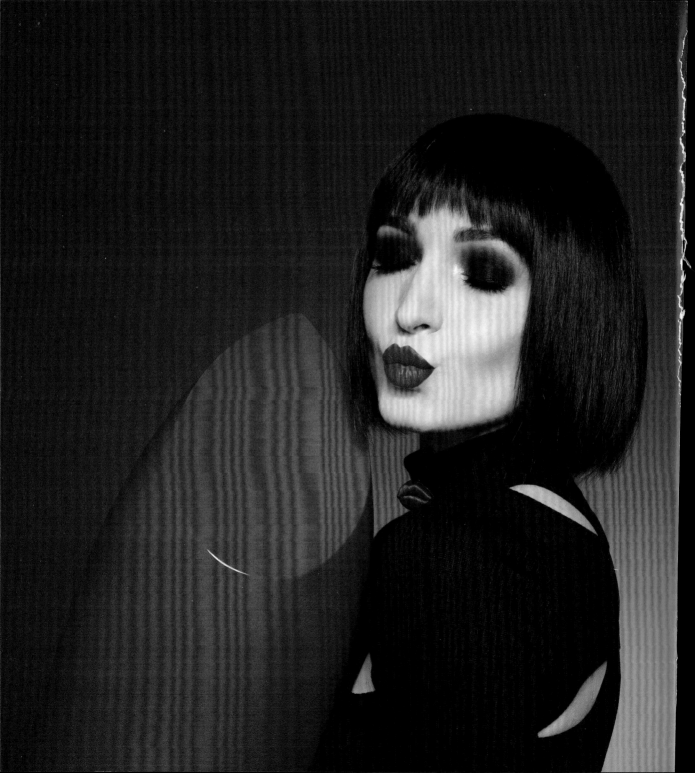

ABOUT THE AUTHOR

Vlada Haggerty is a cosmetic artist from Los Angeles, USA. Born and raised in Kyiv, Ukraine, as a little girl Vlada was fascinated with her mother's makeup collection and loved playing with different colors and textures, but it never occurred to her that this could become a career. She graduated from a pedagogical university but her heart yearned for a more creative path.

At first, Vlada went to a beauty school just for fun, to learn some extra skills for her own makeup application. She quickly realized that cosmetic art was her passion and decided to pursue it as a career. In 2014 Vlada moved to Los Angeles. This is where lip art became her creative outlet and her lips became her canvas.

Vlada's creations quickly drew attention on Instagram, which inspired her to continue exploring the fascinating world of lip art. With over 300 lip art designs to date, Vlada continues to amuse her 650k+ following with her intricate designs.

Vlada's lip art photography has been featured in TV shows, art shows, makeup campaigns, articles and magazines, and is also sold around the world as wall art.

Published in 2023 by Smith Street Books
Naarm (Melbourne) | Australia
smithstreetbooks.com

ISBN: 978-1-9227-5418-9

Publisher: Paul McNally
Project Editor: Hannah Koelmeyer
Designer: Susan Le | Evi-O.Studio
Typesetter: Megan Ellis
Proofreader: Pam Dunne

Images on pages 24, 50, 51, 60, 61, 68, 69, 74, 80, 81, 99, 119, 129, 140, 141,
178, 190, 224 and 245 created in partnership with Smashbox Cosmetics

Printed & bound in China by C&C Offset Printing Co., Ltd.

Book 255
10 9 8 7 6 5 4 3 2 1